IMAGES
IN SPITE
OF ALL

[Images in Spite of All] [FOUR PHOTOGRAPHS FROM AUSCHWITZ]

GEORGES DIDI-HUBERMAN

Translated by
SHANE B. LILLIS

THE UNIVERSITY OF CHICAGO PRESS
Chicago & London

The University of Chicago Press, Chicago 60637
The University of Chicago Press, Ltd., London
This edition © 2008 by The University of Chicago
All rights reserved. Published 2008.
Paperback edition 2012
Printed and bound by CPI Group (UK) Ltd, Croydon, CR0 4YY

Originally published as *Images malgré tout*
© Les Éditions de Minuit, 2003

21 20 19 18 17 16 15 14 13 12 3 4 5 6

ISBN-13: 978-0-226-14816-8 (cloth)
ISBN-13: 978-0-226-14817-5 (paper)

Library of Congress Cataloging-in-Publication Data

Didi-Huberman, Georges.
 [Images malgré tout. English]
 Images in spite of all : four photographs from Auschwitz / Georges Didi-
Huberman : translated by Shane B. Lillis.
 p. cm.
 Includes index.
 ISBN-13: 978-0-226-14816-8 (cloth : alk. paper)
1. Holocaust, Jewish (1939–1945)—Historiography. 2. World War, 1939–1945—
Photography. 3. Historiography and photography. I. Title.
D804.348.D5313 2008
940.53'18072—dc22

 2008018328

♾ This paper meets the requirements of ANSI/NISO Z39.48-1992 (Permanence of
Paper).

CONTENTS

PART I. IMAGES IN SPITE OF ALL [1]

Four Pieces of Film Snatched from Hell [3]

To know, we must imagine for ourselves. Auschwitz, August 1944: four images *in spite of all*, in spite of the risks, in spite of our inability to know how to look at them today. The *Sonderkommando* at work. Survival and impulse to resist: emitting signals to the outside. The photographic image appears from the fold between the imminent obliteration of the witness and the unrepresentability of the testimony: to snatch an image from that real. Organization of the clandestine photo-taking. First sequence: from the gas chamber of crematorium V, images of the incineration pits. Second sequence: in the open air, in the trees at Birkenau, image of a "convoy" of undressed women. The roll of film, hidden in a tube of toothpaste, makes it into the hands of the Polish Resistance, in order to be "sent further."

Against All Unimaginable [19]

The photographs from August 1944 address the unimaginable and refute it. First period of the unimaginable: the "Final Solution" as a generalized "disimagination" machine. To obliterate the victims' psyche, their language, their being, their remains, the tools of their obliteration, and even the archives, the memory of this obliteration. "Reason in history" always refuted by singular exceptions: the archives of the Shoah are made of these exceptions. Photography's particular ability to be reproduced and to transmit *in spite of all*: the absolute prohibition of photographing the camps coexists with the activity of two photography laboratories at Auschwitz. Second period of the unimaginable: if Auschwitz is unthinkable, then we must rethink the bases of our anthropology (Hannah Arendt). If Auschwitz is unsayable,

then we must rethink the bases of testimony (Primo Levi). If Auschwitz is unimaginable, we must give the same attention to an image as we do to what witnesses say. The *aesthetic* space of the unimaginable ignores history in its concrete singularities. How Robert Antelme, Maurice Blanchot, and Georges Bataille did not conform: the fellow human and the human species.

In the Very Eye of History [30]

To remember, one must imagine. Image and testimony in Filip Müller: immediacy of the monad and complexity of the montage. The urgency of the "photographic" present and the construction of images in the *Scrolls of Auschwitz*. The image as an "instant of truth" (Arendt) and "monad" appearing where thought fails (Benjamin). Dual system of the image: truth (the four photos in the eye of the cyclone) and obscurity (the smoke, the blur, the lacunary value of the document). The *historic* space of the unimaginable ignores this dual system of the image, asks too much or too little of it, between pure exactness and pure simulacrum. The photographs from August 1944 rendered "presentable" as icons of horror (touched up) or "informative" as simple documents (cropped), without attention to their phenomenology. Elements of this phenomenology: the "mass of black" and the overexposure where nothing is *visible* constitute the *visual* marks of the condition of their existence and of their very gestures. The images do not say the truth but are a fragment of it, its lacunary remains. The threshold of the *in spite of all*, between the impossible and the actual necessity. "It was impossible. Yes. One must imagine."

Similar, Dissimilar, Survivor [41]

For a visual critique of the images of history: to tighten the viewpoint (formally) and to open it (anthropologically). The photographs from August 1944 as a drama of the human image: the "inseparable" (Bataille) and the similar. When the executioner dooms the human to the dissimilar ("mannequins," "columns of basalt"), the victim resists by maintaining the *in spite of all* image of the world, the image of oneself, of the dream, and of the human in general (Levi: "to stand straight"). To maintain even the images of art: inexactness but truth of Dante's figure of Hell (*Lasciate ogni speranza* . . .). Recourse to the image as a lacunary necessity: lack of information and visibility, necessity of the gesture and of the apparition. The photographs from August 1944 as *surviving things*: the witness did not survive the images that he extracted from Auschwitz. Time of the flash and time of the earth, instant and sedimentation: need for a visual archeology. Walter Benjamin in the face of the "authentic image of the past."

Fact-Image or Fetish-Image [51]

Critique of the unimaginable and its polemic return. The thought of the image as a political terrain. The photographs of August 1944, historical and theoretical symptom. "There are no images of the Shoah." To render *all of the real* absolute in order to contrast it with the *all image*, or to historicize the real in order to observe its lacunary images? A controversy on the relations between singular facts and universal theses, images to think about and an already thought image. The unimaginable as an experience is not the unimaginable as dogma. That the image is *not all*. Images of the camps: ill seen, ill said. "There are too many images of the Shoah." That to repudiate images is not to critique them. Thesis of the fetish-image, experience of the fact-image. The photographic "print" between image and real. The fetish: the all, the standstill, the screen. A philosophical debate on the powers of the image: veil or tear? The dual system of the image. That the imaginary cannot be reduced to the specular. Between the primacy of veil-images and the necessity of tear-images. Susan Sontag and the "negative epiphany," Ka-Tzetnik and the photographic "rapture," Jorge Semprun and the ethical moment of the gaze. "To abruptly attend our own absence."

Archive-Image or Appearance-Image [89]

The historical "readability" of images does not go without a critical moment. From the fetish-image to the evidence-image and to the archive-image. Claude Lanzmann and the rejection of the archive: "images without imagination." The filmmaker and "peremptory" judgment. The fabricated archive confused with the verified archive. The hypothesis of the "secret film" and the polemic between Lanzmann and Semprun. Hyperbolic certainty and unthought of the image. To rethink the archive: the breach in conceived history, the grain of the event. Against radical skepticism in history. To rethink the evidence [*preuve*] with the ordeal [*épreuve*]. To rethink the testimony: neither *différend*, nor pure silence, nor absolute speech. To tell *in spite of all* what it is impossible to tell *entirely*. Testimony of the members of the *Sonderkommando* beyond the survival of the witnesses. The *Scrolls of Auschwitz*, the multiplication of the testimony, and the photographic "scroll" of August 1944. To rethink imagination beyond the opposition between appearance and truth. What is an "image without imagination"? Jean-Paul Sartre, or the image as act. Quasi observation. Door or window? The "margin of the image" and the order of the two sequences: inverting the views.

Montage-Image or Lie-Image [120]

Four images, two sequences, one montage. Imagination and knowledge by montage: access to the singularities of time. The image is neither *nothing*, nor *one*, nor *all*. Claude Lanzmann and Jean-Luc Godard: centripetal montage and centrifugal montage. "No single image" actually *tells* the Shoah, yet "all the images" *speak* only of it. From polarity to polemic: the two meanings of the adjective mosaic. A single all image, or a profusion of part images? Founding moments: memory and the present in the work of Alain Resnais, archive and testimony in the work of Marcel Ophuls. "What we cannot see, we must show." Lanzmann's montage-narrative and Godard's montage-symptom. When making a montage is not to falsify but to create a "form that thinks" and to make the image dialectic. *Table critique*: cinema *shows* history by reviewing it as through a sequential montage. Dachau placed in a montage with Goya, Elizabeth Taylor, and Giotto. Angel of resurrection according to Saint Paul, or angel of history according to Walter Benjamin? A dialectic without outcome.

Similar Image or Semblance-Image [151]

Two viewpoints confronted with the gaze of a third. To make a montage does not mean to assimilate, but rather to fuse together *resemblances* by making *assimilations* impossible. Similar is neither semblance nor identical. Doubles and contrasts: the Jew and the dictator in Charlie Chaplin. The speculative hyperboles of the unrepresentable and of the unimaginable. "To know, one must imagine for oneself." The image at the heart of the ethical question. Hannah Arendt and the imagination as a political faculty. In what way can an image "save the honor" of a history? Redemption is not resurrection. The *Endlösung* and the *Erlösung*: from Kafka and Rozensweig to Scholem and Benjamin. The "true image of the past passes by in a flash." The model of cinema: fleeting images, pregnant nonetheless. Filmic redemption, according to Siegfried Kracauer. Critical realism: the image dismantles and assembles sequentially the spatial and temporal continua. Perseus in the face of the Medusa: the trick of the shield, the courage to know and to confront *in spite of all*. The image in the period of the torn imagination: the crisis of culture. To open, by an image of the past, the present of time.

ILLUSTRATIONS

TRANSLATOR'S NOTE

Didi-Huberman's writing in this work intentionally plays on the multiple meanings of certain words in French. Though few, such instances are nonetheless crucial to the argument and far from gratuitous: as the author explains in his text, they are intended to draw attention to the problem of polysemy in the particular terms debated, and thus to the problem of "closed interpretation" regarding the particular concepts. Therefore, when the translation of a French word into English causes it to lose its multiplicity of meaning or to lose its precision, I have placed the original French word in square brackets after its translation in English. In some instances, a translator's note provides clarification.

In a number of instances, Didi-Huberman explains his use of the French word *tout* (appearing in the title, the chapter headings, and the text in general), giving his reasons for exploring the word's possible semantic variations, as well as its possible syntactic variations. The single French word *tout* can be translated into English variously as "all," "whole," "every," "any"—words which in English, contrary to the French, vary distinctly in meaning, laying out problems for translation. Since the word *tout* refers to a crucial concept in this text, I believe it is important to follow the author and to keep to the one word "all" in most instances—even where the choice (as it is in the French text) is syntactically unusual.

All translations of French texts cited by Didi-Huberman are mine. Where Didi-Huberman uses French translations of texts written in other languages, I have used published English translations of these texts where available. Where they are unavailable, however, or else if it seemed more appropriate to reflect the wording of the French translation used by Didi-Huberman, I have translated directly from that French translation. Such instances are followed in the relevant footnote by an asterisk.

BIBLIOGRAPHICAL NOTE TO THE FRENCH EDITION

The first part of this work, "Images in Spite of All," was written between January and June 2000 for publication, in January 2001, in the catalogue of *Mémoire des camps: Photographies des camps de concentration et d'extermination nazis (1933–1999)*, edited by C. Chéroux (Paris: Marval, 2001), 219–241. The second part, "In Spite of the All Image," which is published for the first time in this work, was the subject of seminars given in May and June 2003 at the Freie Universität in Berlin, in the context of the Interdisciplinary Center for the Science of Art and Aesthetics in the Department of Philosophy there. I would like, in particular, to thank Erika Fischer-Lichte and Ludger Schwarte for their very warm welcome, as well as my listeners who were so involved in the questions and so engaged in discussions.

I am grateful to Claude Lanzmann, Jean-Luc Godard, and Alain Resnais for allowing me to reproduce photograms from their respective films (as well as to Florence Dauman, Claudine Kaufmann, and Stéphane Dabrowski for the printing of the photogram from *Nuit et brouillard*). Clément Chéroux, Pascal Convert, Christian Delage, Henri Herré, and Manuela Morgaine gave me valuable feedback in their reading of the manuscript: I thank them very warmly. Finally, my wholehearted thanks go to Professor David Bankier for having welcomed and guided me at the International Institute for Holocaust Studies, which he directs at Yad Vashem (Jerusalem).

From one text to another, and from one cited edition to another, the spelling of certain words (starting with "Shoah," which is variously written as "shoah" or "Shoa") and of certain proper names (for example that of Zalmen Lewental) has been standardized here.

Tell them, tell your friends
and acquaintances, that if you
do not come back, it will be
because your blood stopped
and thickened at the sight of
those atrocious, barbaric scenes,
of the death of the innocent
and unprotected children of
my forsaken people.
 Tell them that if your heart
should turn to [stone], your
brain become a cold thinking
machine and your eye trans-
form into a camera, you will
not come back to them again.
[. . .] Hold me tightly by the
hand, do not tremble [——]
because you will have to see
even worse.

z. gradowski,
Rouleaux d'Auschwitz, I (1944)

Images
in Spite
of All

even scratched to death
a simple rectangle
of thirty-five
millimeters
saves the honor
of all of the real.

J.-L. GODARD,
Histoire(s) du cinéma (1998)

FOUR PIECES OF FILM SNATCHED FROM HELL

In order to know, we must *imagine* for ourselves. We must attempt to imagine the hell that Auschwitz was in the summer of 1944. Let us not invoke the unimaginable. Let us not shelter ourselves by saying that we cannot, that we could not by any means, imagine it to the very end. We *are obliged* to that oppressive imaginable. It is a response that we must offer, as a debt to the words and images that certain prisoners snatched, for us, from the harrowing Real of their experience. So let us not invoke the unimaginable. How much harder was it for the prisoners to rip from the camps those few shreds of which now we are trustees, charged with sustaining them simply by looking at them. Those shreds are at the same time more precious and less comforting than all possible works of art, snatched as they were from a world bent on their impossibility. Thus, images *in spite of all*: in spite of the hell of Auschwitz, in spite of the risks taken. In return, we must contemplate them, take them on, and try to comprehend them. Images *in spite of all*: in spite of our own inability to look at them as they deserve; in spite of our own world, full, almost choked, with imaginary commodities.

[]

Of all the prisoners in Auschwitz, those whose possible testimony the SS wanted to eradicate at any cost were, of course, the members of the *Sonderkommando*. This was the "special squad" of prisoners who operated the mass extermination with their bare hands. The SS knew in advance that a single word from a surviving

member of the *Sonderkommando* would quash any denials, any sub-
sequent cavils with respect to the massacre of the European Jews.[1]
"Conceiving and organizing the squads was National Socialism's
most demonic crime," writes Primo Levi. "One is stunned by this
paroxysm of perfidy and of hate: it must be the Jews who put the
Jews in the ovens; it must be shown that the Jews [. . .] bow to any
humiliation, even to destroying themselves."[2]

The first *Sonderkommando* at Auschwitz was created on July 4,
1942, during the "selection" of a convoy of Slovakian Jews for the
gas chamber. Twelve squads succeeded each other from that date;
each was eliminated at the end of a few months, and "as its initia-
tion, the next squad burnt the corpses of its predecessors."[3] Part of
the horror for these men was that their entire existence, including
the ineluctable gassing of the squad, was to be kept in absolute
secrecy. The members of the *Sonderkommando* could therefore have
no contact whatsoever with the other prisoners, and even less with
whatever "outside world" there was, not even with the "nonini-
tiated" SS, those who were ignorant of the exact functioning of
the gas chambers and the crematoria.[4] When sick, these prisoners,
kept in solitary confinement, were denied admission to the camp
hospital. They were held in total subservience and mindlessness—
they were not denied alcohol—in their work at the crematoria.

What exactly was their work? It must be repeated: to handle
the death of their fellows by the thousands. To witness all the last
moments. To be forced to lie to the very end. (A member of the
Sonderkommando who had attempted to warn the victims of their
fate was thrown alive into the crematorium fire, and his fellows
were forced to attend the execution).[5] To recognize one's own
and to say nothing. To watch men, women, and children enter
the gas chamber. To listen to the cries, the banging, the death
throes. To wait. Then, to receive all at once the "indescribable hu-
man heap"—a "column of basalt" made of human flesh, of their
flesh, our own flesh—that collapsed when the doors were opened.
To drag the bodies one by one, to undress them (until the Nazis
thought of the changing room). To hose away all of the accumu-
lated blood, body fluids, and pus. To extract gold teeth for the
spoils of the *Reich*. To put the bodies in the furnaces of the cre-

matoria. To maintain this inhuman routine. To feed coal to the fires. To extract the human ashes from that "formless, incandescent and whitish matter which flowed in rivulets [and] took on a grayish tint when it cooled." To grind the bones, the final resistance of the wretched bodies to their industrial destruction. To pile it all up, to throw it into a neighboring river or use it as fill for the road being constructed near the camp. To walk on 150 square meters of human hair, which fifteen prisoners are busy carding on large tables. To occasionally repaint the changing room; to erect hedges—for camouflage; to dig supplementary incineration pits for exceptional gassings. To clean, to repair the giant ovens of the crematoria. To start over each day, constantly threatened by the SS. To survive in this manner for an indeterminate time, drunk, working day and night, "running like the possessed in order to finish more quickly."[6]

"They had no human figure. They were ravaged, mad faces," said the prisoners who were able to see them.[7] They survived, however, for the time left to them, in the ignominy of the job. To a prisoner who asked him how he could stand work of that kind, a member of the squad replied: "Of course, I could throw myself onto the electrical wires, like so many of my friends, but I want to live [. . .]. In our work, if you don't go mad the first day, you get used to it."[8] In a manner of speaking. Yet some who thought themselves "used to it" simply threw themselves into the fire.

If this kind of survival surpasses any moral judgment (as Primo Levi wrote)[9] or any tragic conflict (as Giorgio Agamben commented),[10] then what could the verb *to resist* mean in such constraints? To revolt? That was a dignified way of committing suicide, of anticipating a promised elimination. At the end of 1942, a first projected rebellion failed. Then, in the great mutiny of October 1944—when, at least, crematorium IV was set ablaze and destroyed—not one of the 450 members implicated survived, of whom "only" 300 were due to be gassed soon in any case.[11]

At the core of this fundamental despair, the "impulse to resist" probably abandoned them, condemned as they were to die, leaving them to concentrate rather on *signals to be emitted* beyond the borders of the camp: "We, the prisoners of the *Sonderkommando*,

kept thinking about how we might make known to the world the
details of the gruesome crimes which were perpetuated here."[12] So
in April 1944, Filip Müller patiently gathered some documents—a
plan of crematoria IV and V, a note on their operation, a list of the
Nazis on duty as well as a Zyklon B label—and passed them along
to two prisoners who were attempting escape.[13] Such an attempt,
as all of the *Sonderkommando* knew, was hopeless. This is why they
sometimes confided their testimonies to the earth. Digs under-
taken around the borders of the Auschwitz crematoria have since
brought to light—often long after the Liberation—the devastat-
ing, barely legible writings of these slaves of death.[14] *Bottles cast
into the earth*, as it were, except that the writers did not always have
bottles in which to preserve their message. At best, a tin bowl.[15]

These writings are haunted by two complementary constraints.
First, there is the ineluctable obliteration of the witness himself:
"The SS often tell us that they won't let a single witness survive."
But then there was the fear that the testimony itself would be
obliterated, even if it were transmitted to the outside; for did it
not risk being incomprehensible, being considered senseless, un-
imaginable? "What exactly happened," as Zalmen Lewental con-
fided to the scrap of paper that he was preparing to bury in the
ground, "no other human being can imagine."[16]

[]

It is in the fold between these two impossibilities—the imminent
obliteration of the witness, the certain unrepresentability of the
testimony—that the photographic image suddenly appeared.
One summer day in 1944, the members of the *Sonderkommando* felt
the perilous need to snatch some photographs from their infernal
work that would bear witness to the specific horror and extent
of the massacre. The need to snatch some photographs from the
real. Moreover, since an image is made to be looked at by others,
to snatch from human thought in general, thought from "outside,"
something *imaginable* that no one until then had even conceived
as possible—and this is already saying a lot, since the whole thing
was planned before being put into practice.

It is troubling that a desire to *snatch an image* should materialize at the most indescribable moment, as it is often characterized, of the massacre of the Jews: the moment when those who assisted, stupefied, had room left for neither thought nor imagination. Time, space, gaze, thought, pathos—everything was obfuscated by the machinelike enormity of the violence produced. In the summer of 1944 came the "tidal wave" of Hungarian Jews: 435,000 of them were deported to Auschwitz between May 15 and July 8.[17] Jean-Claude Pressac (whose scientific scrupulousness generally avoids any adjectives or any empathetic phrases) wrote that this was the "most demented episode of Birkenau," carried out essentially in crematoria II, III, and V.[18] In a single day, 24,000 Hungarian Jews were exterminated. Toward the end of the summer, there was a shortage of Zyklon B. So "the unfit from the convoys [i.e., the victims selected for immediate death] were cast directly into the burning pits of crematorium V and of bunker 2,"[19] in other words, burned alive. As for the gypsies, they began to be gassed en masse from August 1.

As usual, the members of the *Sonderkommando* posted at the crematoria had to prepare the entire infrastructure of this nightmare. Filip Müller remembers how they proceeded to "overhaul the crematoria":

> Cracks in the brickwork of the ovens were filled with a special fireproof clay paste; the cast-iron doors were painted black and the door hinges oiled [. . .]. New grates were fitted in the generators, while the six chimneys underwent a thorough inspection and repair, as did the electric fans. The walls of the four changing rooms and the eight gas chambers were given a fresh coat of paint. Quite obviously all these efforts were intended to put the places of extermination into peak condition to guarantee smooth and continuous operation."[20]

Above all, on the orders of *Hauptscharführer* Otto Moll—a particularly feared and hated SS officer who had taken personal charge of the liquidation of the *Sonderkommando* from 1942 on[21]—five incineration pits were to be dug in the open air, behind crematorium V. Filip Müller has described in detail the technical experi-

8

mentation and the management of the site led by Moll: from the conception of gutters to collect the fat, to the concrete slab on which the "workers" would have to pulverize the bones mixed with the human ashes;[22] to the elevated hedgerows forming a screen to make all of this invisible from the exterior (fig. 1). It is significant that, apart from far-off aerial views, *not one single view* exists of crematorium V—situated in a copse of birch trees, from which Birkenau gets its name—that is not obscured by some plant barrier[23] (fig. 2).

To snatch an image from that hell? It seemed doubly impossible. It was impossible by default, since the detail of the installations was concealed, sometimes underground. But also, outside of their work under the strict control of the SS, members of the *Sonderkommando* were carefully confined in a "subterranean and isolated cell."[24] It was impossible by excess, since the vision of this monstrous, complex chain seemed to exceed any attempt to document it. Filip Müller wrote that "in comparison with what [Otto Moll] had imagined and what he had begun to undertake, Dante's Hell was only child's play":[25]

As it began to grow light, the fire was lit in two of the pits in which about 2,500 dead bodies lay piled one on top of the other. Two hours later all that could be discerned in the white-hot flames were countless charred and scorched shapes [. . .]. While in the crematorium ovens, once the corpses were thoroughly alight, it was possible to maintain a lasting red heat with the help of fans, in the pits the fire would burn as long as the air could circulate freely in between the bodies. As the heap of bodies settled, no air was able to get in from outside. This meant that we stokers had constantly to pour oil or wood alcohol on the burning corpses, in addition to human fat, large quantities of which had collected and was boiling in the two collecting pans on either side of the pit. The sizzling fat was scooped out with buckets on a long curved rod and poured all over the pit causing flames to leap up amid much crackling and hissing. Dense smoke and fumes rose incessantly. The air reeked of oil, fat, benzole and burnt flesh.

During the day-shift there were, on average, 140 prisoners working in and round crematoria IV and V. Some twenty-five bearers were employed in clearing the gas chamber and removing the corpses to the pits [. . .].

The SS guards on their watch-towers beyond the barbed wire which encircled the area around the pits [. . .] were badly upset by the ghoulish spectacle [. . .]. Under the ever-increasing heat a few of the dead began to stir, writhing as though with some unbearable pain, arms and legs straining in slow motion, and even their bodies straightening up a little [. . .]. Eventually the fire became so fierce that the corpses were enveloped by flames. Blisters which had formed on their skin burst one by one. Almost every corpse was covered with black scorch marks and glistened as if it had been greased. The searing heat had burst open their bellies: there was the violent hissing and sputtering of frying in great heat [. . .]. The process of incineration took five to six hours. What was left barely filled a third of the pit. The shiny whitish-gray surface was strewn with countless skulls [. . .]. As soon as the ashes had cooled down a little, wooden metal-covered boards were thrown into the pit. Prisoners of the ash team climbed down and began to shovel out the still hot ashes. Although their mittens and berets gave them some make-shift protection, hot ashes kept blowing down on them, especially when it was windy, causing severe facial burns and eye injuries, sometimes even blindness, so that after a short time they were issued with protective goggles.

Once the pits had been emptied and the ashes taken to the ash depot, they were piled up in man-high heaps.[26]

[]

To snatch an image from that, in spite of that? Yes. Whatever the cost, form had to be given to this unimaginable reality. The possibilities for escape or of revolt were so limited at Auschwitz that the mere *sending of an image* or of information—a plan, numbers, names—was of the utmost urgency, one of the last gestures of hu-

manity. Some prisoners had managed to listen to the BBC in the
offices they were cleaning. Others managed to send calls for help.
"The isolation of the outside world was part of the psychological
pressure exercised on the prisoners," wrote Hermann Langbein.
"Among the efforts to defend oneself from the psychic terrorism,
there were obviously those that sought to break the isolation. For
the morale of the prisoners, this last factor increased in impor-
tance year by year as the military situation unfolded."[27] On their
side, the leaders of the Polish Resistance were in 1944 demand-
ing photographs. According to a witness's account collected by
Langbein, a civilian worker managed to smuggle in a camera and

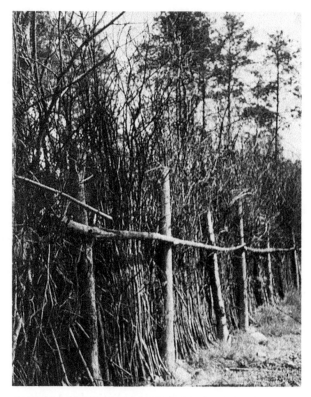

Figure 1. Anonymous (German). Hedge for camouflage at
crematorium V of Auschwitz, 1943–1944. Oswiecim,
Auschwitz-Birkenau State Museum (negative no. 860).

get it into the hands of the members of the *Sonderkommando*.[28] The camera probably contained only a small piece of blank film.

For the shooting, a collective lookout had to be organized. The roof of crematorium V was deliberately damaged so that certain squad members were sent by the SS to repair it. From up there, David Szmulewski could be on watch: he observed those—notably the guards in nearby observation posts—who were charged with overseeing the work of the *Sonderkommando*. Hidden at the bottom of a bucket, the camera got into the hands of a Greek Jew called Alex, still unidentified today, for we do not know his family name. He was positioned on the lower level, in front of the incineration pits, where he was supposed to work with the other members of the squad.

The terrible paradox of this *darkroom* was that in order to remove the camera from the bucket, adjust the viewfinder, bring it close to his face, and take a first sequence of images (figs. 3–4),

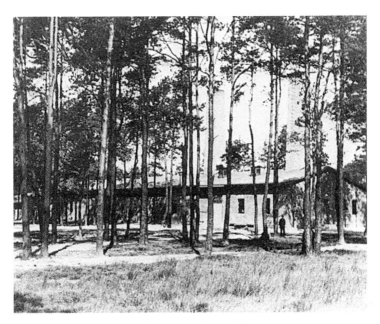

Figure 2. Anonymous (German). Crematorium V of Auschwitz, 1943–1944. Oswiecim, Auschwitz-Birkenau State Museum (negative no. 20995/508).

the photographer had to hide in the gas chamber, itself barely emptied—perhaps incompletely—of victims. He steps back into the dark space. The slant and the darkness in which he stands protect him. Emboldened, he changes direction and advances:

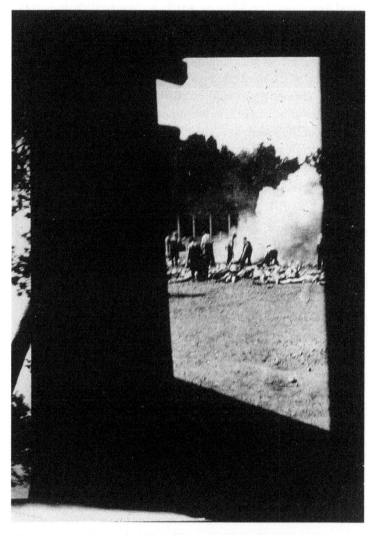

Figures 3–4. Anonymous (member of the *Sonderkommando* of Auschwitz). Cremation of gassed bodies in the open-air incineration pits in front of the

the second view is a little more frontal and slightly closer. So it is more hazardous. But also, paradoxically, it is more posed: it is sharper. It is as though fear had disappeared for an instant in the face of necessity, the business of snatching an image. And we see

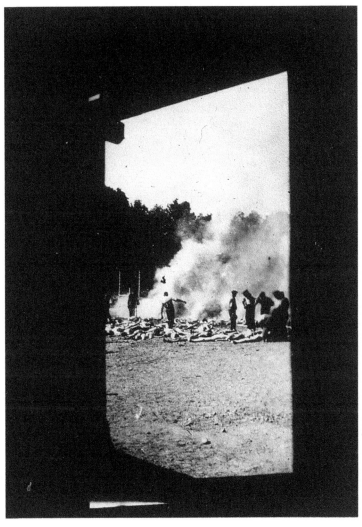

gas chamber of crematorium V of Auschwitz, August 1944. Oswiecim, Auschwitz-Birkenau State Museum (negative nos. 277–278).

the everyday work of the other members of the squad, which is that of snatching the last human semblance from the cadavers, still sprawled on the ground. The gestures of the living tell the weight of the bodies and the task of making immediate decisions. Pulling, dragging, throwing. The smoke, behind, comes from the incineration pits: bodies arranged quincuncially, 1.5 meters deep, the crackling of fat, odors, shriveling of human matter—everything of which Filip Müller speaks is there, under the screen of smoke

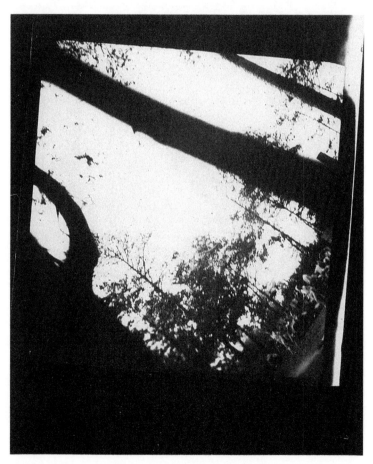

Figures 5–6. Anonymous (member of the *Sonderkommando* of Auschwitz). Women being pushed toward the gas chamber at crematorium V of Auschwitz,

that the photograph has captured for us. Behind is the birch-tree copse. The wind is blowing from the north, perhaps the northeast[29] ("In August of 1944," remembers Primo Levi, "it was very hot in Auschwitz. A torrid, tropical wind, lifted clouds of dust from the buildings wrecked by the air raids, dried the sweat on our skin and thickened the blood in our veins.")[30]

Having hidden the camera—in his hand, or in the bucket, or in a patch of his clothes?—the "unknown photographer" now ven-

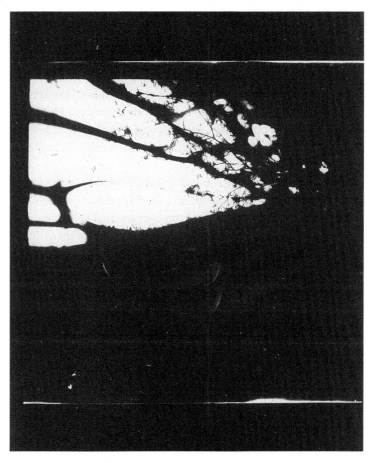

August 1944. Oswiecim, Auschwitz-Birkenau State Museum (negative nos. 282–283).

tures out of the crematorium. He hugs the wall. Twice he turns to the right. He finds himself then on the other side of the building, to the south, and advances in the open air toward the birch trees. There too, the hell continues: a "convoy" of women, already undressed, gets ready to enter the gas chamber. The SS are about. It is simply not possible to take out the camera, even less possible to aim it. The "unknown photographer" takes two snapshots, furtively, without looking, perhaps even while walking (figs. 5–6). On one of the two images—visibly deprived of orthogonality, or "correct" orientation—we can see in the far left corner a whole group of women who seem to be walking or awaiting their turn. Nearer, three other women are headed in the opposite direction. The image is very blurred. We can see, however, a member of the *Sonderkommando* in profile, recognizable by his cap. At the very bottom, to the right, we can make out the chimney of the crematorium. The other image is practically abstract: we can just make out the top of the birch trees. Facing south, the photographer has the light in his eyes. The image is dazzled by the sun, its rays cutting through the boughs.

Alex then returns to the crematorium, probably to the north side. Hastily he returns the camera to David Szmulewski, who has stayed up on the roof, on the lookout for potential movements by the SS. The entire operation will have taken no more than fifteen to twenty minutes. Szmulewski would replace the camera in the bottom of his bucket.[31] The piece of film would be removed from the camera, brought back to the central camp, and eventually extricated from Auschwitz in a tube of toothpaste in which Helena Dantón, an employee of the SS canteen, will have hidden it.[32] A little later, on September 4, 1944, it would reach the Polish Resistance in Krakow, accompanied by a note written by two political prisoners, Jósef Cyrankiewicz and Stanislaw Klodzinski:

Urgent. Send two metal rolls of film for 6×9 as fast as possible. Have possibility of taking photos. Sending you photos of Birkenau showing prisoners sent to gas chambers. One photo shows one of the stakes at which bodies were burned when the crematorium could not manage to burn all the bodies.

The bodies in the foreground are waiting to be thrown into the fire. Another picture shows one of the places in the forest where people undress before "showering"—as they were told—and then go to the gas chambers. Send film roll as fast as you can. Send the enclosed photos to Tell—we think enlargements of the photos can be sent further.[33]

...mog. Sprawa jest pilna ... już u mnie z wtorku
... soli? sprawy, ... bo chyba niejasno
... wszystkich i ... gdzie... kogoś o którym boi
... się... wie.

2. Film: Przyślijcie jak najszybciej, 2 — wielki
zielony film. Rozgrywka fot. gr. 6 × 9.
Jest możliwie zrobienie zdjęć. — Przyślemy...
Nam zdjęcie z Biskena. — z akcji garowania
Zdjęcie puszkiernia ... jestem ze studia
na cały pokoju... — który jak na które
pełno ... są ... na których... uczestniczy
... nie... że... z poleceniem Pułk. które
się tam czekające im... na stos.
Zdjęcie inne puszkiernia jedno z miejsca
... ludzie rozbierają się niekomu
... a potem i ... na gaz. Pułk...
jak najszybciej. / Te rozgrywane zdjęcia wyślijcie
natychmiast do Tell. — Zdjęcia portretowe
... wziąć należy.

3. Pierwsi osobie przyślcie podać...
w ... Tygodniu. — a nie... odpow-
iedzieć kogo... —
4. Rada... podać punkt na kierunek 13, 15,
5, 9, 15, 18, 1, 5 — w odległości 5 - 6 KM. od brzegu — chodzi
o plan nowy prócz tych wszystkich, które przesłaliśmy.
Ma być 11, 13, 2, 3, - 15, 5, 6, 23, 11, 17, 3, 7, 9, - 3 - 22, 13, 10, 18, 5, -
— mogą wyjechać popołudniu z tym. Prócz tego
1 - oborwik z papierami na ... — który
przyjechałby pocztą autem im ten sam punkt.
Prosimy o plany na wtorek. / 13, 24, 17, 11, 17, 5, 13, -
14, 11, 20, 32.).

(356)

AGAINST ALL
UNIMAGINABLE

"Sent further . . ." Further where? We may hypothesize that beyond members of the Polish Resistance (who were perfectly aware of the massacre of the Jews), these images were to be sent into a zone more western in its thought, culture, and political decision-making, where such things could still be said to be unimaginable. The four photographs snatched by the *Sonderkommando* of crematorium V in Auschwitz *address the unimaginable, and refute it*, in the most harrowing way. In order to refute the unimaginable, several men took the collective risk of dying and, worse, of undergoing the punishment reserved for this kind of attempt: torture—for example, that abominable procedure that SS Wilhelm Boger jokingly named his "writing machine."[1]

"Sent further": the four images snatched from the hell of Auschwitz address two spaces, two distinct periods of the unimaginable. What they refute, first of all, is the unimaginable that was fomented by the very organization of the "Final Solution." If a Jewish member of the Resistance in London, working as such in supposedly well-informed circles, can admit that at the time he was incapable of imagining Auschwitz or Treblinka,[2] what can be said of the rest of the world? In Hannah Arendt's analysis, the Nazis "were totally convinced that one of the greatest chances for the success of their enterprise rested on the fact that no one on the outside could believe it."[3] The fact that terrible information was sometimes received but "repressed because of the sheer enormity"

Figure 7. Józef Cyrankiewicz and Stanislaw Klodzinski. Message addressed to the Polish Resistance, September 4, 1944. Oswiecim, Auschwitz-Birkenau State Museum.

[19]

would follow Primo Levi to his nightmares. To suffer, to survive, to tell, and then not to be believed because it is unimaginable.[4] It is as though a fundamental injustice continued to follow the survivors all the way to their vocation of being witnesses.

Numerous researchers have carried out detailed analyses of the machinery of *disimagination* that made it possible for an SS officer to say: "There will perhaps be suspicion, discussion, research by historians, but there will be no certainties, because we will destroy the evidence together with you. And even if some proof should remain and some of you survive, people will say that the events you describe are too monstrous to be believed."[5] The "Final Solution," as we know, was kept in absolute secrecy—silence and smothered information.[6] But as the details of the extermination began to filter through, "almost from the beginning of the massacres,"[7] silence needed a reciprocal discourse. It involved rhetoric, lying, an entire strategy of words that Hannah Arendt defined in 1942 as the "eloquence of the devil."[8]

The four photographs snatched from Auschwitz by members of the *Sonderkommando* were also, therefore, four *refutations* snatched from a world that the Nazis wanted to obfuscate, to leave wordless and imageless. Analyses of the concentration camp have long converged on the fact that the camps were laboratories, experimental machines for a *general obliteration*. It was the *obliteration of the psyche* and the disintegration of the social link, as Bruno Bettelheim's analysis showed as early as 1943, when he was just out from eighteen months in Buchenwald and Dachau: "The concentration camp was the Gestapo's laboratory for subjecting [. . .] free men [. . .] to the process of disintegration from their position as autonomous individuals."[9] In 1950, Hannah Arendt spoke of the camps as "laboratories of an experience of total domination [. . .], this objective being attainable only in the extreme circumstances of a hell of human making."[10]

It was also a hell made by humans for the *obliteration of the language* of their victims. "It is an obvious assertion that where violence is inflicted on man," writes Primo Levi, "it is also inflicted on language."[11] There is the silence imposed by isolation itself. There

is the jargon of the camp and its effects of terror.[12] There is the perverse misappropriation of the German language and therefore of German culture.[13] Finally, there is the lie, the perpetual lie in the words uttered by the Nazis. Consider the innocence of the expression *Schutzstaffel*, which is abbreviated as SS and denotes "protection," "sheltering," "safeguarding" (*Schutz*). Consider the neutrality of the adjective *sonder*—which means "separated," "singular," "special" even "strange" or "bizarre"—in expressions such as *Sonderbehandlung*, "special treatment" (in reality, putting to death by gas); *Sonderbau*; "special building" (in reality, the camp's brothel reserved for the "privileged"); and, of course, *Sonderkommando*. When, in the midst of this coded language, an SS member calls something what it really is—for example, when the Auschwitz administration, in a message on March 2, 1943, lets slip the expression *Gaskammer*, "gas chamber"—one must consider that a genuine lapse.[14]

What the words seek to obfuscate is of course the *obliteration of human beings*, the very program of this vast "laboratory." To murder was not nearly enough, because the dead were never sufficiently "obliterated" in the eyes of the "Final Solution." Well beyond the privation of a grave (the greatest insult to the dead in antiquity), the Nazis concentrated, rationally or irrationally, on "leaving no single trace," and on *obliterating every remnant* . . . Which explains the insanity of *Aktion 1005*, when the SS had the hundreds of thousands of cadavers buried in common graves exhumed (by future victims of course), in order to cremate them and to disperse or reinter their ashes in the countryside.[15]

The end of the "Final Solution"—in all senses of the word "end": its aim, its last stage, but also its interruption by the military defeat of the Nazis—called for a new enterprise, which was the *obliteration of the tools of the obliteration*. Thus, crematorium V was destroyed in January 1945 by the SS itself. No less than nine explosive charges were needed, one of which, being very powerful, was placed in the fireproof ovens.[16] Yet another attempt to make Auschwitz unimaginable. After the Liberation, you could find yourself in the very place from which the four photographs

were snatched a few months earlier, and see nothing but ruins, devastated sites, or "non-places"[17] (fig. 8).

Filip Müller, moreover, specified that up to its destruction, crematorium V continued "burning the corpses of prisoners who had died in the main and auxiliary camps" while the gassing of the Jews had already been interrupted. Members of the *Sonderkommando* then had to burn, under strict surveillance, all "prisoners' documents, card indexes, death certificates, and scores of other documents.[18]" It was with the tools of obliteration that *archives—the memory of the obliteration—had to be obliterated*. It was a way of keeping the obliteration forever in its *unimaginable* condition.

There is a perfect coherence between Goebbels's discourse, analyzed in 1942 by Hannah Arendt according to its central motif, "No one will say Kaddish"[19]—in other words, we will murder you without remains and without memory—and the systematic destruction of the archives of the destruction by the SS itself at the end of the war. Indeed "the forgetting of the extermination is part of the extermination."[20] The Nazis no doubt believed they were making the Jews invisible, and making their very destruction invisible. They took such pains in this endeavor that many of

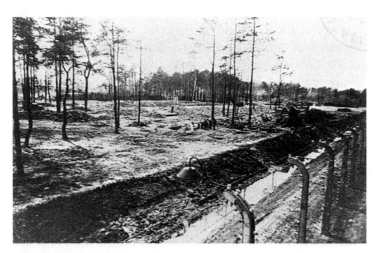

Figure 8. Anonymous (Russian). Ruins of crematorium V of Auschwitz, 1945–1946. Oswiecim, Auschwitz-Birkenau State Museum (negative no. 908).

their victims believed it too, and many people still do today.[21] But "reason in history" is always subjected to the refutation—however minor, however dispersed, however unconscious, or however desperate it be—of particular facts that remain most precious to memory, its imaginable possibility. The archives of the Shoah define what is certainly an incomplete, fragmentary territory—but a territory that has survived and truly exists.[22]

[]

Photography, from this angle, shows a particular ability—illustrated by certain well- or lesser-known examples[23]—to curb the fiercest will to obliterate. It is technically very easy to take a photograph. It can be done for so many different reasons, good or bad, public or private, admitted or concealed, as the active extension of violence or in protest against it, and so on. A simple piece of film—so small that it can be hidden in a tube of toothpaste—is capable of engendering an unlimited number of prints, of generations and enlargements in every format. Photography works hand in glove with image and memory and therefore possesses their notable *epidemic power.*[24] For this reason, photography was as difficult to eradicate in Auschwitz as was memory in the bodies of the prisoners.

What do we mean when we refer to "Reason in history"? It is the state secret decreed at the place where the mass extermination occured. It is the absolute prohibition of photographing the *Einsatzgruppen*'s enormous acts of abuse in 1941.[25] It is the notices put up on the walls and fences around the camps: "*Fotografieren verboten*! No entry! You will be shot without prior warning!"[26] It is the circular sent around by Rudolf Höss, the commander at Auschwitz, dated February 2, 1943: "I would like to point out once again that taking photographs within the camp limits is forbidden. I will be very strict in treating those who refuse to obey this order."[27]

But to prohibit was to want to stop an epidemic of images that had already begun and that could not stop. Its movement seems as sovereign as that of an unconscious desire. The ruse of the image

versus reason in history: photographs circulated everywhere—
those *images in spite of all*—for the best and the worst reasons.
They began with the ghastly shots of the massacres committed by
the *Einsatzgruppen*, photographs generally taken by the murder-
ers themselves.[28] Rudolf Höss did not hesitate either, in spite of
his own circular, to present Otto Thierack, the minister of justice,
with an album of photographs taken at Auschwitz.[29] On the one
hand, this use of photography verged on a pornography of killing.
On the other hand, the Nazi administration was so anchored in its
habits of recording—with its pride, its bureaucratic narcissism—
that it tended to register and photograph everything that was
done in the camp, even though the gassing of the Jews remained
a "state secret."

Two photography laboratories, no less, were in operation at
Auschwitz. It seems astonishing in such a place. However, every-
thing can be expected from a capital as complex as Auschwitz,
even if it was the capital of the execution and obliteration of hu-
man beings by the millions. In the first laboratory, attached to the
"identification service" (*Erkennungsdienst*), ten to twelve prisoners
worked permanently under the direction of SS officers Bernhardt
Walter and Ernst Hofmann, suggesting an intense production of
images here. These consisted mainly of descriptive portraits of po-
litical prisoners. Photos of executions, of people being tortured, or
of charred bodies were shot and developed by SS members them-
selves. The second laboratory, which was smaller, was the "office
of constructions" (*Zentralbauleitung*). Opened at the end of 1941
or the beginning of 1942, it was directed by the SS officer Dietrich
Kamann, who put together an entire photographic archive on the
camp installations.[30] Nor must we forget the whole "medical" ico-
nography of the monstrous experiments by Josef Mengele and his
associates on the women, men, and children of Auschwitz.[31]

Toward the end of the war, while the Nazis were burning the
archives en masse, the prisoners who served them as slaves for that
task availed themselves of the general confusion to save—to di-
vert, hide, disperse—as many images as they could. Today, around
forty thousand photographs of this documentation of Auschwitz

remain, despite its systematic destruction. Their survival says much about the probable size and horror of the iconography that filled the files when the camp was in operation.[32]

[]

A single look at this *remnant of images*, or erratic corpus of *images in spite of all*, is enough to sense that Auschwitz can no longer be spoken of in those absolute terms—generally well intentioned, apparently philosophical, but actually lazy[33]— "unsayable" and "unimaginable." The four photographs taken in August 1944 by the members of the *Sonderkommando* address the unimaginable with which the Shoah is so often credited today—and this is the second period of the unimaginable: tragically, the Shoah refutes it. Auschwitz has been called *unthinkable*. But Hannah Arendt has shown that it is precisely where thought falters that we ought to persist in our thought or, rather, give it a new turn. So, if we say that Auschwitz exceeds any existing juridical thought, any notion of fault or of justice, then political science and law must be re-thought entirely.[34] And if we believe that Auschwitz exceeds all existing political thought, even anthropology, then we must re-think the very foundations of the human sciences as such.[35]

The historian's role is, of course, crucial to this task. Historians cannot and must not "accept that the problem posed by the genocide of the Jews be neglected by relegating it to the unthinkable. [The genocide] was thought, it was therefore thinkable."[36] This is also the direction taken by Primo Levi in his criticism of the speculations on the "incommunicability" of the concentration camp testimony.[37] The very existence and the possibility of such testimony—its *enunciation in spite of all*—refute the grand idea, the closed notion, of an *unsayable* Auschwitz. It is to the very core of speech that testimony invites us, compelling us to work there. It is harsh work, since what it concerns is a description of death at work, with the inarticulate cries and the silences that are implied.[38] To speak of Auschwitz in terms of the unsayable, is not to bring oneself closer to Auschwitz. On the contrary, it is to relegate

Auschwitz to a region that Giorgio Agamben has very well defined in terms of mystical adoration, even of unknowing repetition of the Nazi *arcanum* itself.[39]

We must do with the image what we already do more easily (Foucault has helped us here) with language. For in each testimonial production, in each act of memory, language and image are absolutely bound to one another, never ceasing to exchange their reciprocal lacunae. An image often appears where a word seems to fail; a word often appears where the imagination seems to fail. The "truth" of Auschwitz, if this expression has any meaning, is neither more nor less *unimaginable* than it is unsayable.[40] If the horror of the camps defies imagination, then *each image* snatched from such an experience becomes all the more necessary. If the terror of the camps functions as an enterprise of generalized obliteration, then *each apparition*—however fragmentary, however difficult to look at and to interpret—in which a single cog of this enterprise is visually suggested to us becomes all the more necessary.[41]

The discourse of the unimaginable has two different and rigorously symmetrical modes. The one proceeds from an *aestheticism* that often fails to recognize history in its concrete singularities. The other proceeds from a *historicism* that often fails to recognize the image in its formal specificities. Examples abound. In particular, we will note that certain important works of art have caused their commentators to give misleading generalizations on the "invisibility" of the genocide. Thus, the formal choices of *Shoah*, the film by Claude Lanzmann, have served as alibis for a whole discourse (as moral as it was aesthetic) on the unrepresentable, the unfigurable, the invisible, the unimaginable, and so on.[42] Yet these formal choices were specific and therefore relative: they lay down no rule. Avoiding the use of even a single "document from the period," the film *Shoah* precludes any peremptory judgment on the status of photographic archives in general.[43] What it offers instead is an impressive sequence—over ten hours—of visual and sound images, of filmed faces, words, and places, all composed according to formal choices and an extreme engagement with the question of the *figurable*.[44]

In turn, both the *Dachau-Projekt* of Jochen Gerz and his invisible *Monument against Racism* in Sarrebrück gave rise to numerous commentaries on the Shoah in general: "The Shoah was and remains without images," writes Gérard Wajcman; it is even something both "without visible trace and unimaginable"; "the invisible and unthinkable object par excellence"; the "production of an Unrepresentable"; an "absolute disaster that absolutely cannot be looked at"; a "destruction with no ruins"; "beyond imagination and on the side of memory"; therefore "a thing unlooked at"—to the extent that the "absence of any image of the gas chambers"[45] is impressed upon us. Do the two poor images framed by the door of the gas chamber, at crematorium V of Auschwitz in August 1944, not suffice to refute that negative aesthetic? Furthermore, how could an image act of that kind be prescribed or even interpreted by any thought, however just, on the *exercise of art*? "There is a limit at which the exercise of an art, whatever it be, becomes an insult to misfortune," writes Maurice Blanchot.[46]

[]

It is highly significant that Blanchot, a thinker par excellence of negativity —relentless, without synthesis—in fact did *not* speak of Auschwitz under the absolute authority of the unimaginable or the invisible. On the contrary, in the camps, he wrote, it was the "invisible [that] was forever *rendered visible*."[47] How should we think this paradox? Georges Bataille can help us, he who never feared to interrogate the silence addressed sparingly by Sartre in his *Réflexions sur la question juive* with respect to the gas chambers.[48] Bataille, then—the thinker par excellence of the formless—speaks of Auschwitz in terms of the *similar, the fellow human*:

> In being a man, there is generally an oppressive, sickly element, which must be overcome. But this weight and this repugnance were never as heavy as they have become since Auschwitz. Like you and me, those responsible for Auschwitz had nostrils, a mouth, a voice, human reason, they could

unite, could have children. Like the Pyramids or the Acropo-
lis, Auschwitz is the fact, the sign of man. The image of man is
inseparable, henceforth, from a gas chamber . . .[49]

To engage here the *image of man* is to make of Auschwitz a fun-
damental problem henceforth for anthropology: Auschwitz is *in-
separable* from us, writes Bataille. There is no question, of course,
of confusing the victims with their executioners. But this evidence
must be considered with the anthropological fact—the fact about
the *human race*, as Robert Antelme wrote in the same year[50]—that
it is a *human being* who inflicts torture, disfiguration, and death
upon his fellow human being [*semblable*]: "We are not only poten-
tial victims of the executioners: the executioners are our fellows
[*semblables*]."[51] Bataille, the thinker par excellence of the impos-
sible, well understood that we must speak of the camps as of the
possible itself, the "possible of Auschwitz," as he specified.[52] To say
this does not amount to making horror banal. On the contrary, it
engages with the concentration camp experience summarized by
Hermann Langbein:

> No single criterion of normal life applied to the extermination
> camps. Auschwitz was the gas chambers, the selections, the
> processions of human beings going to death like puppets, the
> black wall and its trails of blood in the camp's roadway mark-
> ing the path of the vehicles which transported the executed to
> the crematorium, the anonymity of death which let no martyr
> shine, the booze-ups of the prisoners with their guards. [. . .]
> In Auschwitz, the spectacle of the prisoners dying from star-
> vation was as habitual as the sight of the well-fed *Kapos*. [. . .]
> Nothing was inconceivable in Auschwitz. Everything was pos-
> sible, literally everything.[53]

If Bataille's thought is so close to this terrible *human possibility*, it is
because he knew from the start how to formulate the indissoluble
link between the image (the production of the similar) and the
aggression (the destruction of the similar).[54] In a story written in
the midst of the war, Bataille had imagined a cruel world where, he
said, "death itself was part of the feast."[55] Throughout the stories

of Auschwitz survivors, we access the real of an infinitely worse cruelty, one in which, I contend, it was possible *that the feast itself was part of death*:

> One evening toward the end of February [1944], I was on night-shift. When our team arrived at crematorium 5 a few hundred corpses were lying in the changing room, about to be cremated. In the *Kommandoführer's* office, which was connected with the cremation room by a door, a party was in full swing. *Kommandoführer* Johann Gorges had been promoted from *Rottenführer* to *Unterscharführer*. [. . .] The long table in the *Kommandoführer's* office was spread with delicacies from all over the world. There were tinned foods, cold meats, cheese, olives, sardines, and other dainties, all taken, needless to say, from deportees. There was also Polish vodka to wash them down and ample supplies of cigarettes. About a dozen *SS-Unterführer* had come to the crematorium to celebrate Gorges' promotion. They sat around the table eating and drinking. One of them had brought his accordion and was playing folk and pop songs with the others joining in. They told each other blue jokes and as the hour advanced, the mood grew increasingly genial. [. . .] From the cremation chamber came the noise of fans humming, *Kapos* shouting and stokers stoking the corpses inside the ovens with their iron forks.[56]

IN THE VERY
EYE OF HISTORY

To remember, one must imagine. Filip Müller, in this narrative of memories, therefore allows the image to appear, overwhelming us. We are constricted in a double bind, of simplicity and complexity: the simplicity of a *monad*, such that the image crops up in his text—and imposes itself on our reading—immediately, as a whole from which we could remove no element, no matter how minimal; the complexity of a *montage*—the tearing antithesis, in the same, unique experience, of two shots brought into contrast by everything in them. The sprawled bodies, stuffing themselves, as against the burned bodies being reduced to ashes; the feasting of the executioners as against the infernal work of the slaves as they "move" their slaughtered fellow humans; the sonorities and melodies of the accordion as against the mournful whirring of the crematorium ventilators. This is so much an *image* that David Olère, another survivor of the *Sonderkommando* of Auschwitz, would make a precise drawing of this scene in 1947, both for his own recollection and to allow those of us who were not there to picture it.[1]

No doubt we can speak of this image in terms of a *deferred action*, but on condition that we specify that the deferred action can be formed immediately, that it can be an integral part of the sudden appearance of the image. It instantly transforms the *temporal monad* of the event into a complex *montage of time*. It is as though the deferred action were contemporaneous to the action. Hence, within the urgency of witnessing a present that the witness knows very well he will not survive, within the event itself, images suddenly appear, in spite of all. I am thinking of the *Scrolls of Auschwitz* buried by the members of the *Sonderkommando* just before their liquidation: I am thinking of Zalmen Gradowski and his tenacious

lyricism ("See this symbolic vision: a white earth and a black cover
made of the human mass advancing on this immaculate ground").[2]
I am thinking of Leib Langfus, who scribbles his testimony as a
series of visual and sound shots briefly described and offered as is,
without commentary, without "thought": the old rabbi who un-
dresses and enters the gas chamber without for a moment ceasing
to sing; the Hungarian Jews who want to drink "to Life!" with the
members of the *Sonderkommando* in tears; SS Forst placing himself
in front of the door to the gas chamber to touch the genitals of
each young woman who enters . . .[3]
 Faced with these stories, as faced with the four photographs
from August 1944, we conclude that the image suddenly appears
where thought—or "reflection"—seems impossible, or at least
where it appears to be at a standstill: stunned, stupefied. Yet it is
just where a memory is necessary. As Walter Benjamin wrote, soon
before committing suicide, in 1940:

> Let us suppose the movement of thought to be suddenly
> stopped—then a sort of shock in return would be produced
> within a constellation overcharged with tension; a shock that
> allows the image its spontaneous organization, its constitu-
> tion as a monad. . . .[4]

Hannah Arendt was to repeat this in her own manner, at the time
of the Auschwitz trial:

> Lacking the truth, [we] will however find *instants of truth*, and
> those instants are in fact all we have available to us to give
> some order to this chaos of horror. These instants arise spon-
> taneously, like oases in the desert. They are anecdotes and
> they reveal in their brevity what it is all about.[5]

[]

This is exactly what the four images taken by the members of the
Sonderkommando are: "instants of truth." A small thing, therefore:
just four instants in August 1944. But it is inestimable, because it
is almost "all that we have available to us [visually] in this chaos of

horror." And how are we to deal with all this? Zalmen Gradowski writes that to sustain the "vision" of the things he speaks of, his hypothetical reader must do as he had to do: we must "take leave" of everything. Take leave of our forefathers [*pères*], of our points of reference [*repères*], of our world, of our thought. "After seeing these cruel images," he writes, "you will no longer want to live in a world where such ignoble acts can be perpetrated. Take leave of your elders and your acquaintances, for after seeing the abominable acts of a so-called cultured people, you will want to erase your name from the human family." Yet in order to sustain the imagination of these images, he then says, "your heart must turn to stone [. . .] and your eye must be transformed into a camera."[6]

The four images snatched from the Real of Auschwitz demonstrate a paradoxical condition: the *immediacy* of the monad (they are snapshots, the impersonal and "immediate givens" of a certain state of horror captured by the light) and the *complexity* of the intrinsic montage (the shooting probably required a collective shot, a "prediction,"[7] and each sequence constructs a specific response to the constraints of visibility: to snatch the image while hiding oneself in the gas chamber, to snatch the image while hiding the camera in one's hand or clothes). *Truth* (in the face of this, it is as though we were irrefutably in the eye of the hurricane) and *obscurity* (the smoke hides the structure of the pits, the movement of the photographer blurs and renders almost incomprehensible all that happens in the birch tree copse.).

Indeed, it is the *dual mode* of all images that so often troubles historians and turns them away from such "material." Annette Wieviorka has spoken of the mistrust that survivors' testimonies, written or spoken, arouse among historians: testimonies are by nature subjective and sometimes inaccurate.[8] They have a fragmentary and lacunary relation to the truth to which they bear witness, but they are nonetheless all that we have available to know and to imagine concentration camp life from the inside.[9] We owe the four photographs from August 1944 an equivalent recognition, even though the historian might have some difficulty in going the whole way.[10]

Why is there such a difficulty? It is because we often ask too

much or too little of the image. Ask too much of it—"the whole truth" for example—and we will quickly be disappointed: the images are merely stolen shreds, bits of film. They are therefore *inadequate*: what we see (four images still and silent, a limited number of cadavers, members of the *Sonderkommando*, and women condemned to death) is still little in comparison to what we know (millions dead, the roaring of the ovens, the heat of the glowing fires, the victims suffering "the extremity of misfortune").[11] These images are even, to a certain extent, *inexact*; or at least, they are missing the exactness which would allow us to identify someone, to understand the disposition of the cadavers in the pits, or even to see how the women were forced by the SS toward the gas chamber.

Or else we ask too little of images: by immediately relegating them to the sphere of the *simulacrum*—admittedly something difficult in the present case—we exclude them from the historical field as such. By immediately relegating them to the sphere of the *document*—something easier and more current—we sever them from their phenomenology, from their specificity, and from their very substance. In every case the result will be identical: the historian will continue to feel that "the concentration camp system cannot be *illustrated*"; that "the images, whatever their nature, cannot tell what happened."[12] And that the concentration camp universe simply cannot be "showable" since "there exists no 'truth' of the image, any more for the photographic, filmic image, than for the painted or sculpted one."[13] And so historicism manufactures its own unimaginable.

This also explains—at least in part—the *inattention* that the four photographs from August 1944, though well known and often reproduced, have suffered. They did not appear until the Liberation and were presented as the "only" existing photos proving the extermination of the Jews. Judge Jan Sehn, who led the investigation in Poland for the Nuremberg trial, attributed them to David Szmulewski. Yet both of these assertions were erroneous: other photographs existed (and may reappear one day); Szmulewski himself remembered being on the roof of the gas chamber while Alex worked.[14] As for Hermann Langbein, he would unite

two testimonies into one to conclude that the photographs were taken "from the roof of the crematorium,"[15] which amounts, quite simply, to not having looked at these photographs.

[]

There are two ways of "being inattentive," so to speak, to such images: the first consists in subjecting them to hypertrophy, in wanting to see everything in them. In short, it consists in wanting to make them *icons* of horror. For this, the original photographs had to be made *presentable*. In order to achieve this, there was no hesitation in transforming them completely. Thus, the first photograph in the outside sequence (fig. 5) underwent a whole series of operations: the lower right-hand corner was enlarged and then made orthogonal, in such a way as to restore the normal conditions of a photo shot that did not in fact benefit from those conditions; then, it was reframed, cropped (the rest of the image discarded) (fig. 9). Worse, the bodies and the faces of the two women in the foreground were touched up; a face was created, and the breasts were even lifted[16] (figs. 10–11). This absurd doctoring—I don't know who did it, or what might have been the doer's good intentions—reveals an urgent desire to *give a face* to what in the image itself is no more than movement, blur, and event. Why should we be surprised that, in the face of such an icon, a survivor might have believed he recognized the lady of his thoughts?[17]

The other way consists in reducing, desiccating the image; in seeing in it no more than a *document* of horror. As strange as that might seem in a context—history—that normally respects its research material, the four photographs of the *Sonderkommando* have often been transformed with a view to making them more *informative* than they were in their initial state. This is another way of making them "presentable" and of making them "present a face." In particular, we note that the images in the first sequence (figs. 3–4) are regularly cropped.[18] There is, no doubt, in this operation a desire—both good and unconscious—*to approach* by isolating "what there is to see," by purifying the imaging substance of its nondocumentary weight.

However, the cropping of these photographs is a manipulation that is at the same time formal, historic, ethical, and ontological. The *mass of black* that surrounds the sight of the cadavers and the pits, this mass where *nothing is visible* gives in reality a *visual mark* that is just as valuable as all the rest of the exposed surface. That mass where nothing is visible is the space of the gas chamber: the *dark room* into which one had to retreat, to step back, in order to give light to the work of the *Sonderkommando* outside, above the pyres. That mass of black gives us the situation itself, the space of possibility, the condition of existence of the photographs them-

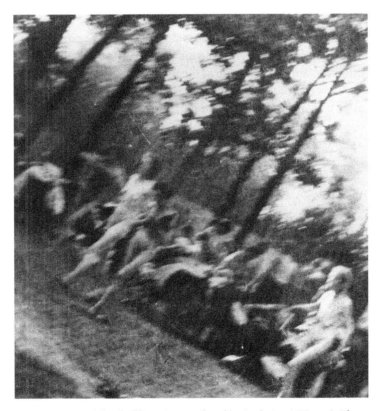

Figure 9. Cropped detail of fig. 5. As reproduced in *Auschwitz: A History in Photographs*, ed. T. Swiebocka (Oswiecim, Warsaw, and Bloomington: Auschwitz-Birkenau Museum, Ksiazka I Wiedza, and Indiana University Press, 1993), 173.

selves. To erase a "zone of shadow" (the visual mass) for the sake
of some lucid "information" (the visible testimonial) is, moreover,
to act as though Alex were able to take the photographs safely out
in the open. It is almost to insult the danger that he faced and to
insult his cunning as *résistant*. The cropping of these pictures was
no doubt believed to preserve the *document* (the visible result, the
distinct information).[19] But instead, their phenomenology was
removed, everything that made them an *event* (a process, a job,
physical contact).

This mass of black is nothing other than the mark of the ulti-
mate status by which these images should be understood: their
status as visual event. To speak here of the interplay of shadow and
light is not the fantasy of a "formalist" art historian: it is to name
the very *structure* of these images. It appears as the paradoxical
threshold of an interior (the chamber of death, which preserves,
at that very moment, the life of the photographer) and of an exte-
rior (the gruesome incineration of the victims that have just been
gassed). It offers the equivalent of the way a witness might speak:
the pauses, the silences, and the heaviness of the tone. To say of the
last photograph (fig. 6) that it is simply "without use"[20]—meaning

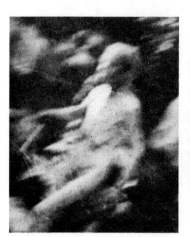 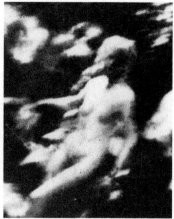

Figures 10–11. Touched-up detail of fig. 5. As reproduced in *Mémoire des camps:
Photographies des camps de concentration et d'extermination nazis (1933–1999)*,
ed. C. Chéroux (Paris: Marval, 2001), 91.

"without historic use"—is to forget all that it tells us phenomeno-
logically about the photographer: the impossibility of aiming the
camera, the risk undergone, the urgency, the fact that he may have
been running, the awkwardness, the sun in his eyes, and perhaps
breathlessness too. This image is, metaphorically, out of breath:
it is pure "utterance," pure gesture, pure photographic act with-

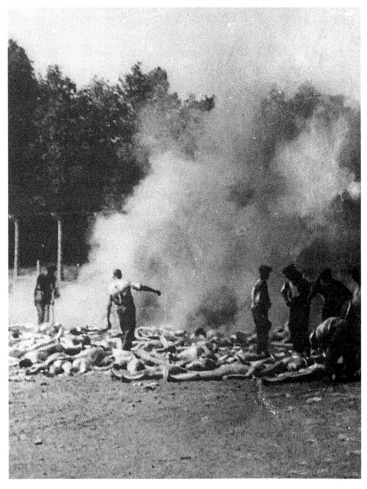

Figure 12. Cropped detail of fig. 4. As reproduced in *Auschwitz: A History
in Photographs*, 174.

out aim (therefore without orientation, with no top or bottom);
it gives us access to the condition of urgency in which four shreds
were snatched from the hell of Auschwitz. Indeed, this urgency
too is a part of history.

[]

It is little, it is a lot. The four photographs from August 1944, of
course, *don't tell* "all of the truth" (it would be very naïve to expect
this from anything at all—things, words, or images): they are tiny
extractions from such a complex reality, brief instants in a con-
tinuum that lasted five years, no less. But they *are* for us—for our
eyes today—truth itself, meaning its vestige, its meager shreds:
what remains, visually, of Auschwitz. Giorgio Agamben's reflec-
tions on testimony can illuminate their status: they too take place
"in the non-place of articulation"; they too find their power in the
"powerlessness to say" and in a process of "desubjectivation"; they
too manifest a fundamental scission where the "essential part" is
at bottom no more than a *lacuna*.[21] Agamben writes that the "rem-
nant of Auschwitz" is to be thought of as a *limit*: "neither the dead,
nor the survivors, neither the drowned, nor the saved, but what
remains between them."[22]

 The little piece of film with its four photograms is a limit of this
kind. The infra-thin threshold between the *impossible* by right—
"nobody can represent to themselves what happened here"[23]—
and the possible, the *necessary* de facto: we have, thanks to these
images, a representation *in spite of all*, which, henceforth, imposes
itself as the representation par excellence, the necessary represen-
tation of what was a moment in August 1944 at crematorium V
in Auschwitz. A visual threshold devoted to the double mode of
testimony, as we read in Zalmen Lewental, for example, when he
claims to write the "story of the truth," knowing full well that "it is
not yet all of the truth. The truth is much more tragic, even more
atrocious."[24]

 It is impossible but necessary, and therefore possible in spite
of all (that is, incompletely). For the Jews of the Warsaw ghetto

at the threshold of their extermination, it seemed impossible to give thought or imagination to what they were enduring: "We are beyond words, now," writes Abraham Lewin. And yet—in spite of all—he writes it. He even writes that all around him "everybody writes," because, "despoiled of everything, only words remain" for the condemned Jews.[25] Likewise, Filip Müller:

> Death by gas lasted
> from ten to fifteen minutes.
> The most horrendous moment was
> the opening of the gas chamber,
> that unbearable vision:
> people, pressed like basalt,
> compact blocks of stone.
> How they collapsed out of the gas chamber!
> Several times I saw this.
> And this was most difficult of all.
> One never got used to that.
> It was impossible.
> Yes. One must imagine.[26]

Unbearable and impossible, yes. But "one must imagine," Filip Müller insists nontheless. *To imagine in spite of all*, which calls for a difficult ethics of the image: neither the invisible par excellence (the laziness of the aesthete), nor the icon of horror (the laziness of the believer), nor the mere document (the laziness of the learned). A simple image: inadequate but necessary, inexact but true. True of a paradoxical truth, of course. I would say that here the image is the *eye of history*: its tenacious function of making visible. But also that it is *in the eye of history*: in a very local zone, in a moment of visual suspense, as the "eye" of a hurricane (let us remember that this central zone of the storm, capable of a flat calm, "contains nonetheless enough clouds to make its interpretation difficult").[27]

From the half-light of the gas chamber, Alex brought to light the nerve center of Auschwitz, that is to say, the destruction, intended to be without remnant, of the Jewish populations of Europe. At the same time, the image was formed by virtue of stepping

back: for a few minutes, this member of the *Sonderkommando* set aside the ignoble work that the SS had ordered him to do. By hiding in order to see, the man momentarily delayed the task he had set himself—seizing a unique opportunity—of putting together an iconography. The image was possible because a zone of calm (but achingly limited) had been spared for this act of looking.

SIMILAR, DISSIMILAR, SURVIVOR

To look at these images today in terms of their phenomenology—even if it can only be restored incompletely—is to expect historians to undertake the kind of visual criticism that I believe they are seldom accustomed to.[1] This work demands a double rhythm, a double dimension. We must *tighten our point of view* of the images and omit nothing of all the "imaging" substance, even going so far as to question the *formal* function of a zone in which "there's nothing to see," as we wrongly say when facing something that seems empty of informative value—a dark area at the edge of a picture, for example. Symmetrically, we must *widen our point of view* to restore to the images the *anthropological* element that makes them work.

If we pay attention to the words of Georges Bataille—when he describes Auschwitz as a question put to the *inseparable*, to the *similar*, to the "image of man" in general—we discover that within or beyond their obvious political meaning, Alex's four photographs present us with a dizzying drama of the *human image*. Let us look again: in these photographs, the dissimilar is on the same level as the similar, as death is on the same level as life.[2] Looking at the first sequence (figs. 3–4), we are struck by the coexistence of such "human," everyday gestures, so many "our" gestures, in the members of the *Sonderkommando*—hands on hips of the one who is thinking for an instant, the exertion and torsion of those already at "work"—with the almost formless carpet made up of the sprawling corpses, as though their reduction, their destruction, has already begun. (They have probably only been dead for a few minutes.)

In the fleeting view of the women waiting to be gassed (fig. 5), we have retrospectively an analogous sentiment: all the smoke that

we are beginning to see—and that the women themselves, almost
definitely, saw over the roof of the building they were about to
enter—seems already to invade, to *destine*, their human resem-
blance. The destiny that they knew or did not want to know, or
of which they caught a glimpse, or in any case that they *felt*.[3] The
destiny that the photographer himself knew with certainty. For
him—and for our own eyes today, retrospectively—the grayish
blur of this image, even before he took the photo, resembles the
ashes that these beings in motion will soon become.

Here we are at the heart of the anthropological meaning of
Auschwitz. To deny the human in the victim was to doom the
human to something dissimilar: the emaciated *Muselmann*, heaps
of disarticulated corpses, the "basalt columns" of the gassed, car-
pets of hair, a pile of human ashes used as road fill . . . To suffer
Auschwitz, at every level of this endless experience, meant suffer-
ing the fate that Primo Levi called simply the "demolition of a
man."[4] In this process, the gaze played a fundamental role: the
"demolished" man was first of all a man rendered apathetic to the
world and to himself; that is, he became incapable of empathy
("when it rains, one would wish to be able to cry"), even incapable
of despair ("I am no longer sufficiently alive to be capable of kill-
ing myself")[5]:

> The feeling of our existence depends for a good part on the
> gaze that the others cast upon us: we can thereby describe as
> nonhuman the experience of anyone who has known the days
> when man had become an object in the eyes of man. [. . .] If I
> were able to fully explain the nature of this gaze [that of the
> SS directed at the prisoner], I would at the same time have ex-
> plained the essence of the great madness of the Third Reich.[6]

This experience is beyond fear.[7] It is beyond death as an acces-
sible representation.[8] In man, it touches being itself; in being, it
even destroys time.[9] It destines all human existence to the status
of a "mannequin" that death will transform, eventually, into an
"ignoble tumult of stiffened limbs": into a "thing," as Primo Levi
puts it.[10] A *dissimilar* thing. In this experience, men—fellows, clos-
est friends—are no longer able to recognize one another.[11] And

this, writes Maurice Blanchot, is brought about by the terrifying power of these *fellowmen* who are the enemies:

> When man, by oppression and terror, falls as if outside of himself, to a place where he loses all perspective, all reference, and all difference, thus given to a time without pause that he endures like the perpetuity of an indifferent present, then his last recourse, at the moment when he becomes the unknown and the stranger, that is, destiny for himself, is to know himself struck not by the elements but by men, and to give the name of man to everything that touches him.—"Anthropomorphism" would thus be the ultimate echo of truth, when everything ceases to be true.[12]

In the eye of the hurricane, therefore, the question of anthropomorphism remains. What the SS wanted to destroy at Auschwitz was not only life, but also—whether within or beyond, before or after the executions—the very form of the human, and its image with it. In such a context, the act of resisting amounted to the act of *maintaining this image in spite of all*, even if reduced to its simplest "paleontological" expression, the upright position, for example: "We owe it to ourselves [. . .] to stand straight and not to drag our feet, not out of homage to Prussian discipline, but to stay alive, so as not to start dying."[13]

[]

To maintain the image in spite of all: to maintain the *image of the world* outside and, in order to do so, to snatch from that hell an activity of knowledge, a kind of curiosity. To exercise one's observation, to take notes in secret, or to attempt to memorize as many things as possible. "To know and to make known is a way of remaining human," writes Tzvetan Todorov concerning the *Scrolls of Auschwitz*.[14] To maintain in the end the *image of oneself*: in other words, "to safeguard one's self" in the psychic and social meaning of the term.[15] Finally, to maintain the *image of the dream*: although—or because—the camp is a genuine machine for "crushing souls,"[16] its terror function can be suspended from the moment

the SS officers accept the vital, if minimal, sleeping time of the prisoners. At that moment, writes Primo Levi, "behind the half-closed eyelids, dreams spring up with violence."[17]

It is the very *image of art* too that the prisoners will have wished to preserve in spite of all, as if to snatch from hell some shreds of spirit, culture, and survival. The word "hell," I might add in passing, is itself a part of that sphere: we employ it spontaneously to speak of Auschwitz even though it proves entirely inadequate, displaced, and inexact. Auschwitz was not a "hell," in the sense that the beings that entered had no "resurrection" to experience (however terrible) but the most sordid of deaths. Above all, these beings were not there to undergo the last "judgment" of their sins: innocent they entered, innocent they were tortured and massacred. Hell is a juridical fiction invented by religious belief, while Auschwitz is an antijuridical reality invented by a politico-racial delirium.

The image of hell, however *inexact* it may be, is nonetheless part of the *truth* of Auschwitz. Not only was it employed by thinkers who were most attentive to the concentration camp phenomenon,[18] but also it is found throughout the victims' testimonies. Almost all of the survivors referred to that from which they came as a hell.[19] The "drowned" themselves invoked this image, in each of its cultural dimensions, including evocations or citations of Dante that emerge in the *Scrolls of Auschwitz*. Lewental spoke of this "hell" as a "picture [. . .] unbearable to see."[20] Gradowski never ceased, throughout his manuscript, to use forms taken more or less directly from the *Divine Comedy*.[21] On a wall of block 11 at Auschwitz, in cell 8, a Polish prisoner awaiting execution by firing squad carved with his own hands and in his own language the famous inscription over Dante's gates of Hell: *Lasciate ogni speranza voi ch'entrate*.[22]

In this sense, Dante's *Inferno*, jewel of the western imagination, appertains also to the Real of Auschwitz: it was scratched on the very walls, grafted onto the minds of many. It preoccupies Primo Levi's testimony to the point of signifying urgency itself, and the persistence of life, like this "anachronism, so human, so necessary and yet so unexpected."[23] Symmetrically, it even preoccupies the

executioner's pen: when unable to sleep or wearied by the horror
that they organized, some Nazis even let themselves get carried
away with the Dantesque metaphor.[24]

What does this troubling unanimity signify? That any recourse
to the image is inadequate, incomplete, always at fault? Certainly.
Must we repeat then that Auschwitz is *unimaginable*? Certainly not.
We must even say the opposite: we must say that Auschwitz *is only
imaginable*, that we are restricted to the image and must therefore
attempt an internal critique so as to deal with this restriction, with
this *lacunary necessity*. If we wish to know something of the camp's
interior, at some point we will have to pay tribute to the power of
images. And also try to understand their necessity through their
very function of remaining deficient.[25]

[]

Let us take a fresh look at the four photographs snatched from the
hell of August 1944. Is the first sequence (figs. 3–4) not permeated
by the *deficiency* of information? Shadow all around, a curtain of
trees, smoke: the scale of the massacre, the detail of the installa-
tions, and the very work of the *Sonderkommando* prove to be poorly
"documented." At the same time, when facing these images we face
the overwhelming *necessity* of a survivor's gesture. He is a very tem-
porary survivor, for he will be murdered by the SS a few weeks
later. It is thus the tragic *self-portrait* of the "special squad" that
we have there before our eyes. Let us look at the second sequence
(figs. 5–6): is it not permeated, even more than the first, by the *de-
ficiency* of visibility? At the same time, when facing this we are fac-
ing the overwhelming *necessity* of an *empathetic* gesture, that is, of
a kind of active similarity: a movement of the photographer—and
the blurring, shaking, of the image—accompanying the move-
ment of the women; the urgency of photography accompanying
the urgency of the last instants of life.[26]

To snatch four images from the hell of the present amounted, in
short, on that day in August 1944, to snatching four shreds of sur-
vival from the destruction. Of survival as relic [*survivance*], I would
say, and not of survival in life [*survie*]. Because nobody, in front of

or behind that camera—except David Szmulewski and the SS per-
haps—survived that to which the images bear witness. So it is the
images alone that remain with us: they are the *survivors*. But from
what time do they come to us? From the time of a *flash*: they cap-
tured a few instants, a few human gestures. We notice that in both
sequences nearly all the faces are looking downward, as though
concentrating, beyond all dramatic expression, on the work of
death. Downward: because the earth is their destiny. On the one
hand, the humans will vanish in smoke: *Todesfuge*;[27] on the other
hand, their ashes will be crushed, buried, swallowed up. Into these
very ashes, all around the crematoria, members of the *Sonderkom-
mando* will have mixed as many as possible of their *surviving things*:
bodily things (hair, teeth), sacred things (phylacteries), image-
things (photographs), written things (the *Scrolls of Auschwitz*):

> I wrote that during the time when I found myself in the *Son-
> derkommando*. [. . .] I wanted to leave it, with many other
> notes, as a memory for the future world in peace, in order that
> what happened here be known. I buried it in the ashes, think-
> ing it was the safest place, that they would most certainly dig
> it up and find traces of the millions who died. But recently
> they have started to remove the traces of the ashes a little ev-
> erywhere. They ordered them to be finely ground and to be
> transported to the Vistule so the waters would carry them
> away. [. . .] My notebook and other manuscripts were to be
> found in the pits saturated with blood, containing bones and
> shreds of flesh not entirely burned. One could tell by the odor.
> Seeker, dig around everywhere, in every piece of land. Docu-
> ments, mine and those of other persons, are buried there,
> casting a harsh light on everything that happened here. We,
> the *Sonderkommando* workers, distributed them over the en-
> tire terrain, as much as we could, so that the world might find
> palpable traces there of the millions murdered. We ourselves
> have already lost hope of living until the liberation.[28]

The time of the flash, the time of the earth. Instant and sedimenta-
tion. Snatched from the present, buried for a long time: such is the
rhythm of images—*anadyomene*. The four photographs from Au-

gust 1944 were snatched from a vast hell, then hidden in a simple tube of toothpaste. Snatched from the perimeter of the camp, then buried somewhere in the papers of the Polish Resistance. Dug up only after the Liberation. Reburied under the cropping and retouching of historians who thought they were doing good work. Their charge of invalidation—against the Nazi enterprise of disimagining the massacre—remains tragic in that they came too late.[29] From August 1944 to the end of the hostilities, American airplanes continually bombed the factories of Auschwitz III–Monowitz, but they left the crematoria to their intense functioning of "nonmilitary" killing.[30]

[]

Are they useless images, then? Far from it. They are infinitely precious to us today. They are demanding too, for they require *archeological* work. We must dig again in their ever so fragile temporality. "The authentic image of the past," writes Walter Benjamin, "appears only in a flash. An image that springs up, only to be eclipsed forever in the very next moment. The motionless truth that merely keeps the researcher waiting does not correspond in any way to the concept of truth in the subject of history. Rather, it relies on Dante's lines, which say: it is another, unique and irreplaceable image of the past that fades with each present that has failed to recognize itself as its aim."[31]

> No trace anywhere of life, you say, pah, no difficulty there, imagination not dead yet, yes, dead, good, imagination dead imagine.[32]

(2000–2001)

In Spite of the All Image

The whole problem is born
of the fact that we *have come
to the image with the idea of
synthesis* [. . .]. The image is
an act and not a thing.

J.-P. SARTRE,
L'imagination (1936)

FACT-IMAGE OR FETISH-IMAGE

The preceding chapter, "Similar, Dissimilar, Survivor" (originally published in 2001 in the catalogue of the exhibition *Mémoire des camps*), inferred from its case study a more general questioning of the double (aesthetic and historical) mode of the "unimaginable." Consequently, it stirred up matter for discussion. If historians have not had to defend themselves regarding the *visual archeology* that was suggested to them, it is quite simply because history as a discipline today recognizes its own critical backwardness in the domain of images, and it intends as honestly as possible to make amends.[1] Yet the questioning of the *aesthetic unimaginable*—a sublime, absolute negativity, developed by means of a radical challenging of the image, and assumed, according to some, to account for the radicality of the Shoah—provoked a violent polemic in the form of two lengthy articles published in *Les temps modernes* in March–May 2001. The authors were Gérard Wajcman and Elisabeth Pagnoux.[2]

What exactly is this debate about? To give a sufficient idea of the arguments, as well as of the tone, adopted by my critics, I would have to pace through the lengthy accusations that appear in their two texts. A "risk of overinterpretation," according to Gérard Wajcman, is the least of the faults in my analysis. He sees above all "errors of thought," "fatal reasoning" and "disastrous logic" bordering on "stupidity," even "reassuring falsehood"—which is obviously much more serious.[3] Having cast such a "slogan" against the unimaginable of the Shoah, I am accused of no less than "denying with one fell swoop both theses and fact"; my work is taken as no less than that of an "adventurer of thought." All this "promotion of the imagination" amounts to an "invitation to hallucinate," a

"fantasy-machine" that "borders on an inevitably deluding identification."[4] As a psychologist, Wajcman seeks to underline "the almost infantile exultation" of an argument that "considers itself the destruction of a taboo":

> Didi-Huberman seems as though carried away, absorbed, swallowed up in a kind of forgetting of everything and of the essential [. . .]. It is as though he were under a sort of hypnotic captivation of images that allows him to think only in terms of the image, of the similar. It is stupefying to see this value, this power, accorded to the quasi-divine image of man.[5]

It is thus as a professional—a clinical psychoanalyst—that Gérard Wajcman characterizes this "forgetting of everything": the "regression of such a discourse," he affirms, is no less than *perverse*. It is a "religious fetishization" of the image, "a kind of blatant denial, offered, if not unconsciously, at least in an unconsidered manner." Such that the attention brought to the four photographs of August 1944 becomes related, according to him, to the typical "fetishistic denial" with which a perverse subject "will display and adore shoes, stockings, or panties, like relics of the missing phallus."[6]

But something related to sexual *perversion*—and sickness of the soul—is averred, in the case in point, to be much more serious: the "magical incantation" of the fetishist is paired here with *perversity*, that is, with charlatanism of thought, with an intellectual sleight of hand. Within the "acrobatic sophistry" performed on the subject of Auschwitz, he sees "fraud" and "false advertising" for the images of the Nazi extermination camps.[7] This fundamental perversity is something Wajcman calls "a thought infiltrated with Christianity," an "inclination toward Christianization." The "passion of the image" is "intimately Christian," he maintains: "it infiltrates and sticks to everything that concerns images in our regions." These "litanies," this "virtuous sniveling" in face of the four photographs taken by the members of the *Sonderkommando*, the "prophetic tone" of their description: all of this, in his opinion, reveals an "elevation of the image to the status of a relic" typical of the Christian religion.[8] This explains why, at one moment, he attempts to clothe me in a whole patchwork of hagiographic rags:

Georges Didi-Huberman attempts to stretch, over the armor
of Saint George, the lambskin of a Saint John with pointed
finger, as well as the mantle of Saint Paul announcing to the
world the coming of the Image.[9]

Wajcman still wasn't satisfied. To be pointed out also were the so-
cial, ethical, and *political* dangers of such a "faith in images" and of
this "Announcement of the Image." In his diagnosis of my analysis
of the four photographs from August 1944—and with his "one
must admit, aggressive rejection of the idea that something there
could be unrepresentable"—Gérard Wajcman finds a "crowning
of the thought of consensus," an "almost unexpected justification
for the widespread love of representation" in our modern world.
Here, then, visual inattention is reduced to a "televisual ideal":
having "rediscovered the virtues of memories in photo albums,
[. . .] Georges Didi-Huberman likes to flatter our simplest inclina-
tions [. . .] as a way of satisfying the desire to see nothing, to close
one's eyes."[10] Where a *generalized* cult of the image appears on the
one hand, an *annihilated* capacity to open the eyes appears on the
other.

The result, beyond "disastrous confusion," is a most harmful
political and moral danger: "truly culpable, injurious thought-
lessness," "rather disturbing thought," "really dangerous misin-
terpretation throughout," since it conceals a "disturbing element
of blindness [of] obvious seriousness."[11] Thinking of the image is
thinking of the similar: Wajcman will deduce that it is thinking
that *assimilates everything*. In the situation analyzed—that of the
Sonderkommando of Auschwitz—he finds that "abject idea" which,
in the name of the image, assimilates the executioner and the vic-
tim, which verges on generalized Christianization, even on anti-
Semitism and on the perverse reversal of roles in the present
Israeli-Palestinian conflict:

> In this waltz of possibilities, in which everyone is the other's
> fellow, it was fatal to come to the abject idea of the infinite
> and reciprocal exchange of places between executioner and
> victim. [. . .] There is something unbearable in that which is
> nothing more than an invitation to error, to lies, and to illu-

sions, to the error of thought, to the easy lie and the alienating illusion. [. . .] I do not necessarily see, in all of this, the manifestation of a rampant anti-Semitism but rather the effect of an almost irresistible inclination, which we see just as much in professed Jews, to basically "Christianize" the debate around images in general. [. . .] It is no doubt the same impulse that impels one to denounce [. . .] a State of Israel as "worse than the Nazis" with regard to the Palestinians, the true Jews of our time.[12]

Elisabeth Pagnoux adds to these condemnations twenty-five pages of the same. She condemns the alleged role of deception—a "double deception" according to her—and admonishes the "passion for constructing nothingness" at the risk of "confusing everything [. . .] in order to consolidate a void." She mounts a heavy attack on what she terms the "intellectual pirouette," the "sleight of hand," and the "narrative fuzziness that mixes up tenses, imposes meaning, invents content, and insists on filling the nothingness instead of facing it."[13]

To fill the nothingness: the attempt to reconstitute historically the four images from August 1944 represents nothing more, for Elisabeth Pagnoux, than an "appearance of scientificity" inspired by the documentary work of Jean-Claude Pressac, with his "summits of technicalizing emptiness." His hypothetical character is "endless," and he therefore limits himself to "constantly enclosing himself within the vanity of conjecture [and to] refusing to enter into [. . .] interpretation." At the same time, the visual analysis can be qualified as hyperinterpretation (what Wajcman called "over-interpretation"), since it is "reconstitution, fiction, creation." Thus it becomes—another inversion—a genuinely "relentless determination to destroy the gaze." As for the attention to history, it is turned into a "nullification of memory" and a "hindrance [to] the advent of the past."[14]

To nullify memory: political and moral infamy will once more be superimposed upon interpretative emptiness. Analysis of the photographs of Auschwitz is hence "totally inappropriate," "gruesome, and encouraging pernicious ways of thinking"—anti-Semitism

or negationism. More precisely, "his method, itself an imprecise mechanics, discredits the speech of the witnesses only to finally deny it": the "sufficiency of a present that attempts to supplant testimonies":[15]

> Georges Didi-Huberman takes the position of the witness [. . .], usurps the status of the witness. The source lost, the word is denied. [. . .] To look at the photo and to believe oneself to be there. Distance, once again, is denied. To make us witnesses of this scene, besides the fact that it is an invention (since we cannot reanimate the past) is to distort the reality of Auschwitz, which was an event without a witness. It is to fill the silence. [. . .] At the limit of confusion, Georges Didi-Huberman, some lines before the end of his article, gives witnesses and speech the coup de grace, declaring that "they [the photos] are the survivors."[16]

Denial of the witnesses as moral perversity therefore culminates in denial of reality as fetishistic perversion. Elisabeth Pagnoux, too, sees no more than "voyeurism" in the visual attention given to the four photographs of the *Sonderkommando*; no more than "*jouissance* in horror," "inappropriate words," and a perverse fantasy "obsessed with the interior," "fiction" of the past mixed—one might well ask why—with a "humanitarian present."[17] Extending the anathema to the exhibition catalogue in which my essay had originally been published, Elisabeth Pagnoux repeats her moral condemnation of a specific attention brought to the history of the photography of the camps:

> Comparable to the scoop, it is nauseating. [. . .] It is shocking. What novelty worthy of being uttered are we dealing with? What could a supplementary photo bring? We know much more than what the photos could say one by one. Moreover, what is to know? And it is deeply shocking because it is immediately clear that mixed with the claimed novelty of the content and of the gaze is the arrogance, to be precise, of what is no more than pretence, even manipulation. [. . .] Auschwitz, a photogenic object? [. . .] This is deeply shocking. Women

walking toward the gas chamber. Unless one exults in the horror, there is reason enough not to go to see the exhibition. For those who guard the memory of the crime, the idea of seeing yet another image—the idea of looking once again at those images already known—is unbearable, and a photo teaches nothing more than what we know already. [. . .] Upon the negation of the distance that separates today and yesterday, a lie is built, all the more ignominious because it thwarts any plan for transmission. A double lie, a confusion which entertains all the perversity of the enterprise: we can go inside the gas chamber [. . .]. You don't summarize Auschwitz, you don't fetishize it, you don't turn it into a museum piece so as to capture it and put an end to it.[18]

[]

Must we respond to this? Should we argue with such a refusal to read? Should we object to an attack that distorts the arguments in one stroke and prefers to dwell on personal implications (for example, the way in which Wajcman portrays me, authoritatively, in a clinical setting as a fetishist, giving me the moral status of a renegade, a "Christianized" Jew, or the way in which Pagnoux calls for, but doesn't offer, an inquiry into the "origins" of my discourse, since it seems to "come from nowhere")?[19] By definition, I can always argue with anyone who considers my analysis "arguable"; but can I still do this when the critic makes me the very incarnation of error and, worse, of moral infamy?

Is it enough to retort to Gérard Wajcman that, contrary to what he thinks, I in no way express an "abject idea"—"the infinite and reciprocal exchange of places between executioner and victim"—but rather the very opposite idea? Is it enough to respond kindly to Elisabeth Pagnoux that her accusation of theoretical "arrogance" would be even less justifiable if, armed with her annulling question "Moreover, what is to know?" she risked opening the books that I have devoted to this question in the visual field, when she herself has not, to my knowledge, begun to answer it? Faced with these four photographs of Auschwitz, I have simply *attempted to*

see in order to *know better*. How can I respond to those who *see red* before the very principle of such an attempt?

There is, however, much to say beyond a simple riposte and the concomitant risk of satisfying oneself with counterarguments. Let us keep in mind that image by Goya in which two hairy fighters thrash *each other* with sticks, without realizing that they are sinking *together* into the same quicksand. It would be better, then, to investigate the common ground and the underlying stakes of such a controversy, however moving, however biased it may be, or simply because it is biased throughout—and sedimented. The violence of this controversy, let it be noted, where it is most outrageous and sometimes undignified, springs from the rhetoric of political quarrels, while it is in fact all about history and images dating from about sixty years ago: a definite clue that the *thought of images* today comes to a great extent from the *political field* itself.[20]

But this polemical violence comes primarily from its very object, as though the only response to the photographic images of the Nazi terror were a horrified gaze (of empathy or, on the contrary, of regret), or anxious interpretations, even violent, reaching a critical point in discourse itself. If I have chosen to investigate the four photographs from August 1944, it is precisely because they are an extreme case within the known corpus of visual documents from that time, and a troubling singularity: they are a *historical symptom* capable of disrupting, and reconfiguring, the relation habitually maintained by the historian of images with his or her own objects of study. In this extreme case, therefore, there is something that questions our own seeing and our own knowing: a *theoretical symptom* which, precisely because disputed, clearly shows that it has shaken *all of us* throughout our common history.[21]

Gérard Wajcman believes that this singularity—whether it be visual or photographic—teaches nothing that we do not know already and, worse, that it inveigles its spectator to error, phantasm, illusion, credulity, voyeurism, fetishism, and so forth. Even to "the abject idea." This is why, faced with the four photographs, he finds it necessary to repeat loudly what he, along with many others, has previously affirmed: "There are no images of the Shoah." These words begin, or begin again, his polemical text.[22] But let us ana-

lyze this a little. Wajcman says not one but many things—some
unbeknownst to him—starting from this single, key phrase. Note
how he writes successively, in the space of one page: "There are
no images of the Shoah." Then, in the singular: "There is no image
of the Shoah." Then, elliptically: "There is no image." And finally,
metaphysically: "There is not."[23]

The first occurrence is intended to denote an *exact fact* issued
from historical knowledge (hence revisable knowledge, as Wajc-
man admits): "To this day we know of no single photograph or
film that shows the destruction of the Jews in the gas chambers."[24]
Such would be the factual version of the unimaginable, of which
Wajcman himself, in other versions of his thesis, seems to be in
doubt.[25] If the controversy were to stick to this single factuality,
then we could conclude it immediately, by saying that we simply
did not agree on what the *imaged of the image* was;[26] in other words,
that we did not agree on the extension of the word "Shoah." By
this, Wajcman means the absolutely specific operation and mo-
ment of the gassing of the Jews, of which, indeed, we know of no
single photographic image. I myself maintain that the "destruction
of the European Jews," following Raul Hilberg's conception, is an
infinitely large, complex, ramified, multiform historical phenom-
enon. In the history of Nazism, there were a hundred different
techniques for bringing the "Final Solution" to fruition, ranging
from radical *evil* to disconcerting *banality*. In this sense, we are
justified in saying that there were indeed—and in considerable
numbers—images of the Shoah. I have obviously never claimed
that the four photographs from August 1944 showed the moment
of the gassing as such. But they do show, and extremely well, two
constitutive moments of the "special treatment" (*Sonderbehand-
lung*): the victims being led naked to the gas chambers, while other
victims, already gassed, burn in the outside incineration pits of
crematorium V at Birkenau (figs. 3–6).

Gérard Wajcman needed a few historical errors to make the
first case (a factual, historical one) into a *universal truth*. "There
is no image of the Shoah," he says, because "the Nazis worked at
leaving no trace whatsoever and had carefully prohibited all im-
ages." Yet we know to what point this interdiction was circum-

vented by the Nazis themselves and, exceptionally (in the case that has caught my attention), by the members of the Jewish resistance of the *Sonderkommando*. Wajcman gives a second reason: "because there was no light in the gas chambers," he says; but he is wrong.[27] Finally, he argues: "because, fifty years after, we would already have found a little piece of something"[28] — to which the four photographic "rags," known about since 1945, offer an immediate response.

But Wajcman has already left the order of facts: a "revisable" order is not strong enough in his eyes. He needs not "a fact, but a thesis. It does not aim for exactness, but instead for truth. This thesis is absolute and unrevisable."[29] What does the thesis signify exactly, beside the general statement that "there is no image of the Shoah"? It actually means two things. On the one hand, a piece of common sense, a philosophical fact known since the dawn of time, taking account of the fact that "not *all of the real* is solvable in the visible," or that there is an "incapacity of the image to transmit *all of the real.*"[30] In any case, whoever made such a claim? If the controversy stemmed from this single truth, we could bring it to a close immediately, saying that we simply did not agree about that which is the *imager of the image,*[31] that is, that we did not agree on the extension of the words "image" and "real."

A dual intellectual operation occurs: Wajcman makes the real absolute, referring to "all of the real," in order to better claim it; then he makes the image absolute as an "all image" [*image toute*], to better revoke it. On the one hand, he overlooks what was shown by Bataille or Lacan, for whom the real, of being "impossible," exists only as manifested in the form of pieces, rags, *part* objects. On the other hand, he pretends to ignore what I attempted to elaborate concerning the essentially *lacunary* nature of images. While he doesn't hesitate to use my own critique of the visible in his recent commentaries on Duchamp or Malevitch,[32] he imputes to me a hallucinatory trust — a "belief" — in the face of this same visible, where the Shoah is concerned. A little dishonesty seems to have crept into the intellectual operation in question.

A certain naïveté has crept in too. Wajcman believes that a philosophical act is recognized by its "absolute" or "radical" factors. He

therefore makes everything absolute and radicalizes everything, blending his propositions with rhetorical markers so rhetorical, so bandied around in his mind, that they become inconsistent: "necessary," "integral," "alone," "unique," "all [*tout*]," "absolutely," "unrevisable," "I know it," "that is all [*c'est tout*]," and the like. Against the *few* images particular to the Shoah, Wajcman wants to oppose the undifferentiated *all* [*tout*] of a "single object [. . .], true object, real object [. . .], unique object. And irreducible. The only object that can be neither destroyed nor forgotten. The absolute object [. . .], unthinkable [. . .], nameless, and imageless" [. . .], which he terms, with a rather unusual play on words, *O.A.S.*, meaning "*Objet-Art-Shoah.*"[33] Indeed, it is for this entity that the unimaginable becomes so necessary. It is for this entity that the unimaginable becomes absolute, knows no more exceptions, ultimately extends its tyranny to the "unrepresentable," the "unfigurable," the "invisible" and the "impossible."[34] Might there be, with regard to the Shoah, only judgments of inexistence or of totality?

We are nearing the crux of this controversy. It has to do with the expression *in spite of all*, which in the title of this book modifies the word *images*: not images of all (of the Shoah as absolute), but *images in spite of all*. In other words, images that were snatched, at incredible risk, from a Real that they certainly didn't have time to explore (hence the inanity of Elisabeth Pagnoux's choice of title, "Photographic Reporter in Auschwitz"), yet which managed in a few minutes to capture incompletely, fugitively, some aspects of that Real. Wajcman refuses, in principle, to situate this *in spite of all* in the historicity proper to the Jewish resistance at Auschwitz, determined to send out visual signs of the murderous machine to which the resisters themselves knew they would succumb. Where the expression *in spite of all* attempted to name the act of producing these particular images—an act of resistance in Auschwitz of 1944—Wajcman prefers to understand it merely denoting an opinion on the image in general—a gesture of theoretical arrogance in Paris of 2001: "In spite of all what? In spite of the fact that the Shoah is unimaginable, in spite of all and in spite of everyone."[35] My *in spite of all* is understood thereafter as a mere stylistic formula, a "slogan," an "incantation," or a "miracle solution"

to the irreconcilable contradictions of the Shoah as a philosophical concept in the postmodern age.[36]

This refusal to understand my point of departure is explained, of course, by the refusal to acknowledge my point of arrival. By invoking the two "periods of the unimaginable," I wanted to analyze, one after another, two counterexamples to these common systems: first, the *in spite of all* of history itself, the *political resistance*, the heroic resistance of those who succeeded in taking four photographs of Birkenau in the midst of its operation; second, the *in spite of all* of thought, which questions the memory of history, the thought that sees in the singular historical fact a *theoretical exception* peculiar to modifying a preexisting opinion on the "unimaginable." If Gérard Wajcman holds his *truth* to be "an unrevisable thesis," manifesting complete indifference to the *exactness* of the facts—having admitted that, on the historical level, he "knows nothing about it," but declaring that this doesn't make any difference[37]—it is because he wants to dissociate *history* from *concept* at all costs. He is therefore ready to throw out all the singularities of the first for the single generality of the second. He sees no solution of continuity, no possible transmission, between the attempt by the prisoners at Auschwitz to *extract images* in order to allow something of the extermination machine to be seen, and the historian's attempt years later, to *extract from these images* something that makes sense in our (never closed) understanding of the Shoah.

The crux of this controversy lies in a different evaluation of the relations between *history* and *theory* (where debates concerning the epistemic status of images so often come into play). It lies, correlatively, in a different evaluation of the relations between the *singular* and the *universal*. Even in its ethical and aesthetic consequences, this dispute constantly refuses even to address the question of the relations between singular *fact* and universal *thesis*. For Wajcman, the four photographs from August 1944 may be a historical fact but could under no circumstances depart from the general truth of the *already thought image*: the image, he believes, is no more than delusion, misrecognition, inveiglement, alienation, and lie. It is significant that Wajcman did not risk an internal critique of my analysis of the four images of Auschwitz: otherwise, he would have

proposed a different or diverging interpretation, a visual or factual alternative analysis. As it is, he is content with dismissing the very principle of such an analysis and, further, with dismissing any gaze upon these images, thus nullifying them as historical facts: "It is because there was nothing to be seen" of the Shoah, he claims.[38]

I began with a different and no doubt more pessimistic presupposition: there were things to see, and in all kinds of ways. There were things to see, and to hear, and to feel, and to deduce from what one saw or from what one did not see (the trains that continually arrived full of people and left empty). And yet this, for many, remained outside the sphere of knowledge. People saw, in spite of the censorship, indubitable segments of the "Final Solution"; yet no one wanted to know about it. In the same way, the radical nature of the Nazis' crime forces us to rethink law and anthropology (as Hannah Arendt showed); just as the enormity of this history forces us to rethink narrative, memory, and writing in general (as both Primo Levi and Paul Celan showed so well, each in his own way); in the same way, the "unimaginable" of Auschwitz forces us, not to eliminate, but to *rethink the image* when an image of Auschwitz, suddenly, concretely, even if it remains an incomplete image, appears before our eyes. The four photographs taken in August 1944 by the *Sonderkommando* of crematorium V are the exception that asks us to rethink the rule, the fact that asks us to rethink the theory.

The *image that is resolved* by its rule or by its "unrevisable theory" was to make way in my mind for a new, unresolved question, one that reveals all of the theoretical stakes of an interminably *rethought image*. Is it not unjust or even cruel to dismiss in advance the mission of the members of the *Sonderkommando* of Auschwitz—however utopian their project might be—in the name of an authoritarian concept? If the risk they took signifies the hope they placed in such a transmission of images, should we not take this transmission itself very seriously, and concentrate attentively on the images in question, not as deceptive artifacts but rather as "instants of truth," whose importance was emphasized by Arendt and Benjamin?

My objection to the "thesis of the unimaginable" seems to have riled my two critics so much that they refused to understand it for

what it was. I did not dismiss the unimaginable as absolutely as they themselves claim to undo my own argument. They confuse *criticism* with *rejection*, and they remain within the pseudo-radicality of the *all or nothing*. My attempt—to know something specific from a few images—sprang explicitly from the statement of fact that "we cannot, that we could not by any means, imagine it to the very end." So I never rejected the *unimaginable as experience*. "Unimaginable" was a necessary word for the witnesses who forced themselves to tell, as it was for those who forced themselves to hear them. When Zalmen Lewental undertakes his narrative of the worst, he warns his reader that nobody can imagine such an experience: *this is why he tells it in spite of all*, until our soul is definitively inhabited by the images—precise but partial, sovereign but incomplete—that he chose to transmit to us.[39]

"Unimaginable" is a tragic word: it concerns the intrinsic pain of the event and the concomitant difficulty of being transmitted. Wajcman, and others before him, made it into an "unrevisable thesis": henceforth, the word would refer to the ontological status and to the "purity" of the event; an event "free of images" since "there was nothing to see." It is to this unimaginable, to this *unimaginable as dogma*, that I objected. Let me be precise, since this was not very well understood: the critique concerns the pretext used by Wajcman for always speaking in terms of an *absolute rule*, whether regarding images in general, history in general, the Shoah in general, or even art in general. Faced with this theoretical infatuation, faced with a certainty so great that it dissuades any argument—"it is a thesis [. . .], and it is absolute and unrevisable"—I recalled some historical facts to which Wajcman had simply never paid attention: some *exceptions in spite of all*, having critical value where the unimaginable is held as an absolute rule. From here on, one must hear in that *in spite of all* an objection to the *all*, a collection of arguments and facts given *in spite of the all* of the unimaginable established as a dogma.

On this point, Gérard Wajcman is right to feel that he is being called into question. For him, the unimaginable of the Shoah means *to imagine nothing*. According to him, there was not only "nothing to see," a claim that is false (let us reread once again the descriptions by members of the *Sonderkommando*) and in any case

does not foreclose the working of the imagination—quite the contrary. But aside from that, according to him, to imagine is "impossible," "quite beyond the power of the will, beyond all consciousness and beyond all unconsciousness."[40] This is certainly strange coming from a psychoanalyst. Wouldn't it be more reasonable to observe how much the Shoah occupies our imaginary and symbolic world, our dreams and our anxieties, our unconscious in general? And to observe also how often it is *only* possible for us to imagine, which does not mean, of course, to drain the truth from what we imagine? Has Wajcman never felt *images of the terrible rise within him* when listening to witnesses, relatives, when reading history books, lists where our names appear, the first awful nightmares, the first discoveries of animated images in *Nuit et brouillard*, the archeological reconstitutions by Raul Hilberg, the albums of Yad Vashem, the real-life testimonies in the images, faces, and words in the film *Shoah*?

The very existence and form of the testimonies powerfully contradict the dogma of the unimaginable. It is as a tragic experience that the unimaginable calls upon its contradiction, the act of imagining *in spite of all*. It is because the Nazis wanted their crime to be unimaginable that the members of the Auschwitz *Sonderkommando* decided to extract *in spite of all* those four photographs of the extermination. It is because the words of the witnesses defy our capacity to imagine what they tell us that we must attempt *in spite of all* to do so, in order to better hear those words in the testimony. Where the act of producing an image there in the concentration camp was an affirmative power, an act of *political resistance* on the part of the clandestine photographers of Birkenau, for us here today to reject all images amounts to the impotence of pure avoidance, a symptom of *psychic resistance* in the face of the horror that gazes at us from these photographs.

A characteristic trait of this "resistance to the image" is its spontaneous adoption of traditional forms of political iconoclasm: outright rejection, the rhetoric of moral censure, the desire to destroy "idols." We know that the iconoclast hates the image precisely because he endows it with far more power than the most convinced iconophile would do. This has clearly been the case from the Byzan-

tine quarrels and the fathers of the western church, right down to the most recent "image wars" that accompany attacks, massacres, and armed conflicts.⁴¹ So when Gérard Wajcman sums up his thesis of the unimaginable by declaring: "Not all of the real is solvable in the visible,"⁴² he implicitly supposes that the opposite thesis—which he thinks is mine—would claim that "all of the real *is* soluble in the visible." He thinks therefore that the image, for his fantasized adversary, *resolves the real*, constituting a kind of *integral* of the real. If the unimaginable for him means to *imagine nothing*, then the image will inevitably mean to *imagine all*. Why create a conceptual chimera in order to dismiss it so fiercely? Doesn't exorcising ghosts suggest that one might be haunted by them?

In this exorcising perspective, which ignores any theoretical nuance—and scorns any sensitive observation—the image will be sustained conceptually only as an *all image*. This makes it easier to banish it in the name of "all of the real." And it is against such a presupposition that I raised the theoretical objection to the *lacuna-image* and that I justified the archeological search concerning the role of visual vestiges in history, of which the four photographs of August 1944 constitute a particularly powerful example. The image is made *of all*: by this I refer to its nature as an amalgam, an impurity, visible things mixed with confused things, illusive things mixed with revealing things, visual forms mixed with a certain thought in action. It is therefore *neither all* (as Wajcman secretly fears) *nor nothing* (as he affirms peremptorily). If the image were "all," then no doubt we would have to say that there are no images of the Shoah. But it is precisely because *the image is not all* that it remains legitimate to establish the following: there are images of the Shoah, which, even if they do not say everything (and still less "the all") of the Shoah, are nonetheless worthy of being looked at and examined as characteristic facts and as fully fledged testimonies of this tragic history.

[]

This historical value of the image was examined, under the scientific direction of Clément Chéroux, a historian of photography,

in the exhibition that opened in January 2001, entitled *Mémoire des camps*.[43] It was the exhibition itself, as much as my own analysis—which appeared at the end of the exhibition catalogue—that "shocked" Elisabeth Pagnoux. Consequently, she concluded that to visit the exhibition amounted to an act not only of inappropriate voyeurism but even of abject sadism: "Unless one exults in the horror, there is reason enough not to see the exhibition."[44] Photographic exhibitions on the subject of the Nazi camps have not, however, been scarce in the last fifty years. In France alone we may point to the constant pedagogical efforts made by the *Centre de documentation juive contemporaine*, whose photographic displays circulated freely without arousing, to my knowledge at least, this kind of moral protest.

Paradoxically, therefore, the controversy seems to have arisen not from the question of exhibiting such images—which had often been done, since the great majority of the images were known—but rather from the moment when the *photographic medium as such* was examined in this very demanding iconography. Such was the "novelty" that shocked my two critics, as though one were to be shocked that a linguist or a stylist should dare one day to take on the written testimonies of the Shoah as an object of study. Yet this kind of initiative corresponds exactly to the currently evolving historiography of the Nazi concentration and extermination camps.[45] In his recent book on the question of "sources," Raul Hilberg has emphasized the crucial problem of documentary materials, especially "visual materials." He evokes both the frequent difficulty of "deciphering what [we] see" in a photograph and the necessity of confronting a type of document for which "words would poorly summarize the richness of its content."[46]

It made sense, therefore, that historians of the Nazi period should meet with historians of the photographic medium in order to plan for this exhibition;[47] together they thought about the particular status of visual documentation relative to the camps. They started from two important observations. On the one hand, the existing images—around a million and a half photographs distributed throughout various archive collections—are *surviving images* that make up, in spite of their already considerable number, the

inferior portion of an archive that was largely created by the Na-
zis themselves, who then systematically destroyed it in face of the
approaching allies. On the other hand, these surviving images are
generally *ill seen images*, and ill seen because they are *ill said*: poorly
described, poorly captioned, poorly classed, poorly reproduced,
poorly used by the historiography of the Shoah. That the photogra-
phy of Rovno in the Ukraine—the imminent execution of women
and children of the Mizocz ghetto—should *still* be used as a docu-
ment for the advent of the gas chambers at Treblinka; that the
photograms of the bulldozer pushing corpses into a pit at Bergen-
Belsen should *still* be associated with the extermination of the Jews
by Zyklon B: all of this cries out the need for "a genuine archeol-
ogy of photographic documents" as Clément Chéroux suggests.
It could only be done by "examining the conditions of their cre-
ation, by studying their documentary content, and by questioning
their use."[48]

It is a tough program. It would require, for example, access to
the reverse side of the images—which recent digitization proj-
ects often forget about—in order to glean the slightest sign, the
slightest inscription that might better situate the image and iden-
tify, as far as possible, the person who took the photograph: the
question of viewpoint (undoubtedly Nazi, for the most part) is
capital in this domain. The *Mémoire des camps* exhibition and, more
precisely, its catalogue provided a typological framework for this
clearly unfinished work. The manner in which photography in
the camps was rigorously prohibited yet systematically exploited
by the concentration camp administration becomes more under-
standable.[49] So is the manner in which the Nazis themselves cir-
cumvented censorship and produced "amateur images" outside
of any official framework;[50] the manner, too, in which certain
prisoners managed to create—from their own point of view but
at their own peril—those *images in spite of all*, of which the four
photographs from August 1944 provide, without any doubt, the
ultimate example.[51]

If the part devoted to the Liberation appeared more complete
than the others, it was primarily because the production of images
reached a remarkable level after the opening of the camps. It was

also because the historiography of that moment had already re-
flected on the essential role of images. In 1945, what may be called
a period of *visual evidence*, or *visual proof*,[52] began, when the admin-
istrative staff of the allies accumulated photographic testimonies
of war crimes so as to confound the perpetrators at the Nuremberg
trials.[53] But it was also a period of *visual ordeal*:[54] a period of "peda-
gogy through horror" that the allied governments had decided
to institute and that was portrayed with intensity in magazines
and newsreels worldwide.[55] From this moment on, photographic
images became an integral part of the collective memory of the
camps, for better or for worse.[56]

In all this photographic memory—as well as cinematographic
memory, to which we will return later—Elisabeth Pagnoux and
Gérard Wajcman focused only on the worst. This is understand-
able, to a point: the worst dominates, and the *mainstream* sanc-
tions the worst. A little boy from the Warsaw ghetto haunted
our childhood nightmares;[57] he is used today in an advertisement
for a rock group.[58] But Elisabeth Pagnoux and Gérard Wajcman
confuse everything. Firstly, when they mount their attack against
the falsity of the "scoop" or the impropriety of a "revelation [. . .]
about the Shoah," they unjustly accuse the organizers of *Mémoire
des camps* of the kind of advertising that has existed only in jour-
nalistic treatment of this whole business.[59]

The other confusion is more fundamental since it is found
throughout Wajcman's and Pagnoux's entire conception of the
image as such: not one of the photographs exhibited in *Mémoire
des camps* is adequate to its object, the Shoah. Is this proof that
"there is no image of the Shoah"? This reasoning was taken up by
Jacques Mandelbaum in an article eloquently entitled "The Shoah
and Its Missing Images." One must admit, he writes, "regarding
the Shoah, the image is precisely what is missing." To anyone who
might point to the numerous (and overwhelming) snapshots col-
lected in *Mémoire des camps*, he replies, in advance: "All known im-
ages concerning that crime would therefore be, if not false, at least
inappropriate."[60] More radically, Wajcman and Pagnoux suggest
that, since all of the images of the Shoah are inappropriate to their
object, they are necessarily false or even falsifying. This is why

"there are no images of the Shoah." The images *are missing* because the images *lie*.[61]

There is theoretical confusion here: a value of existence and an *ontological status* are linked to a *use value*. Ontological status, yes: the images are "inappropriate." The images are not "the whole truth"—that *adaequatio rei et intellectus* of the traditional formula—so they are "inadequate" to their object. This contention is indisputable; yet its generality is so great that it permits nothing more than a principle of gnoseological uncertainty. Does inadequacy not characterize all that we make use of to perceive and describe the world? Are the signs of language not just as "inadequate," albeit differently, as are images? Do we not know that the "rose" as a word will always be "the absent one of any bouquet"?[62] One can understand the absurdity of an argument that attempts to throw away all words or all images under the pretext that they are *not all*, that they do not say "all of the truth." There again, Wajcman ought to have reread Lacan—on the famous "half-saying"—before thinking himself authorized to curse an entire class of objects under the pretext that they *do not say all*.[63]

With respect to use-value, both of my critics take the absurd position of wanting to sacrifice language in its entirety whenever a single lie might be emitted. Yet the myriad of lies that are constantly uttered will never prevent words from being that which is most precious to us. The same goes for images: yes, images lie. But *not all* do, not about all things, and not all the time. When Gérard Wajcman observes that "today there is a bulimia of images" and of lies,[64] he does no more than state a sad banality with which we are all confronted (and that I myself evoked when speaking of a "world, full, almost choked, with imaginary commodities"). It is true that today *the terrible*—war, civilian massacres, mass graves—has itself become *a commodity* by means of interposed images. When Wajcman writes that "there are *no images* of the Shoah," he is silently lamenting the absence of true images of the Shoah, images that are *all images* [*images toutes*], and lamenting out loud that there are *too many false images* of it, too many *not-all* images [*images pas-toutes*].

False images: beginning in the 1950s, Roland Barthes critiqued this manner in "shock-photos" of "almost always *overconstructing*

the horror" such that the images become "false, [immobilized in] an intermediary state between the literal fact and the overestimated fact."[65] Then media sociologists analyzed the numerous procedures of *manipulation* to which the images are so often subjected with the aim of inducing some belief or other.[66] In her work on the photography of the camps, Barbie Zelizer used an expression established in the journalistic world, "covering atrocity," implying that this job consisted as much in covering atrocity up as in describing it.[67] From the journalistic *coverage* to the media *cult*, from the legitimate constitution of an iconography to the improper production of social icons, there is often a single step.[68] Pierre Vidal-Naquet rightly remarked that the development of negationism saw its full expansion "only after the broadcast of *Holocaust* [the televised series], that is, after the spectacularization of the genocide, its transformation into pure language and into an object of consumption for the masses."[69] Even the audiovisual testimony of the survivors—to which Claude Lanzmann gave credibility in *Shoah*—is now going through a stage of industrialization.[70]

What can be done about this? One can *doubt images*: in other words, one can call for a more demanding gaze, a critical gaze that guards itself against being invaded by the "referential illusion." Such was the position defended by Clément Chéroux and Ilsen About.[71] Any consistent critique seeks to maintain the existence of its object. We critique only that which interests us: to critique is never to reject, to reject is never to critique. Gérard Wajcman, however, does no more than *repudiate images*, which amounts to *not doubting* that they are "false." In this way, he does no more than follow another mainstream: the radical skepticism of postmodern discourse toward history (I will return to this point) and equally toward the image, even a photographic image.[72] There was a time, no doubt, when the indexicality criterion and the Barthesian *ça-a-été* [it-has-been/it-was] were abused. Every time we looked at a photograph, we spoke of ontology, consequently neglecting the formal procedures specific to this medium. But to opt for the diametrically opposed point of view is to trade the *all* for the *nothing*, which means losing sight of photographic power itself, as well as the (problematic) point *where the image touches the real*. Far from

such pursuits, Gérard Wajcman merely offers long, iconoclastic tirades, in which all kinds of material are mixed up only to be rejected: archival photos along with Hollywood vulgarity, historical science along with "televisual ideal," all imbued with "a certain spirit of Christianity":

> We love images [. . .]. It is a devouring human passion that animates our era. [It is], I fear, the essential undercurrent of a certain public adherence that the exhibition entitled *Images des camps* [*sic*] seems to arouse. Giving a place and an occasion to [. . .] some images in the forms of an outlet [. . .], a discreet consolation, an invisible monstrance for the love of images. [. . .]
>
> How, in the vast movement of images of the camps that has unfurled in recent times, can we neglect the fact that the global scale of the public success and the official recognition of the films of Spielberg and Benigni rest on a common, powerful, irrepressible feeling that we must and we can represent the Shoah [. . .], that we can therefore, without remorse, go to see *Life Is Beautiful* and take our children, since this amounts to doing a good deed while enjoying ourselves as well. [. . .] The belief that all the visible is virtually visible [*sic*], that we can and must show all and see all [. . .], is a credo of the period (a credo that responds just as well to science's fantasy of a real that is entirely penetrable as to a certain spirit of Christianity, those two polarities, far from repelling each other, tying themselves together in the televisual ideal—television is basically the place of conjunction between the Christian passion of the image and the scientific belief in a real transparency of the world by means of technology).[73]

Amalgams rather than arguments: in less than three pages, a question of *knowledge* (analyzing four photographs created by the Jewish resistance of Auschwitz) was joined to a question of *exhibition* (as though Clément Chéroux's endeavor could be related in some way to a gallery of photographs), the latter being joined in turn to a question of *entertainment* ("the worldwide scale of the public success" of Spielberg's and Benigni's films), all of this finally joined to

a question of *stupefaction* ("television"). Polemical zeal makes Wajcman forget that when we speak of images created by members of a *Sonderkommando* destined for death, and of cinematographic images created by the members of the Spielberg and Benigni teams, we are *not* speaking of the same images. The image is *not all* [*pas toute*], the image is *not the same* everywhere. Yet Wajcman tries to ignore this distinction at any cost by fantasizing about a "consensus" of the image whose only value, in all cases—or whose only fault—would be the lie.

[]

From this view arises the theme of generalized *fetishism*, that perverse power of images upon our consciousness and our subconscious. Elisabeth Pagnoux constructs the motif while fashioning herself an apotropaïc necklace from the words "perversity," "fiction" (from which the word "fetish," we know, derives its etymology), "voyeurism," and "*jouissance* by horror."[74] She seems to discover that "the photo will never replace the gaze."[75] This platitude will be employed in order to prevent us from looking at the photographs from August 1944. To look at them would be *fiction* ("determination to construct nothingness"), and therefore *lie* ("we can go inside the gas chamber": a direct allusion to the sickening shower sequence in *Schindler's List*). To look at them would be *to get too close*, with a look "obsessed by the inside" and proceeding with the "negation of distance." But it would also be to go *too far* ("we are moving away from Auschwitz"). It would be *to see too much*, to the point of "voyeurism." But it would also be *to see nothing*, by a "determination to destroy the gaze."[76] Why all these reversals? Because the very activity of "looking at the photos" would serve only, according to Pagnoux, to "silence the witnesses" and even to perpetuate sadistically the work of death inflicted upon the victims by the Nazis:

> A photo of the gas chambers transmits the horror in the sense that it perpetuates it. [. . .] To perpetuate, that is to say to annihilate, to continue to annihilate. [. . .] For those who retain

the memory of the crime, the idea of looking at another image
[. . .] is unbearable, and a photo teaches nothing more than
what we already know.[77]

This entire conception is obviously dominated, beyond its moral-
ism, by the absolute antagonism of *seeing* [*voir*] and *knowing* [*savoir*]
(while a historian of images seeks, no less obviously, to highlight
their points of contact). The images, according to Pagnoux and
Wajcman, teach us nothing; worse, they attract us to that gener-
alized lie which is *belief*. The "fetishist" is then designated as the
one who thinks he is learning something from what he sees in a
photograph: he offers sacrifices to false divinities, to idols (the
traditional meaning of the concept of fetish) or to the spectacu-
lar commodity of generalized capitalism (the Marxist and even
situationist meaning of fetishism). To this veritable *demonizing* of
the image, Wajcman seeks the support of psychoanalysis, superim-
posing the *religious* paradigm of belief upon the *psychopathological*
paradigm of sexual perversion:

> There is [. . .] something about these four images that is like
> displaying the shroud of Auschwitz. [. . .] The truth revealed
> by the image, confirmed in the image, because these images
> are taken to be what visibly remains to us of Auschwitz. [This
> operation corresponds to] a kind of manifestation of religious
> fetishization [. . .] whose fetishistic [. . .] mechanism Freud
> dissected, a mechanism that will focus on covering absence,
> the failure to see all kinds of things that the mechanism will
> expose and adore as relics of the missing phallus.[78]

Beyond the question of *seeing* and *knowing* is the parallel question
of *image* and *truth*. My analysis of the four photographs of Ausch-
witz, indeed, assumed a certain relationship—a lacunary relation-
ship, "in rags," as precious as it is fragile, as clear as it is difficult to
analyze—of the image to truth. I looked at these images as *image-
facts*, in other words, as an attempt at visual representation car-
ried out by the members of the *Sonderkommando* at the site of their
experience of this infernal world in which they knew they were
condemned, and, at the same time, as a concrete, political gesture,

the act of clandestinely taking four photographs of the extermina-
tion from within the camps, so as to transmit them to the outside
by means of the Polish Resistance. From this point of view, the
photographs from August 1944 are at the same time *images* of the
Shoah in action—even if extremely fragmentary, as are images in
general—and a *fact* of historic resistance having the image as its
main concern.

For Wajcman, on the other hand, these four photographs are no
more than *fetish-images*. This judgment starts from two "unrevis-
able" theses: first, that all truths are founded on a lack, an absence,
a nondialectisable negativity (a thesis inspired by Lacan); second,
that "every image is a sort of denial of absence," something that is
still said: "No image can show absence," since "the image is always
affirmative."[79] Conclusion: every image is an "attractive substi-
tute" for a lack, that is to say its fetish. The reasoning is so quickly
attached to the damning *all image* [*image toute*] that, in a nobler
context—that of "the work of art," for which Wajcman claims to
have found the "definition"[80]—we would have to ask if there exist,
in spite of all, images of another kind: "Visual works that refuse us
and ignore us. Pictures upon which every gaze would be a break-
ing and entering."[81] Certainly. But could we not propose another
kind of exception to Gérard Wajcman: images that we are inclined
to refuse but that do not ignore us and, rather, beg for our gaze? Is
this not the case with the photographs of Birkenau, whose authors
so ardently wanted us to pay attention to them, so that we might
understand, visually, something of what went on there?

But Wajcman has already gone too far in his scorched-earth
logic. He can no longer step back. What he concedes to "pictures,"
preferably abstract ones, he rejects altogether with regard to pho-
tography, *all photography*. With as much seriousness as he has given
"the" definition of the work of art, he considers himself authorized
to judge photography itself, in general, as "especially fetishistic,"
for which it must simply be excommunicated from the domain
of art:

[...] beyond these photographs, it is photography as a dis-
cipline that seems to reveal itself here. Not only do we have

the feeling that photography arouses fetishism especially, but there is also something like a fundamental photographic fetishism (of which the extreme frenzy that animates the photography market is only one, albeit irrefutable, symptom). I would add that this fetishistic logic of photography not only creates an obstacle, in my opinion, to considering photography an art, but even gives it the value of accomplishing the opposite of a work of art.[82]

These lines are not solely a matter of ignorance. Gérard Wajcman must have seen one or two *works* by Brassaï, Man Ray, or Kertesz. His judgment is so absurd and so radical that it shows signs not of ignorance but of *denial*. By so quickly cutting all links between truth and photography, Wajcman simply hides the very power—some would have said "the absolute rupture," "the specificity"—of photography in the history of techniques of visual representation: I am speaking of its nature to record, that famous *indexicality* that today's postmodernists are wrong to have tired of so quickly.[83] There is no need to turn to Barthesian empathy to know that, *in spite of all*—that is to say, in spite of their formal limits, their grain, their relative obscurity, the parceled framing—the four images by the *Sonderkommando* do not constitute an "attractive substitute" for the extermination of the Jews in the gas chambers, but, very much to the contrary, they are a possible point of *contact*, with the aid of the photographic medium, between the *image* and the *real* of Birkenau in August 1944.

Certainly, it is always possible to fetishize an image. But *use-value*, once again, says nothing of the image itself or, in particular, of its *truth-value*. When a sexual pervert uses a shoe as a substitute for the maternal penis, the shoe doesn't cease to be a real shoe; it doesn't become the illusion of a phallus for everyone. It is by means of a reasoning that constantly transforms the (possible) use into the (necessary) truth that Wajcman reaches his ridiculous conclusions. Moreover, he embraces not only a *denial of photographic reality* but also a *denial of fetishistic reality* itself, which is even more surprising. While invoking Octave Manoni's famous formula for characterizing perverse denial—"I do know, but all

the same . . ."[84]—he inverts its theoretical structure, which is a way of perverting it without knowing. For Manoni, as for Freud, the fetishistic constitution originates in an experience of reality that contradicts an imaginary theory (that of the maternal phallus). Denial then becomes an attempt to *maintain the theory in spite of all* ("I do know that she has no phallus, but all the same I adore her shoe, to the extent that my belief will be sustained by the virtue of that object"). In the controversy that sets us against each other—here, very symmetrically—Wajcman places the imaginary theory on the side of "images in spite of all" and the experience of reality on the side of his own "unrevisable thesis." I believe, to the contrary, that his "unrevisable thesis" was an imaginary theory, an initial belief about the unimaginable of the Shoah, one that is contradicted by the singular experience of the four "images in spite of all." Regarding such a debate, we must ask ourselves whether our knowledge will progress by our denying the singular facts in the name of a general thesis, or on the other hand, by our denying the general thesis whenever singular facts worthy of analysis should appear.[85]

But let us return to the fetish, that anti-fact. What characterizes it exactly? Wajcman doesn't say, and is content to wave the trivial panoply around—"shoes, stockings, or panties"[86]—as if that were clear enough. Instead, he ought to have clarified quite methodically such characteristics, then researched and recognized them in my own analysis of the four photographs in question. So let us get things a bit clearer: by introducing the concept of fetish, Freud showed that it forms a *totalitarian image* by the conjunction between its nature as "substitute" (*Ersatz*) and its screen-like or "cover-like" nature (*Decke*).[87] That is why, contrary to what Wajcman says, the notions of fetish and relic do not overlap.[88] If the photographic "rags" of Birkenau are indeed *images* and *remains* of the real-life experience of the members of the *Sonderkommando*, they still do not constitute totalitarian, "attractive substitutes" of a fetishization. I evoked the much more modest idea of a "lacunary necessity."

In the second place, the fetish-image is an *image at a standstill* [*image à l'arrêt*]. This fundamental characteristic has more than once been described by Jacques Lacan: "Perverse desire is supported by the ideal of an inanimate object," he said in his first seminar.[89]

Three years later, dealing with the *relation of object*, he stated his conception of denial of reality as, so to speak, a *freeze-gaze* [*arrêt sur regard*]: "The very principle underlying the fetishist position is precisely that the subject freezes at a certain stage of the investigation and of the observation."[90] The fetish-image can only be *all*—unique, satisfying, totalitarian, beautiful with the beauty of "monuments" and of "trophies," conceived so as never to disappoint—on condition that it be kept *inanimate* by its exclusive holder:

> In fetishism, the subject himself says that he finally finds his object, his exclusive object, all the more satisfying when it is inanimate. As such, at least he will be more at ease, reassured that he will not be disappointed by it. To love a slipper is to have the object of one's desires at hand. An object devoid of any subjective, intersubjective, even transsubjective ownership is more reliable.[91]

These characteristics of the fetish are most certainly not found in the images of Birkenau, nor, I think, in the reading that I attempted of them. It would be difficult to see these images from the point of view of "ease," of the "inanimate," of integral "satisfaction," of "beauty" or of the object of leasure that can be manipulated because it is "devoid of any subjective [and] intersubjective [. . .] ownership." The most important thing perhaps—I will return to this even though Wajcman ignores it for a particular reason—is that these four photographs of Auschwitz are precisely *four*: the all image, the integral image, and the fetish-image are thought of as the *one-image*, while the sequence of August 1944 places us in front of *several images*, laid out together forming something like an elementary *montage*. A montage, I have contended, whose segments it would be disastrous—and no doubt fetishistic—to isolate or reframe. Lacan insists on comparing the fetish to a *freeze-frame*, that is to say, to the choice of one photogram in a sequence in which change prevailed—in other words, the *historical dimension*:

> What constitutes the fetish [. . .] is the moment of history at which the image freezes. [. . .] Think of a fast-rolling cinematographic movement stopping all of a sudden, freezing all of

the characters at one point. This snapshot is characteristic of
the reduction of the full, signifying scene, articulated from
subject to subject, to what is immobilized in the phantasm.[92]

Perhaps Wajcman would attribute this immobilization of history
to the photographic medium itself and to its snapshot character,
which freezes the "full scene" of reality. But the immobilization
that Lacan speaks of is indeed that of the *phantasm*: it both ne-
crotizes and hyperbolizes the image, for example to maintain the
fiction of a view that only seizes "the" absolute moment of the
Shoah, at the heart of the gassing process (this phantasm is obvi-
ously not mine). It is the phantasm—and not the medium—that
reduces the sequence of individual images in order to hypostasize
it into an *all image*, which is an *empty image*. I attempted rather to
conserve the sequential, plural, animated, even gestural character
of the photographs of Auschwitz, impossible to close up (we will
experiment with this later).

A third characteristic of the fetish, according to Lacan, is that
it forms a *screen-image* (its link with "screen-memory" was pointed
to very early on by Freud). It is a curtain, a veil, a "point of repres-
sion" that asks the psychoanalyst as well as the philosopher this
huge question: "Why is the veil more precious to man than reality?
Why does the order of this illusory relation become an essential,
necessary element of its relationship with the object? That is the
question asked by fetishism."[93] Could we say then that the four
photographs of Birkenau form a "screen" over the gassing of the
Jews because they show only the moment before and the moment
afterward? Was it in the interest of the members of the *Sonderkom-
mando*—even unconsciously—to have such a screen interposed in
order to give greater "satisfaction" to the spectator? Such reason-
ing would be absurd and terribly unjust. Does Wajcman believe
that I pored over these photos, sixty years later, merely so as *not* to
think about the Shoah? I leave this thought to him.

[]

I see, however, a more philosophical reason for Gérard Wajcman's
attempt to define (and enclose) *once and for all* this class of objects

called "images," in which he sees nothing but a subjective illusion, an "attractive substitute," a "spirit of Christianity," or an opium of the people. He begins with the following statement, which is legitimate: the Shoah constitutes an exceptional horror, the extreme horror of the "century." Then he asks: "Is it really in the power of images to make us see the horror?"[94] The answer, a violently negative one, is already contained in the form of the question.[95] While making the reality absolute (where the horror happens) and while making the image absolute (where according to him there is only the consolation, the negation of the Real) Wajcman ends up, by his own logic, making their antagonism absolute. Thus, he categorically concludes (simplifying his theory) a very long philosophical and anthropological debate on the powers of the image.

This debate in no way opposes a "thought shot through with Christianity" (that which "sees salvation in the image")[96] with an Enlightenment thought that can eliminate the duplicities of the visible world. The debate has existed at least since Aristotle discussed Plato, since Spinoza discussed Descartes. It shook up, from within, theologies both iconoclastic and iconophile. But it also underlay Renaissance thought in its entirety. It metamorphosed in the romantic controversies regarding the imagination. It illuminated surrealism from the inside. Psychoanalysis could not ignore it.

In a word—since this is not the place to recount its history—this debate roils all thinking that attempts to exceed or dialectize the Platonist theme of the *veil-image*. Wajcman would like to ignore this kind of thinking and thus remains firmly within the cliché of the mimetic illusion, the "attractive substitute" that "covers up the absence" or the essence, incapable in the present case of touching the Real of the horror in the camps. My own work, from the beginning, has taken the opposite direction,[97] that of the *tear-image* [*image-déchirure*].[98] It was a question not of hypostasizing a new definition of images taken as a whole but rather of observing their dialectical plasticity, which I have called the *dual system* of their working: visible and visual, detail and "patch," resemblance and difference, anthropomorphism and abstraction, form and formlessness, comeliness and cruelty, and so on. Like the signs of language, images in their own way—and this is the problem—

are able to produce an effect *along with* its negation.[99] They are, in turn, fetish and fact, vehicle of beauty and site of the unbearable, consolation and the inconsolable. They are neither pure illusion nor all of the truth, but a dialectic stirring together *the veil with its rip.*

Georges Bataille presupposed this duel system, I think, when, faced with the mollifying usage of familiar imageries, he tried to uncover the inconsolable—the "supplication," the essential "violence"—that the image is capable of evoking.[100] After Bataille, Maurice Blanchot said that it was correct, but incomplete, to speak of the image as that which "denies nothingness": what also needed to be recognized was the moment when the image becomes, reciprocally, "the gaze of nothingness upon us." From here, Blanchot is led to the profound idea of a "dual version" of the imaginary.[101] This (phenomenological) lesson was subtly understood by Lacan when he said, around the same time, that the "function of the imaginary is not the function of the unreal."[102] A little later, in a few superb pages echoing the style of Bataille, Lacan analyzed the "sudden appearance of the terrifying image" in the most initiatory of Freudian dreams:

> The phenomenology of the dream of Irma's injection has allowed us to distinguish the sudden appearance of the terrifying, harrowing image of this true Medusa's head, [. . .] a revelation of something that is unnamable [. . .]. There is therefore a harrowing apparition of *an image that sums up what we can call the revelation of the real* in what is least penetrable, of the real without any possible mediation, of the last real, of the essential object that is no longer an object but, rather, something before which all words stop and all categories fail, the object of anxiety par excellence. [. . .] It is an essential dissimilar, neither the supplement nor the complement of the similar, which is the very image of the dislocation, of the essential tearing of the subject.[103]

Where "all words stop and all categories fail"—where theses, refutable or not, are literally stunned—that is where an image can suddenly appear. Not a *veil-image* of the fetish, but the *tear-image* from

which a fragment of the real escapes. It is significant that in this text Lacan should have endeavored to describe a psychic system where "image" and "real," "image" and "object," cease to be opposed—as Gérard Wajcman does mechanically throughout his book *L'objet du siècle*—finding instead their common ground or, rather, their common rupture. Obviously, we are no longer in the sphere of consensual experience, but in a *tearing experience* that causes the upheaval of territories and thus of limits. At that moment, says Lacan, "the imaginary relation attains its very own limit."[104]

This analysis of the "terrifying image," however fecund, must not make us forget that its specific object (the psychic image of a dream) is not our own (the photographic image of a fact). But its methodological fecundity remains at least at this level: it compels us to rethink the image according to its dual system. Most notably, it forces us to distinguish, in the immense corpus of images of the camps, between that which *veils* and that which *tears*. That which holds the image in its consensual rule (where nobody really looks) and that which swells the image toward its tearing exception (where everyone suddenly feels looked at). Wajcman, from the beginning, has played the rule against the exception. He has thereby prevented himself from understanding any process of rupture, displacement, or pushing to the limit. Moreover, his case illustrates a sterile, post-Lacanian reading which in the obtuse rejection of phenomenology has progressively purified the "symbolic" of its "imaginary" dross, the *imaginary* as a psychic register progressively and improperly joined to a simple structure of *mirrored* alienation.[105]

If we look at the four photographs of Birkenau as *tear-images* rather than *veil-images*, as the exception rather than the rule, we find ourselves perceiving a *naked horror*, a horror that leaves us all the more devastated as it ceases to bear the hyperbolic mark of the "unimaginable," whether the sublime or the inhuman, bearing instead the marks of human banality at the service of the most radical evil: for example in the gestures of those few men set on moving the corpses of their fellows who have been murdered in front of their eyes. Their gestures concern the work they are doing, and there is the horror (figs. 3–4).

There are many images of the Shoah. As I have already said, for
better (where knowledge is always revised) or for worse (where
opinion is always preconceived). Especially for worse. In *The
Drowned and the Saved*, Primo Levi worried about the "gap that ex-
ists and grows wider every year between things as they were 'down
there' and things as they are represented by the current imagina-
tion fed by approximative books, films and myths."[106] More re-
cently, Imre Kertesz made the picture even darker, including in
the *imagery* of the genocide the "ritual language" and the "system
of taboos," speaking, as it were, of the *unimaginable*: "Many more
are those who steal the Holocaust from its guardians only to make
cheap junk of it. [. . .] A Holocaust conformism was formed, as
well as a sentimentalism, a Holocaust canon, a system of taboos
and its ritual language, Holocaust products for the consumption
of the Holocaust."[107]

This statement from an imagination always a step back from
itself,[108] this prevalence of photos—visual icons or *topoi* of lan-
guage—provided me, as well as the organizers of the *Mémoire des
camps* exhibition, with the best reason to return to and reexam-
ine the visual or written testimonies that surged from the events
themselves. The human gestures photographed in August 1944
by the *Sonderkommando* of their own work, of the inhuman task
of death, do not, of course, form the "integral" image of the ex-
termination. The *all image* of the Shoah, we agree, does not exist,
but not because the Shoah is necessarily unimaginable. Rather, it
is because the image is characterized by *being not all*. And it is not
because the image gives what Walter Benjamin called a *flash* rather
than the *substance* that we must exclude it from our inadequate
means of broaching the terrible history in question.

Archival documents never allow us to see an "absolute." Gérard
Wajcman is wrong to disqualify them for that theoretical lack,
because what they suggest to us is much more complex, much
more difficult—but important—to grasp and to transform into
knowledge. A dual system indeed: we look at the pictures of the
Auschwitz Album,[109] "and of course we are disappointed because
photography [. . .] records no more than outer envelopes [. . .],
and when we enter into people's eyes, we enter into the grain

of the photograph."[110] One is therefore disappointed because a photograph remains an image, a piece of film limited by its own material. But, if we look at it *in spite of all* a little more attentively, then "those grains are interesting [. . .]; in other words, photography can disrupt our perception of the real, of history, and of existence."[111]

Obviously the images don't give everything. Worse, we know that they sometimes "transfix," as Susan Sontag wrote: "Images transfix. Images anaesthetize. An event known through photographs certainly becomes more real [. . .]. But after repeated exposure to images it becomes less real."[112] But one must still take into account the *dual system* of images, the flux and reflux of truth in them. When their surface of *misrecognition* is disturbed by turbulence, by a wave of *cognition*, we cross the difficult but fecund moment of a *test of truth*. A test that Susan Sontag, on the same page, calls a *negative epiphany*, that "modern prototype of the revelation":

> Photographs shock insofar as they show something novel. [. . .] One's first encounter with the photographic inventory of ultimate horror is a kind of revelation, the prototypically modern revelation: a negative epiphany. For me, it was photographs of Bergen-Belsen and Dachau which I came across by chance in a bookstore in Santa Monica in July 1945. Nothing I have seen — in photographs or in real life — ever cut me as sharply, deeply, instantaneously. Indeed, it seems plausible to me to divide my life into two parts, before I saw those photographs (I was twelve) and after, though it was several years before I understood fully what they were about. What good was served in seeing them? They were only photographs — of an event I had scarcely heard of and could do nothing to affect, of suffering I could hardly imagine and could do nothing to relieve. When I looked at those photographs, something broke. Some limit had been reached, and not only that of horror; I felt irrevocably grieved, wounded, but a part of my feelings started to tighten; something went dead; something is still crying.[113]

Susan Sontag is certainly not describing her experience as a revelation of an *absolute knowledge*. She does not say that "all" of the

Shoah was given to her in these photographs. At the late period in which she recounts her experience, Sontag knows—better than it could be known in 1945—the difference between Dachau and Treblinka, concentration camps and extermination camps. To her, the photographs were merely the *opening of knowledge* through the mediation of a moment of *seeing*. They were therefore decisive for this knowledge itself. Wajcman, for his part, remains convinced that an absolute knowledge, outside of the image and outside of time, must respond to the absolute horror: "Either we know, and then we know all and we are on a level with all the knowledge—to know all is precisely to know that it took place, that the gas chambers took place, and that the most important event of the twentieth century took place there—or we do not know, meaning that we do not want to know or that in one way or another, radically, secretly, insensitively, in a nuanced manner, discretely, or unknowingly, we deny that it took place."[114] Thus, he refuses even to credit Serge Daney's witness account of the decisive role played by Alain Resnais's film *Nuit et brouillard* in his consciousness and knowledge of the Shoah.[115]

For those who want to know, and indeed for those who want to *know how*, knowing offers neither miracle nor respite. It is *knowing without end*: the interminable approach of the event, and not its capture in a revealed certainty. There is no "either–or": no "yes or no," "we know all or we deny," revelation or veil. There is an immense veil—due to destruction itself, and also to the Nazis' destruction of the archives of the destruction—a veil that is furrowed or even lifted slightly, that overwhelms us every time a testimony is listened to for what it says through the very silences, every time a document is looked at for what shows through the gaps. For this reason, in order to know we must imagine as well. By confusing the unimaginable with the unrepresentable, of which Freud speaks with regard to death in general, Wajcman inhibits himself from thinking psychoanalytically that *trauma* has any *destiny*: to transmit it is not to strip it of a human figure and to make it absolute in a perpetual "there is not," both abstract and intimidating. When images disappear, words and feelings also disappear.[116] So, too, does transmission itself.

This is so true that the discovery of visual documents—films or photographs—by the survivors of the camps has played a constitutive role in the assumption of their own experience, that is, in the constitution of their own memory. What they experienced, they had to *picture* for themselves if only to bear witness to it. Ka-Tzetnik provides a significant example of the dual system I have spoken of. First of all, he writes that upon his return from Auschwitz, he found that documentary images appeared meaningless to him: "I saw films on Auschwitz, I saw photos of Auschwitz, heaps of bodies, pits full of skeletons, and none of this touched me. I have often been surprised by this indifference."[117] But one day he sticks a photograph onto the wall of his office: "I can't take my eyes off it." Then comes a kind of revelation and even, he says, "rapture." For a long time he attempted to enfold himself in the temporality of the photograph; and this attempt played a crucial role in the very particular "psychoanalytic cure" that he undertook with the more or less controlled help of LSD, in order to put his infinite suffering into images.[118] As though, at a certain point, the act of *facing the image* were necessary for the *assumption of the fact* itself by the survivor's psyche.

Jorge Semprun bore witness to an experience probably less extreme and more typical but one that was analyzed more precisely. Having returned from the camps, wandering, in despair, Semprun sought calm in fiction one evening by going to the movies. But the news was shown first:

> Suddenly, following the results of a sports competition and of some international reunion in New York, I had to close my eyes, blinded for a second. I reopened them, I had not dreamed, the images were still there, on the screen, inevitable. [. . .]
>
> The images had been filmed in various camps that had been liberated by the advancing of the allies a few months earlier. In Bergen-Belsen, in Mauthausen, in Dachau. There were also images of Buchenwald, which I recognized.
>
> Or rather: which I knew with certainty came from Buchenwald, without being certain of recognizing them. Or rather: without the certainty of having seen them myself. I had seen

them, however. Or rather: I had experienced them. It was the
difference between the seen and the experienced that was
troubling. [. . .]

Suddenly, in the silence of that theater [. . .], those images
of my intimate experience became foreign to me, made objec-
tive on the screen. Thus they escaped the process of memoriza-
tion and of censorship that were personal to me. They ceased
to be my property and my torment: the deadly riches of my
life. They were no more than, or they were merely, the radical,
exteriorized reality of Evil: its icy yet burning reflection.

The gray images, sometimes blurred, filmed with the jumpi-
ness of a hand-held camera, acquired a dimension of immod-
erate, overwhelming reality that my memories themselves did
not touch. [. . .] As though, at first sight paradoxically, the di-
mension of the unreal, the content of fiction inherent to every
cinematographic image, even the most documentary image,
filled my most intimate memories with the weight of an in-
contestable reality.[119]

This page offers us a genuine phenomenological description of
the dual system offered to the survivor's gaze by the documentary
image. First of all there is the *veil effect*, linked with the *derealiz-
ing* of images by a person who has experienced the *there*, which
is being shown *here*. The images of the camps that appear on the
screen are "inevitable," says Semprun, but already they belong—
still inconceivably for him—to the flux of "normal" history, after
a sports competition and an international meeting in New York.
This is the first derealization. Then come the images of Buchen-
wald, from which Semprun has only just returned and in which
his soul remains imprisoned. Images "recognized" by him, but he
hardly lets the word slip before modifying it by a complex chain of
nuances, like *caesuras* of the feeling experienced. The dual system
of the image will therefore occupy every moment of this expe-
rience: between a *certain* knowledge of what is represented and
an *uncertain* recognition of what is seen; between the uncertainty
of having *seen* and the certainty of having *experienced*. "It was the
difference [. . .] that was troubling." A difference hollowed out by

the continuous flux in what tears it. A difference by which images of the *intimate*, having appeared on screen, become the *strangeness*, even the *foreignness*, of collective history.[120]

Because they cease at that moment to be his "property" and his "torment," because they become *impersonal* by being seen in the grayness or blur of images filmed with a shoulder camera, these images suddenly take on a *tear effect* and arouse the experience of something Semprun so honestly calls "a dimension of immoderate, overwhelming reality, that my memories themselves did not reach." The fictive nature of the filmic image—screen, scale, black and white, absence of live sound—is transformed into a dimension of *reality* in the very moment when that which the survivor can witness escapes his own subjectivity to become, in a cinema, the common "property" and "torment." By merely looking at the images—and also thinking intensely about his gaze—Semprun launched himself into his work of testimony and transmission. Pure intimacy, mute or unfigured, "absolute" intimacy, would have transmitted nothing to anyone.

This phenomenology of the dual system of the image thus appears equally well as the description of an *ethical moment of the gaze*: Semprun establishes himself as a witness not with subjective assurance but rather with knowledge to transmit, to put into motion, to share collectively as "property" and as "torment." He moves from the specular system ("I had experienced them") to the distorted system ("without being certain of recognizing them"), then to a renewed questioning of what is nonetheless very familiar to him, since he knows that he saw it with his own eyes. At that moment, he is probably at the optimum distance from the images of Buchenwald: *inhabited* by them as he was once enclosed in the reality that they represent, without being alienated by them (like a pervert, who believes in the total power of his fetish); *distanced* from them, impersonally, without being detached (like a cynic who believes he can forget all his old fears).

The four photographs of Auschwitz present us with a less burdensome responsibility, since we are "survivors" of the camps in an altogether different sense than those who suffered the ordeal; yet it is an analogous responsibility too, on the level of knowledge

and of its transmission. Looking at them, we must neither dismiss them as Wajcman does, nor "believe ourselves to be there" as he thinks I do. Imagination is not identification, and even less hallucination. To approach does not mean to appropriate. These images will never be reassuring *images of oneself*; they will always remain *images of the Other*, harrowing, tearing images as such: but their very otherness demanded that we approach them.

No one, perhaps, has spoken better than Proust of this necessary *disappropriating approach*. When the narrator of *À la recherche du temps perdu* discovers his grandmother from a certain visual angle as a "ghost" suddenly unknown, he describes this, significantly, as looking in the manner of "a photographer who has just taken a picture." What happens then? On the one hand, *the familiar is distorted*: the object looked at, however well known, begins to appear as though "I had never known it before" (and this is quite the opposite of designing one's own tailor-made fetish). On the other hand, *identity is altered*: for an instant, the looking subject, however firm he is in the exercise of observation, loses all spatial and temporal certainty. For this, Proust crafts an unforgettable expression: "that privilege which does not last and in which, during the brief instant of the return, we have the ability to abruptly attend our own absence."[121] And this is quite the opposite of "believing oneself to be there" or "usurping the place of the witness." But to attend one's own absence is not so simple: it asks the gaze to perform a gnoseological, aesthetic, and ethical task, which determines the *readability*—in the sense that Warburg and Benjamin gave to this term[122]—*of the image*.

ARCHIVE-IMAGE OR APPEARANCE-IMAGE

"The historical index of the images not only says that they belong to a particular time; it says, above all, that they attain to legibility [*Lesbarkeit*] only at a particular time. [. . .] The image that is read—which is to say, the image in the now of its recognizability—bears to the highest degree the imprint of the perilous critical moment on which all reading is founded."[1] By attempting to "read" the four photographs from August 1944, we had to produce—by intersecting memories (Hermann Langbein or Primo Levi evoking this exact period), topographical knowledge (according to the archives gathered by Jean-Claude Pressac), contemporary testimonies (Zalmen Gradowski), and retrospective testimonies (Filip Müller) by the members of the *Sonderkommando*—a sort of interpretative montage which, even if woven as tightly as possible, will always have that inherent fragility of the "critical moment."

I don't know whether my two critics took this fragility too much or too little into account. Too little, perhaps, insofar as they do not discuss it from the inside (apart from the question of a "door" and a "window," to which I will return). Or too much, perhaps, since they prefer *no* reading *at all* to a fragile reading *in spite of all*. Elisabeth Pagnoux writes that whatever the case, "horror generates silence: it does not say it, it imposes it. There is nothing to be done, we can say nothing. [. . .] Auschwitz was silence."[2] Thus reading would make something "speak" in an "improper" if not odious manner, something that was meant to remain in its—supposed—originary muteness.

Or else reading "usurps the status of the witness." Dissatisfied with merely filling the silence of the place, it supposedly steals the originary speech of its inhabitant: "The source is lost, speech is

denied."[3] The source is lost? Yet Wajcman criticizes the film *The Last Days* for the absence of documentary contextualization (which I myself would apparently be guilty of abusing): "This degradation concerning archival images seems to go hand in hand with a profound distortion of the value of the witnesses' speech."[4] Speech is denied? This is what would be produced by any "reading" attached to a "disastrous logic" of historical reconstitution, that is, of "evidence" [*preuve*]. New reductions en masse: the search for the *fact-image* is reduced to that of the *evidence-image*, which is immediately reduced to the "logic of negationist thought" itself, in the sense that "the Shoah took place without any evidence, and everyone must know this, without evidence. No one needs evidence, except those who deny the Shoah."[5]

Henceforth the harmfulness of images is characterized from a different angle: the (fantastical) perversion of *fetish* is replaced by the (historical) perversity of *evidence*. It is the image as document, as certificate, as *archive*, that will then embody the "disastrous logic" employed in the analysis of the four photographs of Auschwitz. If, in my critics' respective texts, there is not one specific argument concerning the archive as a "screen" to the truth, it is because this development is presumed to be known: it was undertaken elsewhere. The precise place is designated by the astonishing accusation that the sole object of my analysis—as well as the entire *Mémoire des camps* exhibition—was to entirely "sweep aside" the work done by Claude Lanzmann for his film *Shoah*:

> Do the organizers of the exhibition hope to sweep aside with one stroke the eleven years of work that it took Claude Lanzmann to produce his film *Shoah*? [. . .] Claude Lanzmann chose not to use photography. His film is rooted in a profound reflection on the status of the image, and on the role of the archive in the transmission of the memory of the camps. Surely it is time to try to understand Lanzmann's so-called "iconoclastic" words instead of seeking a pretext to sweep both him and his work aside.[6]

I never attempted, any more than the organizers of the *Mémoire des camps* exhibition did, to "sweep aside" Lanzmann's work. In its

very title, the present book stands as the development of a reflection begun on the subject of *Shoah*.[7] *Shoah* is a film: nine and a half hours of images—at a rate of twenty-four photographs per second—and of sounds, faces, and spoken words. Yet the discourse on this film by my two polemicists turns it into the *unimaginable* itself, the unimaginable embodied as a work of "pure" speech and an "absolute" rejection of the image: "*Shoah* reaches the absolute degree of the spoken word [. . .]. By deciding not to use any archival images, Lanzmann made a choice that exactly reveals his determination: to oppose the absolute silence of horror with absolute speech."[8]

As for Gérard Wajcman, he had invested even more in the unimaginable by claiming that the author of *Shoah* had succeeded in "showing in a film something that no image can show, [since] it shows that there is some Nothingness to be seen, [and that] what this shows is that there is no image."[9] A blinding consequence: "If there is *Shoah*, then there is no image to come."[10] A paradoxical consequence: "One could say that, even without seeing it, the mere existence of Lanzmann's film [. . .] suffices to ensure that every human today is a witness of the Shoah."[11] Even at the height of the humanist cult around *The Divine Comedy*, Dante's exegetes—from Boccaccio right up to Landino and beyond—would never have thought of saying that this poem was not made of words, that after it there would be no more words to come; and that this absolute condition of the poem dispensed with the need to read it, sufficing to make every human a witness of Hell, for example.

[]

It is in any case in Claude Lanzmann's own positions that we should seek to understand why the psychological rejection of the image as *fetish* was reiterated as a historical rejection of the image as *archive*. Let it be noted that all the attacks developed by Elisabeth Pagnoux and Gérard Wajcman over more than sixty pages had been pointed up beforehand in a few lines by Lanzmann himself, in a brief interview given to the French newspaper *Le Monde*: the methodological critique of my analysis had been sealed

in the words "unbearable interpretive mishmash" [*insupportable cuistrerie interprétative*]; the theme of fetishism was already omnipresent; the rejection of archival images, in the name of the testimony, was justified in the brief definition, "They are images without imagination."[12] What Wajcman and Pagnoux *repeated*—in the articles they published in *Les temps modernes*, the journal edited by Claude Lanzmann—against my analysis of the four images of Auschwitz was nothing more than a conscious *repetition* of the theses defended by the filmmaker on the subject of his own conception of image, of archive, and testimony.

The premise of his conception was legitimate—as I have already stressed—before becoming unjustly generalized: "What was at the outset of the film," he explains, "was on the one hand the disappearance of the traces: there is nothing left, it is nothingness, and a film had to be made from this nothingness."[13] The sweeping aside of all archival images became legitimate once Lanzmann had stated that *there were no images* of the specific—extreme—reality to which his film was dedicated: meaning by this, extermination camps such as Chelmno, Majdanek, Sobibor, or Treblinka. This choice, furthermore, was made against a symmetrical situation: *there were too many images* of the concentration camps—such as Bergen-Belsen, Buchenwald, or Dachau—images made confusing by the fact that they were generally used as an iconography of the extermination in the gas chambers. This historically founded choice, both a formal choice and a reflection on documentary cinema, is something to which *Shoah* owes much of its force and its admirable rigor.

But beyond the film itself, the rigor became discourse, then dogma, and finally, rigorism. "I admire those who are peremptory," Lanzmann has written, "those who don't have a single doubt. Those who know everything."[14] As though applying the formula to himself, he has turned a choice into something peremptory, that is, into a choice that generalizes and is therefore wrong, that was legitimate only in the framework of his initial rule. There seem to be two Claude Lanzmanns: on the one hand, the filmmaker of *Shoah*, the great opinionated journalist who questions relentlessly, and does so—at the cost of tragic moments—with the specific,

concrete, precise, unbearable characteristics of the extermination; on the other hand, once the questions have been categorized and stashed away, his "peremptory" side takes over, and he sets about providing answers himself, universal and absolute answers on *all* of the *Shoah*, *all* the archives, *all* the images, *all* the cinema. It is then, of course, that legitimate choices are turned into aberrant rules. It is then that the great art of asking questions becomes a small mastery of imposed answers.

While it is right to claim, as Lanzmann does, that "there is not one single [archival] image of the camps of Belzec, Sobibor, and Chelmno, and practically nothing of Treblinka,"[15] it is wrong to conclude that "there are no images of the Shoah." And it is histori-cally incorrect—regarding our case—to put the case of Auschwitz on the same level as the "disappearance of the traces." While it is legitimate to let the survivors of the extermination speak,[16] it is wrong to conclude that archival images teach us nothing of the "truth," and that attentive questioning of images amounts to no more than a cult of icons: "What is that absurd cult of the archival image? To what idea of evidence (or refutation) of the real does it refer?"[17] Elsewhere, Lanzmann clarifies in the following terms:

> I have always said that archival images are images without imagination. They petrify thought and kill any power of evo-cation. It is much more worthwhile to do what I did, an im-mense work of development, of creation of the memory of the event. My film is a "monument" that is a part of what it monumentalizes, as Gérard Wajcman says. [. . .] To prefer the cinematic archive to the speech of the witnesses, as though the former could do more than the latter, is to surreptitiously reiterate the disqualification of human speech in its destina-tion to the truth.[18]

It is difficult to see why a piece of the real—the archival docu-ment—would so inevitably call for the "refutation" of the real. It is difficult to see why the fact of questioning an archival image could amount so mechanically to the refusal to listen to "human speech." The questioning of the image does not only concern visual exami-nation, what has been called the "scopic drive":[19] it requires the

constant intersection of events, speech, and writing. It is difficult to
see why working on archives should amount to depriving oneself
of a "work of development," quite the contrary: the archive—an
often unorganized mass at the outset—does not become mean-
ingful unless it is patiently developed. This generally demands
more time of a historian than it takes a filmmaker to make a film.

And why would constructing a "monument," as Lanzmann calls
his own work, be equivalent to disqualifying "documents" without
which the monument would be built on a void? Do Lanzmann's
questions in *Shoah* not start more often than not from a profound
knowledge of the history that has emerged from documents them-
selves? Why adopt the tone of "legend"—"this is what permits me
to say that the film is immemorial"[20]—and deny, with the necessary
"legend" of archival photos, a whole field of memory? Lanzmann
openly claims to have created, in eleven years, "a visual work of the
most unrepresentable thing," a work whose authority he has now
been defending for almost twenty years. Can he not imagine, from
his generalized refusal of the photographic document, that Alex—
along with all the members of the *Sonderkommando* engaged in this
collective risk—had hardly more than eleven minutes to make a
visual document of the most unrepresentable thing, and to trans-
mit it as best he could beyond his own imminent death? And that
therefore the "document," however poorly developed, however
poorly "immemorial" and "legendary" it might be, deserves our
attention in return?

What Lanzmann builds around the notion of archive is a gen-
uine embedding of sophisms and excesses. (It is a construction,
too, in which Gérard Wajcman easily finds the authority to relate
any effort toward visual knowledge to Hollywood entertainment
and then to the mindlessness of television). First, the archival im-
age is steered by Lanzmann solely toward the notion of *evidence*:
it is intended not to be known but only to prove, and to prove
that which has no need to be proved. In this sense, it amounts to
a "refutation," that is to say, to *negationism*.[21] The archival image is
then steered toward fiction and *fetishism*, in the form of the Hol-
lywood "lie." Lanzmann is certainly right to criticize Spielberg by
reproaching him—as Godard himself did—for his "reconstruc-

tion" of Auschwitz.[22] But in the process, by an extravagant reason-
ing, he claims that "to reconstruct" is to "manufacture archives."[23]
Thus, the *archive*—whether in connection with a well-intentioned
deceiver (Spielberg) or an ill-intentioned deceiver (Faurisson)—is
no longer distinguishable from its own *falsification*. Regarding the
spectacular abjection inherent to the Hollywood reconstitutions
of Auschwitz, Lanzmann writes indiscriminately of "manufactur-
ing archives" and "manufacturing false archives."[24]

It is less surprising, once he no longer distinguishes in his dis-
course between the historical archive and the falsified archive, that
Claude Lanzmann should have arrived at the famous hypothesis
of the *film maudit* [cursed film]. It was from his pen that this hy-
pothesis flowed, from the extension of his critique of Spielberg, as
though the—quite justified—challenging of Hollywood images
(even if animated by a humanist viewpoint) could bring about the
unjustified destruction of a visual archive from Auschwitz (even if
animated by a Nazi viewpoint):

> Spielberg chose to reconstruct. To reconstruct, in a sense,
> means to manufacture archives. And if I had found an existing
> film—a secret film because it was strictly forbidden—made
> by an SS that showed how three thousand Jews, men, women,
> children, died together in a gas chamber at crematorium II
> at Auschwitz, if I had found that, not only would I not have
> shown it, but I would have destroyed it. I am unable to say
> why. It is obvious.[25]

For those who have read Jorge Semprun's text concerning his
perception of cinematic documents about the camps, it is easy to
understand the polemic that arose later between the two authors:
Semprun challenged Lanzmann's "extreme, fundamentalist formu-
lation"; Lanzmann replied by contrasting the documentary *evidence*
of "images without imagination" with his own "immense chorus
of voices [which in *Shoah*] *attests* to that which was perpetrated."[26]
Since a certain consternation persisted against his "theoretical" bias,
Lanzmann pressed his point by varying his tone. He complained of
not having been heard: "No one wanted to understand."[27] He min-
imized: "I simply wanted to contrast the archive with *Shoah*"[28]—

but doesn't Lanzmann see that he is contrasting a class of historical objects *in general* to a cinematographic work *in particular*, which already constitutes an "excessive" misinterpretation?

The archive, he would claim, communicates nothing but bits of information: as an "image without imagination" it affects neither emotions nor memory and ultimately yields nothing more than exactitudes, never the truth. (I think I now understand, *a contrario*, what Lanzmann called an "interpretive mishmash"—the ability to take emotion and scraps of memory, imagination and scraps of truth, from an archival image.) On the other hand, he says, "*Shoah* is not made to communicate bits of information, but tells everything."[29]

The contradictory argument is eventually replaced by obstinacy and the seal of certainty: "All [those who contest the proposition concerning the "forbidden film"] subscribe to the world of evidence. I have never doubted the reality of the extermination,"[30] writes Lanzmann, as though there were any question, particularly for a survivor of the camps such as Semprun. And elsewhere: "I have never spoken of destroying a document about the gas chambers [. . .], but I would have destroyed it. I added that I did not seek to justify my argument, one cannot go further, it is like the Cartesian *cogito*. One understands or one does not, that is all."[31] I myself would rather say that if we don't understand this "*that is all*," we do understand, *in spite of all*, something of the stakes that motivate this contraction in thought.

It is difficult to understand how an intellectual can openly claim not to justify his argument. Descartes never scorned his interlocutor to the point of leaving him with a statement such as, "One understands or one does not, that is all." I can understand (with Descartes) that doubt can become hyperbolic. I do not understand (except in the domain of mysticism) a hyperbolic certainty, because such certainly is intended not to be understood but to be imposed. This is what happens when Elisabeth Pagnoux writes: "Lanzmann would have destroyed the film for overwhelmingly profound reasons that make *Shoah* an absolute speech."[32] This is what happens with Gérard Wajcman and his continuous imitation of the discourse of the master: "Nothing else. [. . .] That is all. It is the foundation of everything. [. . .] Is there anything else to say?"[33]

This is what happens, finally, when Jean-Jacques Delfour rather desperately attempts to justify Lanzmann by arguing that the archival image offers "a distance, such that killing becomes no more than a piece of information"; that the image, in general, is disqualified because of its "voyeur structure"; that we would be quite right to destroy that "strip filmed by the Nazis because it contains and legitimizes the position of the Nazi; to look at it necessarily implies taking the position of a spectator, exterior to the victims, to therefore adhere cinematically, perceptively, to the Nazi position itself"; and that, in any case, Lanzmann would be justified in destroying any such document "and that he would do it because he filmed *Shoah*, a work of art that is the alternative to that film strip [and therefore makes it] useless."[34] What, then, is to be understood of this so-called *cogito*, except that its hyperbolic certainty is founded on the carte blanche of an "I am, therefore I destroy": "I am the all image [*image toute*] of *Shoah*, therefore I can destroy all the (other) images of the Shoah."

This sounds less like a *cogito* than the *specular passion* of a man for his own work. It is significant that the film strip imagined by Lanzmann in order to establish the authority of his own work— which had no need for any such help—seems like an abstract link, a phantasm that has been tossed between the two photographic sequences of August 1944, that is, between the images of the "before" (the women being led to the gas chambers) and those of the "after" (the incineration pits). Lanzmann therefore blinds himself by speculating on a document that does not exist, for the obscure purpose of not thinking about documents that do exist. He blinds himself above all by rooting his whole discourse—not his film, which he developed in 1985, but the dogmatic certainty he claimed ten or fifteen years later—in an obtuse incomprehension of what constitutes an archive, a testimony, or an act of imagination.

[]

"With history," wrote Michel de Certeau, "you begin by putting aside, gathering, thus transforming into 'documents' certain objects that have been distributed differently. This new cultural distribution is the first task. In reality, it consists in *producing* such

documents by copying, transcribing, or photographing these objects and, in so doing, changing their place and their status."[35] Only a metaphysician would wish to ignore this way of constructing an archive and to claim that "the origin speaks of itself."[36] Only a metaphysician, having accepted this way of constructing, would deduce that the archive is disqualified from it.

If it is necessary today "to redevelop a concept of the archive," as Jacques Derrida invites us to do, it is no doubt because history binds us to a harsh confrontation with the "archives of evil," to which the photographs combined in *Mémoire des camps* gave a particularly demanding visibility. It is also, analogously, because Freud—with whom I would associate Aby Warburg on the anthropological level—made possible "the idea of a hypomnesic archive," or an unconscious archive.[37] But Freud himself perpetually struggled with the different theoretical models that the archive could offer: How should we reconcile the destruction of the traces with the indestructible memory of the destruction (a problem, as we know, that is inherent to all thinking about the Shoah)? How should we interpret, if not translate, the inevitably "idiomatic," almost untransmittable character of the archive? How should we think the immanence of technical support and of the archived message, which is rejected by any metaphysics in the "pure"[38] sense? (Does this explain why Wajcman takes on the medium of photography itself so directly, to preserve the purity of the event, of the origin?)

Indeed, "nothing is less sure, nothing is less clear today than the word 'archive.'"[39] Here is yet another reason to look from up close, physically, instead of dismissing the meticulousness of the attempts at documentary reconstitutions as mere "technicalizing vacuity." In her magnificent phenomenology of the archive, Arlette Farge evokes the excessive amount of materials in "archive depositories," their "difficult materiality," their essentially lacunary nature—"the archive is not a stock from which we draw for pleasure, it is constantly a lack"—and even sometimes, "the impotence of not knowing what to do with it."[40]

You only have to visit a documentation depository once to understand that an archive does not give memory that fixed meaning,

that set image, that Claude Lanzmann sees in it. It is always—tire-lessly—a "history under construction whose outcome is never en-tirely perceptible."[41] Why is that? Because each discovery emerges from it like a *breach in the history conceived*, a provisionally inde-scribable singularity that the researcher will attempt to weave into the fabric of everything he or she already knows, in order to pro-duce, if possible, a *rethought history* of the event in question. "The archive breaks ready-made images," writes Arlette Farge. (Don't the four images of Birkenau also, in their own way, break the ready-made image, the "industrial" or abstract image, of the Nazi criminal organization?)[42] On the one hand, the archive divides up historical understanding through its appearance as a "scrap" or as a "raw trace of lives that asked in no way to be told in this manner." On the other hand, it "brutally opens onto an unknown world," and liberates a quite unpredictable "reality effect" that provides us with a "living sketch" of the interpretation to be reconstituted.[43]

Yet the archive is by no means the pure and simple "reflection" of the event, nor its pure and simple "evidence." For it must always be developed by repeated cross-checkings and by *montage* with other archives. One must neither overestimate the "immediate" character of the archive nor underestimate it as a simple accident of historical knowledge. The archive always demands to be con-structed, but is always the "witness" of something, as Arlette Farge says, emphasizing its appearance as a "sound-memory"; Aby War-burg, at the very beginning of the twentieth century, spoke of the timbre of "inaudible voices," which the archive of the Florentine *ricordanze* brought to his mind.[44] So we should not be surprised that film with sound—the filmed archive of a trial, for example—can contribute profoundly to a historical understanding of the "grain" or even the "phrasing" of an event:

> Robert Badinter.—I have a question to ask you. When you look at the recordings which, necessarily, are very limited, since they represent only five minutes of a very long trial, in-evitably containing both very strong moments and dull mo-ments, do you have the feeling that you are approaching the atmosphere of a trial?

> Annette Wieviorka.—Of course. [. . .] The image gives us access to a theatrical dimension of the trial, and to the tonality of the voices. To hear, for example, Papon's lawyer is something quite different from reading what he writes. There are a certain number of elements that are inestimable in an image and that writing cannot recreate.[45]

As such, the collection of testimonies brought together in *Shoah* form an *archive*, even if this "form" is presented to us as a *work* [*oeuvre*] in the full sense of the term. Moreover, it is how historians have sought to understand this film: "the film in which one single *document* is presented to us," as Pierre Vidal-Naquet wrote; the film that has succeeded in "creating [its] own basis of *sources*," as Raul Hilberg wrote in turn.[46] *Shoah* is a great documentary film: it would therefore be absurd to contrast it with a "monument" or a "document" (and we can well imagine how present or future historians may benefit from this immense "archive of speech" made up of some 350 hours of film rushes).

Whether made up of images or speech, the archive cannot be reduced to a "manufacture" or an *appearance*, as Claude Lanzmann sees it in his polemical texts. By repudiating the archival image— not only a priori, as material for his particular film, but, above all, a posteriori, as material for all research into the historical truth of the Shoah in general—the filmmaker subscribes, to a greater or lesser degree, to a line of thought that has radicalized the critical perspectives opened, in the discourse of history, by Michel Foucault and Michel de Certeau. Both of these men have taught us a thing or two, so to speak, about the first certainty of a positivist historian: they showed that an archive is in no way the immediate reflection of the real but is a writing endowed with syntax (we might think, in the case of the photographs of Auschwitz, of the constraints imposed by the frame or the angle) and with ideology (the four photographs are not the "pure reflection" of the real of Auschwitz in general but, rather, its specific, material, and intentional trace: an act of resistance against the real itself that a member of the *Sonderkommando* records partially, according to his *vantage point* and at a precise moment).

We also had to understand—after Warburg, Marc Bloch, and Walter Benjamin—that the *source* is never a "pure" point of origin but an already stratified time, already complex (as is clearly demonstrated by the sequential nature of the four images of Auschwitz, outside of the fact that they themselves are part of a larger series of testimonies left by the members of the *Sonderkommando*). We finally had to understand that history is constructed around perpetually questioned *lacunae*, which are never fully compensated for (like the "mass of black" in the photographs or like the difficulty of reconstituting the time that elapsed *between* the four images). Whatever the case, a healthy *doubt* arises regarding the links between the historical "real" and the historian's "writing." Must we therefore expel "all of the real" from the archive? Certainly not. Pierre Vidal-Naquet's firmness on this point would be equaled only by his engagement in the fight against the "murderers of memory": for the historian does not escape the responsibility of distinguishing an archive from its falsification or fictional "manufacture."[47] It is strictly unacceptable to all thinking about history—even aesthetic thinking about history—that the same kind of doubt should be cast on both the *set* (that of Hollywood fiction) and the *place* (that of the four photographs of Auschwitz or of the supposed *film maudit*).

Not only is this historiographical debate not closed, but it is still regularly focused on the extreme question—which not does mean the "absolute" question—of the Shoah. It is no coincidence that a colloquium a few years back on the *limits of representation* should have engaged Carlo Ginzburg in a vehement and salutary clarification of the "radical skepticism" formulated by Hayden White or, differently, by Jean-François Lyotard.[48] Between the excesses of positivism and the excesses of skepticism, one must, according to Ginzburg, constantly relearn to "read testimonies"; one must not be afraid to test the "tensions between narration and documentary," to see in sources "neither open windows, as the positivists think, nor walls obstructing sight, as the skeptics claim."[49]

The dialectical balance between these two errors is situated, according to Ginzburg, in an *experience of evidence*, or *proof* [*preuve*].[50] It is important that in this context our polemicists grasp the mean-

ing of the French word *preuve*—close to the word *épreuve* [ordeal,
trial; printer's proof], and, in Italian, close to the French word *essai*
[attempt, trial, essay]:

> The language of evidence or proof is that of all those who
> submit the materials of research to an incessant checking
> (*Provando e riprovendo* was the motto of the Accademia del
> Cimento in Florence, in the seventeenth century). [. . .] It is
> a matter of feeling one's way along, like the violin maker who
> delicately taps the wood of the instrument, an image that
> Marc Bloch contrasted to the mechanical perfection of the
> lathe, emphasizing the artisan component, which is impos-
> sible to eliminate in the work of the historian.[51]

It is therefore absurd to claim to relate "the logic of *evidence* or
proof" to that of "negationist thinking."[52] The latter is a process of
falsification, while the former is a process of *verification*. The nega-
tionist Udo Walendy one day claimed to have found "proof" that
a famous photograph showing an orchestra at Mauthausen was a
fake; the response was not to let him keep his "proof" and his "ab-
solute certainty" but, instead, on the one hand to show that he fal-
sified the elements of his argumentation and, on the other hand, to
double-check the document itself—to deepen the "reading"—by
research into and cross-checking of the survivors' testimonies.[53]

[]

This one example reveals the inanity of a reasoning that would
force a contrast between *archive* and *testimony*, between an "image
without imagination" and the "speech of the unimaginable," be-
tween evidence and truth, between a historical document and an
immemorial monument. Lanzmann's film certainly brings the no-
tion of testimony to a genuine incandescence, to an intensity—an
overwhelming precision—of living speech that the historian can
no longer confine to the background of the written archives of
the Shoah.[54] But this is not a reason to *make testimony absolute*, as
Elisabeth Pagnoux did by invoking "absolute speech," or as Gérard

Wajcman did by invoking "true speech [. . .], universal Truth addressed, in the present of the immemorial, to universal Subjects."[55]

Even less does it offer an excuse for *disqualifying the archive* or for deducing from the testimony itself that "the idea of a visual document on the Shoah is ruled out."[56] The heart of history and the heart of speech have nothing to do with the great ontological capital letters, the "absolutes" or the "universal truths": it is not with the word "absolute"—that discursive fetish—that one can do justice to the extremity of such a history. Characteristically, one of the most beautiful works of *testimony* ever written about Auschwitz—I am thinking of Primo Levi's *Se questo è un uomo* (If This Is a Man)—begins modestly, far from any monumental immemoriality, with a *documentary-style*, psychological, and therefore relative proposition: "I have not written with the intention of making new charges, but rather to provide documents for a dispassionate study of certain aspects of the human soul."[57]

The testimonies of the Shoah entail a painful paradox, which we will take into account only in order to reintroduce the *historical* singularities into the *theoretical* thinking of the phenomenon. On the one hand, the witnesses themselves use up all their energies by attempting to tell, to pass on, to make something understood (Primo Levi, as we know, devoted his whole life to this endeavor).[58] That is, to offer to the community—or to the "common measure" of human language—words for their experience, however defective or disjointed such words might be with respect to the experienced real. "It is a matter of telling the truth such as it can be transmitted from one man to another, of reestablishing the mediating function of language," writes Renaud Dulong in his book on "the eyewitness" (*Le témoin oculaire*).[59]

When, on the other hand, philosophical reflection makes absolute—in order to conceptualize—this disjunction and this flaw inherent in the testimony, we find configurations in which the narrative purity and the visual remains are abolished in order to guarantee a "purer," more universal idea of the paradoxes in question. Hence we disdain what is most precious in the testimony *in spite of any* flaws and *in spite of any* disjunction: in other words, we

disdain the remains themselves, those *vestiges* in which the flaw is both pronounced (since the vestige presupposes, even signifies, destruction) and contradicted (since the vestige resists, survives, destruction). We know of at least three versions of testimony as the absolute and "sublime" excess of human speech: the *différend*, according to Jean-François Lyotard, establishes the impossibility of a fair exchange of arguments in a conflict over testimony.[60] The *pure silence*, according to Giorgio Agamben, establishes the impossibility of speech for the "integral" testimony of the extermination, for such testimony can come only from the *Muselmann*, the extreme—and mute—figure of the "drowned" of whom Primo Levi spoke.[61]

The third version is that of *absolute speech*, which Claude Lanzmann claimed for his film *Shoah*. It is what makes Gérard Wajcman say: "Either we know all, or else we deny." It takes for granted the impossibility of an extended question, of an "image to come." It erects its own archive in the form of an impassable monument, at the end of history. Worse, it disqualifies other archives and reduces them to documents that will always lack truth. This hierarchy ignores the necessity of a *dialectical approach* capable of handling both speech and silence, both flaw and remains, both the *impossible* and the *in spite of all*, both testimony and archive:

> History's memory cannot ignore, beside "objective" documents, the irreplaceable experience of witnesses, of those who lived through the event. By accomplishing their duty to memory, these witnesses could not, for their part, ignore the demand for truth that is at the heart of the historian's work; it is on this *dual condition* that social memory will be able to do its work of reconnecting with the past, by avoiding mythology without falling into oblivion.[62]

The "dual condition" of which Jean-Pierre Vernant speaks is complicated here by a dual difficulty inherent to the phenomena of the extermination. If I so frequently emphasize the expression *in spite of all*, it is because each existing scrap—of images, speech, or writings—is snatched from a mass of *impossibility*. To bear witness is to

tell *in spite of all* that which it is *impossible* to tell entirely. The impossible is doubled when the difficulty of telling is compounded by the difficulty of being heard.[63] The desperate situation of the four images of Auschwitz—produced at the cost of considerable risks, extracted from the camps but never transmitted "to the outside," beyond Poland—resembles the fate of the testimonies gathered by the resistance fighters in the Warsaw ghetto: composed and transmitted, these accounts were not listened to by the very people who could hear them:

> The description of the massacre at Chelmno is distributed in several dozen copies in the ghetto. We are quickly putting together a report for abroad, asking among other things that reprisals be taken against the German civilian population. But abroad, no one believes either. Our call remains unanswered even though, in a radio transmission addressed to the whole world, the actual text of our message was read in London by comrade Artur Zygielbojm, the representative from our National Council.[64]

The only ethical position, in this frightening trap of history, consisted in resisting *in spite of all* the forces of the *impossible*: to create *in spite of all* the *possibility* of a testimony. The *Muselmann* of the concentration camps and the person in full health taken from a train and exterminated fifteen minutes later are both caught in the grip of the impossible, the grip of speech killed: it is impossible, indeed, to bear witness *from the inside* of death.[65] As for those who were living and could use speech, either they didn't wish to (the Nazis in the camp), or they were unable to and couldn't bear witness *to anything*.[66] Between these two extreme positions—since history always holds more possibilities than binary thought will offer it—is what we may call a third position. It is no less extreme, such is its incomparable force. It is the testimony formulated and transmitted *in spite of all* by the members of the *Sonderkommando*.

I refer here to a very specific situation: not that of the survivors who, after the war, snatched from the years of silence an all the more harrowing testimony,[67] but to that of the members of the

Sonderkommando at the very heart of their hideous, devastating la-
bor, their imminent death. The members of the *Sonderkommando*,
as we know, were *living beings in spite of all*, very provisional survi-
vors: their testimonies, produced in secret and hidden wherever
possible within the perimeter of the camp, formed therefore the
testimonies in spite of all—and the only products by the victims—
from the inside of the machine of extermination, what I have called
the eye of the cyclone, the "eye of history."

> In a few weeks, the *Sonderkommando* will be no more. We will
> all perish here and we know it very well. We are already used
> to this thought, for we know that there is no way of escaping
> it. Yet something worries me. Eleven *Sonderkommandos* have
> died here and have revealed, with their last breath, the hor-
> rifying secret of the crematoria and the pyres. Even if we do
> not survive, it is our obligation to make sure that the world
> learns of the cruelty and baseness—unimaginable for a nor-
> mal brain—of this people that claims to be superior.
> A message must be addressed to the world from here.
> Whether it be found soon or in several years, it will always be
> a terrible accusation. This message will be signed by the two
> hundred men of the *Sonderkommando* of Crematorium I, fully
> conscious of their imminent death [. . .]. The message has been
> carefully prepared. It describes in great detail the horrors that
> have been committed here these last years. The names of the
> executioners of the camps appear. We publish the approxi-
> mate number of people exterminated, describing the manner,
> the methods, and the instruments used in this extermination.
> The message has been written on three large parchment pages.
> The writer-editor of the *Sonderkommando*—a former artist
> from Paris—has copied it in beautiful calligraphy according
> to the style of old parchments, in India ink so that the writing
> does not fade. The fourth page contains the signatures of two
> hundred men of the *Sonderkommando*. The parchment pages
> have been attached with a silk thread, rolled, enclosed in a
> cylindrical zinc box, specially made by one of our tinsmiths,
> and finally sealed and welded to be protected from the air and

humidity. This box has been left by the carpenters between
the springs of the ottoman in the wool of the padding.
 Another identical message has been buried in the yard of
crematorium II.[68]

In these conditions, the testimony is no longer even a "matter of
life or death" for the witness himself: it is simply a matter of death
for the witness and eventual survival for his testimony. By relating
any logic of testimony to the mechanism of *Shoah*, Gérard Wajcman
has accepted a unilateral identification of the witness with the sur-
vivor.[69] Furthermore, Elisabeth Pagnoux feels morally obfuscated
that the testimonies should survive the witnesses.[70] Yet the victims
themselves, in the ghettos as in the camps, were perfectly aware of
this situation. What could they do, then, but *build up archives* that
had a chance of survival—hidden, buried, disseminated—beyond
the extermination of the witnesses themselves?

> Everyone wrote [. . .]. Journalists and writers, this stands to
> reason, but also schoolteachers, social workers, young people,
> and children. Most of the writings were diaries, in which the
> tragic events of this period were caught in the prism of per-
> sonal experience. These writings were innumerable, but the
> majority of them were destroyed at the time of the extermina-
> tion of the Warsaw Jews.[71]

In Auschwitz, things were the same as in the Warsaw ghetto, except
that the members of the *Sonderkommando* were practically alone—
because of the "privileges" accorded them by their work—in being
able to build up this kind of archive. Many of them recorded the
facts, wrote the lists, drew the maps, and described the process of
the extermination. But very few of these testimonies were found,
in large part because after the war the Polish peasants, persuaded
that these fields of death contained the "treasures" of the Jews, pil-
laged the camps and destroyed everything that did not seem valu-
able. (The calligraphy parchments that Miklos Nyiszli mentions
have not been found.) What was found at least, under the earth
in Birkenau, were manuscripts by five members of the *Sonderkom-
mando*: by Haïm Herman (in French, discovered in February 1945),

Zalmen Gradowski (in Yiddish, discovered in March 1945), Leib
Langfus (in Yiddish, two texts discovered in April 1945 and April
1952), Zalmen Lewental (in Yiddish, two texts discovered in July
1961 and October 1962), and Marcel Nadsari (Greek, discovered in
October 1980). They form what is called—with reference to the
megilot of the Hebrew Bible, the scrolls of the "Lamentations of
Jeremiah" in particular—the *Scrolls of Auschwitz*.[72]

Writing of the disaster, writing of the epicenter, the *Scrolls of
Auschwitz* constitute the testimonies of the drowned who were not
yet reduced to silence, who were still capable of observing and of
describing. Their authors "lived closer to the epicenter of the ca-
tastrophe than any other prisoner. [They] were present, day after
day, at the destruction of their own people, and were aware, in its
global scale, of the process to which the victims were doomed."[73]
Their whole effort was to *transmit the knowledge* of such a process
as far as they possibly could. A knowledge that would have to be
searched for in the blood-soaked earth, in the ashes, and in the
heaps of bones in which the members of the *Sonderkommando* dis-
seminated their testimonies in order to give them some chance of
surviving:

> The notebook and other texts remained in the pits soaked
> with blood as well as bones and flesh often not fully burned.
> These we could recognize from the smell. Dear finder, look
> everywhere in every parcel of earth. Underneath are buried
> dozens of documents, mine and those of other people, which
> cast light on what happened here. Numerous teeth have been
> buried. It was we, the workers of the *Kommando*, who deliber-
> ately dispersed them around the terrain as much as we could,
> so that the world might find tangible evidence of the millions
> of murdered human beings. As for us, we have lost all hope of
> surviving until the Liberation.[74]

> We will continue to do what is imposed upon us. We will [try]
> everything and hide [for?] the world, but simply hide in the
> ground, and in [*lacuna*]. But anyone wanting to find [*lacuna*]
> more, you will find more [*lacuna*] the yard, behind the crema-
> torium, not near the road [*lacuna*] on the other side, you will

find much there [*lacuna*] because we must, as we have until
now, until [*lacuna*] event [*lacuna*] continually make all known
to the world by means of a historical chronicle. From now on,
we will hide everything in the ground.[75]

I ask that all of my various descriptions and notes, buried and
in their time signed Y.A.R.A., be collected. They are found in
different containers and boxes, in the yard of crematorium II.
There are also two longer descriptions: one, entitled *Depor-
tation*, is found in the bone pits of crematorium I; the other
entitled *Auschwitz*, is found under a pile of bones, southwest
of the same yard. After that, I rewrote it, completed it, and
reinterred it separately among the ashes of crematorium II. I
wish them to be put in order and printed together under the
title *In the Horror of the Atrocities*. We, the 170 men remaining,
are about to leave for the sauna. We are sure that we are be-
ing brought to our deaths. They have chosen thirty men to
remain at crematorium IV.[76]

Reading the *Scrolls of Auschwitz*, we realize that they form only
a small vestige of an intense activity of testimony. The texts are
obsessed by multiplication. Since he had to give an idea of a phe-
nomenon that was unimaginable in its magnitude—the organized
extermination of millions of people—Zalmen Gradowski, in the
second of his manuscripts (which as early as 1945 was sold by a
young Polish man to Haïm Wollnerman), warns his reader: "I am
only giving you a minuscule part, a minimum of what happened
in this hell of Auschwitz-Birkenau."[77] Thus, the multiplication of
the testimony sought, as far as possible—that is, desperately—to
answer to the multiplication of the crime: "I have written many
other things. I believe you will surely find the traces, and from all
of that you will be able to imagine how the children of our people
were killed."[78]

Multiplying the testimony must first be understood quantita-
tively: every means possible must be found for *reproducibility*—for
example, by tirelessly copying the facts, the lists, the names, the
maps, and by dispersing these copies everywhere "under the ashes"
of the camp. But it can also be understood qualitatively: *traces of*

all kinds were to be called upon to bear witness to the terrible mas-
sacre. Not only texts—in a wide range of forms, fragmentary or
systematic, literary or factual—but also physical remains, teeth for
example, were "sown" everywhere so that one day the earth itself
could bear witness, archeologically, to what had happened there.

It seemed logical in any case—and useful, and valuable—for
the *image* to be called upon in this great range of traces, signs, and
signals to be emitted from the "heart of hell." In 1945, another sur-
vivor of the *Sonderkommando*, Alter Foincilber, averred in a state-
ment for the Krakow trial that he had buried a camera—contain-
ing, in all probability, some undeveloped photos—with other
types of *vestiges* of the extermination:

> I have buried, in the terrain of the Birkenau camp near the
> crematoria, a camera, the remains of the gas in a metal box,
> and notes in Yiddish on the number of people who had ar-
> rived in the convoys and were sent to be gassed. I remember
> the exact location of these objects and I can show them at any
> moment.[79]

The photographic scroll of August 1944 participates directly in
this attempt to broaden the channels—and the voices—of testi-
mony.[80] Is it not, from then on, absurd to forcefully contrast *image*
with *testimony*? Is it not obvious that the photographs of Birke-
nau are other "minuscule parts"—as Gradowski said of his own
writings—of what happened, and that, cross-checked against and
combined with all the rest, they allow us, perhaps incompletely,
to "represent [in our own mind] how the children of our people
were killed"? Is it not probable that photography, by its very re-
producibility, might have fulfilled the expectation of anxious wit-
nesses to maximize the copies of the testimonies? Should we not
note a troubling complementarity between the photograph of the
women walking toward the gas chamber (figs. 5 and 9) and Gra-
dowski's narratives —but also Leib Langfus's—this particularly
ignoble phase of the criminal process?[81] Should we not acknowl-
edge that these narratives allow us—even if they don't give us a
"key"—to take a better look at the four archival photos, to *read*

them better in Benjamin's sense, just as they allow us to better *picture* for ourselves what the narratives, attempting the impossible, strive to describe?

[]

How, then, can anyone persist in the bankrupt notion of an archival image defined as an "image without imagination"? Having been mistaken on the nature of the archive in general (which he discredits to the point of seeing it as *only appearance*) as well as the nature of the testimony in general (which he emphasizes to the point of seeing it as *nothing but the truth*), Claude Lanzmann is mistaken about the nature of the image and of the imagination. The four photographs of Auschwitz appear to him to be "without imagination" insofar as they carry, according to him, only limited, dry, documentary information, without the value of testimony, emotion, or memory. To attempt to draw "imagination" from these images would be a forced effort amounting to "voyeurism," "fetishism," or, in the vocabulary of Gérard Wajcman, "hallucination." Images *without imagination*, according to Lanzmann: psychically sterile — hence sterile with respect to memory. Images calling for *too much imagination*, according to Wajcman: psychically pregnant with delirium, because the image will always be an "alienating illusion," the illusion of basing belief on "a tiny 'deduction' [. . .], of mentally recreating *all* of the crime"[82] of the Shoah (which, of course, I never claimed to do).

Between these two radical critiques of the image, we are between the *nothing* of the "image without imagination" and the *all* of the "call to hallucinate." Must we repeat that the image is neither *nothing* nor *all*? And that, being in no way absolute, it is no less that impurity necessary to knowledge, to memory, and even to thought in general? "To know, we must *imagine*," I said, which shocked Wajcman, who reacted in the name of "all of philosophy, backed on this point by psychoanalysis."[83] Yet all I attempted to do was to recall, against the trivial Platonism of the illusion-image, the classic Aristotelian position, experimental rather than ideal-

ist, which holds that "since there is, as it is thought, no separable thing apart from perceptible sizes, the objects of thought are in the forms that are perceived [. . .]. This is also [. . .] why it is necessary that, whenever one is contemplating, it is some image that one is contemplating."[84]

Where does Lanzmann derive the strange notion of *image without imagination*, as though the image were supposed to contain—or could not in this case—the imagination that arouses it, or that it arouses? How can an object possess, once and for all, all of the characteristics of the gaze that is cast upon it and the understanding that we take from it? The archival image is merely an object in my hands, an indecipherable and insignificant photographic printing so long as I have not established the relation—the imaginative and speculative relation—between what I see here and what I know from elsewhere.

One would be tempted to seek in the work of Jean-Paul Sartre—to whom Lanzmann was close—a justification for the notions of image and imagination. But we find the contrary. Far from making any appeal to the unimaginable, Sartre actually insisted on the role of the image in thought and in knowledge, which somehow cannot do without *the sight of an object*:

> Always ready to get stuck into the materiality of the image, thought escapes by sinking into another image, from this one into another, and so on. [. . .] It would be absurd to say that an image can harm or hinder thought, or else one would have to infer that thought harms itself, loses itself in meanderings and detours. [. . .] Thought takes an imaged form when it seeks to be intuitive, when it seeks to found its affirmations on the sight of an object.[85]

The whole Sartrean reevaluation of the imagination entails the hypothesis according to which the object is no more in the image than the image is a diminished object or a "lesser thing."[86] When Elisabeth Pagnoux and Gérard Wajcman estimate that *to look* at an image of Auschwitz already amounts to believing oneself to be in it, they confuse what Sartre is very careful to distinguish: *imagina-*

tion (to lose oneself in the image) cannot be reduced to *false percep-tion* (to deceive oneself about the real). Why is that? Because if the object is not *in* the image (what Wajcman believes that I believe), the object is aimed at *by* the image (what Sartre theorizes from the notion of intentionality).[87] To affirm, against the thesis of the unimaginable, that there are images of the Shoah is not to claim that "all of the real is solvable in the visible" or that *all* of the Nazi crime is found *in* four photographs. It is to discover, more simply, that we can aim with a little more precision, *through* these images, at *one* reality of Auschwitz in August 1944. It is with this *intention* that the members of the *Sonderkommando* took so many risks to transmit to us this kind of possibility of *imagination*.

To speak of an image without imagination means literally to cut the image off from its activity, from its dynamics. It is clear that of the exhausting mass of visible things that surround us, not all deserve the time it would take us to decipher their dynamics. But this is precisely not the case with the four images of Birkenau. To refuse them our historical imagination is the same as demoting them to an insignificant zone of imagery and "lesser things." If "the image is an act and not a thing," Jean-Paul Sartre observed,[88] it is as an *act* and not as a "lesser thing"—a mere container of infor-mation—that these four images were to be looked at. Hence, the necessity to unfold their phenomenology as much as possible.

It is a phenomenology not of *perception* strictly speaking, but, says Sartre, of a *quasi observation* of the world.[89] To look at an im-age and to think one is directly perceiving the objects of reality that are represented there—or even, in the case of photography, recorded there—would be, for example, to try to walk around the cloud of smoke, in the first sequence, so as to "see what there is behind" (figs. 3–4). This is as absurd as it is impossible, and it is certainly not in this way that we should look at an image. But attention to the viewpoint produced, to the grain of the image, to the traces of movement, can all be put to work in articulating the *observation* of the image itself in the *quasi observation* of the events that it represents. This quasi observation, both lacunary and frag-ile in itself, will become *interpretation*, or "reading" in Walter Ben-

jamin's sense, when all the elements of knowledge susceptible of being assembled by historical *imagination* —written documents, contemporary testimonies, other visual sources—are convoked in a kind of montage or puzzle that Freud might describe as "construction in the analysis."

By qualifying my attempt as "voyeuristic," "fetishistic" or "hallucinatory," are my critics suggesting that the four photographs document a *different reality* from the one I have invoked? Claude Lanzmann casts the most radical doubt on the idea that "these photos [figs. 3–4] were taken from inside a gas chamber": "Nothing allows them to claim this. No one knows."[90] Elisabeth Pagnoux adds, without going much further: "A photo of the interior. Is it absolutely certain? I am asking a simple question."[91] Gérard Wajcman is more specific:

> But the image of what? In the four photographs Georges Didi-Huberman suddenly gives extreme importance to the black frame of the wall around the window against the daylight through which the photos were taken. [. . .] This mass of black becomes "the visible certification" of the place from which they were taken, the gas chamber north of crematorium V, according to Georges Didi-Huberman, [whereas] we should regard it as a hypothesis, for nothing assures us that this is indeed the gas chamber.[92]

Let us certainly "regard it as a hypothesis": we should beware of being peremptory. But let us also take a look: the two photographs in this sequence (figs. 3–4) incontestably show us the incineration pits in the spring of 1944, dug for the purpose of managing the intensive extermination of the Hungarian Jews. These pits, mentioned by all the witnesses, are even visible in the aerial photographs taken by American airmen in June 1944.[93] Their location having been corroborated, the two photographs by the *Sonderkommando* cannot logically have been taken from anywhere else but the north wall of crematorium V. Where Wajcman sees a window (to avoid, at all costs, the hypothesis of images taken from a gas chamber), I saw—and I still see, by allowing the viewpoints of the two photos to play off each other—a door. How do

we come to a decision, on the basis of only these photos, that is, on the basis of a *quasi observation*?

It is here that Jean-Claude Pressac's archeological meticulousness seems to have given the most plausible solution so far, supported furthermore by the testimony of David Szmulewski, one of the rare survivors—along with Alter Foincilber and Szlomo Dragon—of the whole operation. The photographs must indeed have been taken from inside the door, in the second gas chamber of crematorium V (fig. 13). Pressac went so far as to take an "experimental" photograph with the intention of finding, in the actual ruins of crematorium V, the exact angle of view of the images taken in August 1944.[94] We would, of course, never say that his thesis "is unrevisable" (and we will, besides, "revise" it a little in a moment). However, to invalidate that thesis would require finding another, even more solidly substantiated by historical facts, testimonies, and the configuration of the places and of the images themselves.

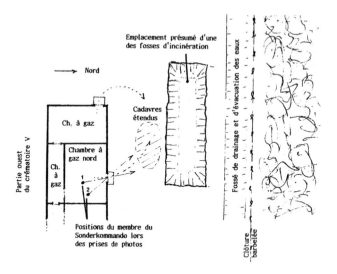

Figure 13. Plan for reconstitution of the locations occupied by the *Sonderkommando* in their attempt to take two photos of the incineration pits in August 1944. From J.-C. Pressac, *Auschwitz: Technique and Operation of the Gas Chambers* (New York: Beate Klarfeld Foundation 1989), 422.

By simply looking through the catalogue of the *Mémoire des camps* exhibition, Gérard Wajcman might have noticed that the two sequences from August 1944 were so little "fetishized"—which would suppose them fixed once and for all as the response of the *visible* to the *lack*—that they are the objects, in reality, of two different readings, founded on two approaches to the *visual lacunae* inherent to this "piece of film."

During his research at the Auschwitz museum, while studying the "original" document—that is, the four contact prints, the negatives of which are lost—Clément Chéroux noticed around the edge of one of the photos (fig. 3) the *remains of an image*, so to speak. These "remains" are easily recognizable: we can see the tree trunk and the leaves visible on one of the other photos (fig. 5). Chéroux deduced from this that the order of the two sequences needs be reversed: Alex would first of all have taken the two exterior views, among the trees, before returning to the north gas chamber and taking his two photos of the incineration pits[95] (figs. 14–17). For my part, I have decided to maintain the chronology suggested to Pressac in the testimony of David Szmulewski. But the "edge of the image" is incontestable: to maintain the chronology of the testimony would suppose that the contact prints of the Auschwitz museum were produced from an *inverted negative*, a lack of technical attention all the more banal since the films in this format carry no single permanent inscription allowing us to distinguish between the obverse and the inverse of the negative. If such was the case, it would then be necessary—while keeping this chronology—*to reverse the photos* that we are shown in the prints conserved at Auschwitz (figs. 18–21).[96]

The question, then, remains open. Is the *margin of image* questioned by Clément Chéroux not emblematic of the *margin of indetermination* with which all research is confronted necessarily in its study of the *vestiges of history*? We cannot close the question by projecting all of history into an unimaginable absolute. We cannot close it by casting the archive aside as a "lesser image" or an "image without imagination." An image without imagination is quite simply an image that one didn't spend the time to work on. For imagination is work: that *work time of images* acting ceaselessly

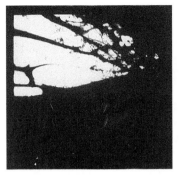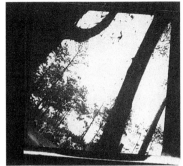

Figures 14–15. Anonymous (member of the *Sonderkommando* of Auschwitz).
Women being pushed toward the gas chamber at crematorium V of Auschwitz,
August 1944. Oswiecim, Auschwitz-Birkenau State Museum (negative nos.
282–283). As reproduced in *Mémoire des camps*, 88. (Compare figs. 5–6 above.)

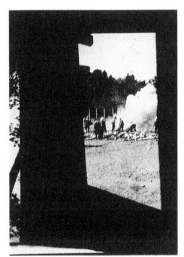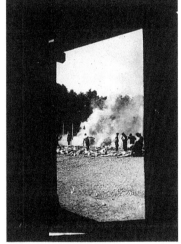

Figures 16–17. Anonymous (member of the *Sonderkommando* of Auschwitz).
Cremation of gassed bodies in the open-air incineration pits in front of
the gas chamber of crematorium V of Auschwitz, August 1944. Oswiecim,
Auschwitz-Birkenau State Museum (negative nos. 277–278). As reproduced
in *Mémoire des camps*, 89. (Compare figs. 3–4 above.)

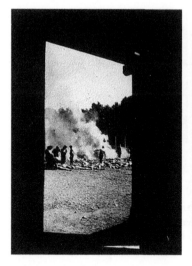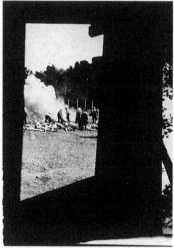

Figures 18–19. Anonymous (member of the *Sonderkommando* of Auschwitz). Cremation of gassed bodies in the open-air incineration pits in front of the gas chamber of crematorium V of Auschwitz, August 1944. Oswiecim, Auschwitz-Birkenau State Museum (negative nos. 277–278, reversed). (Compare figs. 3–4 above.)

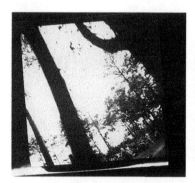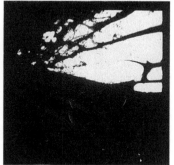

Figures 20–21. Anonymous (member of the *Sonderkommando* of Auschwitz). Women being pushed toward the gas chamber at crematorium V of Auschwitz, August 1944. Oswiecim, Auschwitz-Birkenau State Museum (negative nos. 282–283, reversed). (Compare figs. 5–6 above.)

one upon the other by collision or fusion, by ruptures or meta-morphoses—all of these acting on our own activity of knowledge and thought. To know, one must therefore *imagine for oneself*: the speculative *work table* does not go without an imaginative *montage table*.

MONTAGE-IMAGE OR LIE-IMAGE

Yet, why a montage? We use the term "montage" for two reasons. First, because the simple "shred of film" extracted from Birkenau by the members of the *Sonderkommando* presented not one but four images, each distributed according to a temporal discontinuity: two sequences, from one end to the other, showing two distinct moments of the same process of extermination. Second, because the "readability" of these images—and thus their potential role in providing knowledge of the process in question—can only be constructed by making them resonate with, and showing their difference from, other sources, other images, and other testimonies. The knowledge value could not be intrinsic to one image alone, any more than imagination might consist in passively enfolding oneself in a single image. On the contrary, it is a question of putting the multiple in motion, isolating nothing, showing the hiatuses and the analogies, the indeterminations and the overdeterminations.

Imagination is not a withdrawal to the mirages of a single reflection, as is too often thought. It is instead a construction and a montage of various forms placed in correspondence with one another. This is why, far from being an artist's privilege or a purely subjectivist recognition, it is an integral part of knowledge in its most fertile, albeit most daring, movement. Its heuristic value is incomparable: we have seen it in Baudelaire—and his definition of the imagination as a "scientific faculty" for perceiving "the intimate and secret relations between things, their correspondences and analogies"[1]—right up to the structuralism of Lévi-Strauss.[2] Warburg and his *Mnemosyne* atlas, Walter Benjamin and his *Arcades Project*, or Georges Bataille and his journal *Documents*, among

other examples, have shown the fertility of *knowledge through montage*: a delicate knowledge—like everything concerning images—at the same time bristling with traps and laced with treasures. Knowledge of this kind demands perpetual tact. It allows us neither to quarantine each image nor to place everything on the same level—such as we saw in a 2002 visual, *Album of the Shoah*, which reduced the sequence of August 1944 to a single image, framed and inserted into a jumble of photographed models, scenes, "virtual" reconstitutions, and graphic manipulations in which the document is quite simply disfigured, despised, severed from its phenomenology at the very moment of pretending to give a synthetic representation of the event.[3]

Montage is valuable only when it doesn't hasten to conclude or to close: it is valuable when it opens up our apprehension of history and makes it more complex, not when it falsely schematizes; when it gives us access to the *singularities* of time and hence to its essential *multiplicity*. In quite the opposite direction, Gérard Wajcman seeks to subsume the multiplicity in a totality; but since it is impossible—and for good reason, for this is the domain par excellence of "nontotalities"—he rejects the singularities as little more than a *nonentity*: if "*all* of the real is not solvable in the visible," according to him, then "there are *no* images of the Shoah." We must respond to this conceptual brutality by pointing out that the image is neither *nothing*, nor *one*, nor *all*, precisely because it offers multiple singularities always susceptible to differences, or (to borrow Jacques Derrida's coinage) to "*différances*." Beyond the model of the graphic or cinematographic process as such, we ought to conceive of montage as doing for the field of images what signifying difference did for the field of language in the post-Saussurian conception.[4]

The image is not nothing. And to seek to eradicate images from all historical knowledge under the pretext that they are never adequate is not proof of "radicality." Radicality is a matter of roots, that is to say, of impurities, rhizomes, radicles, subterranean infiltrations, unexpected repercussions, and bifurcations. Gérard Wajcman is so afraid of being hypnotized by the image (which is an extreme form of assent) that he prefers to reject it altogether

from his field of thought (which is a banal form of resentment and denial). However, we are not obliged to choose in such a binary manner. Between "we know all" and "there is not," a wide spectrum of possibilities opens up. For example: Wajcman reproaches the the *Sonderkommando*'s images for showing mass graves—which he associates (wrongly, since the conditions for taking the photos are incomparable) with the mass graves so often photographed in 1945 by Western reporters—while an "image of the Shoah" would be in his opinion "beyond the mass grave," on the level of a "disappearance beyond the visible,"

> because there is something beyond mass graves [. . .], a degree of disintegration over and above, of disappearance beyond the visible, because the bodies were gassed, then burned [. . .]. All bodies, all remains, all traces, all objects, all names, all memories, and also all instruments of obliteration were obliterated, cast outside of the visible, outside of memory itself.
>
> To show that which was unique to the Shoah, the distinctive feature of the crime of the gas chambers? To show that obliteration, that real obliteration: that is what each image is confronted with here. It is the very Real of the images of the Shoah. This Real lies beyond the tumefied visages, beyond the lacerated bodies, beyond the mass graves. What remains to be shown is smoke, where the bodies rose to the heavens—indeed the only way in Auschwitz to reach the heavens—and to show the dust [. . .]. Those are the true images.[5]

To write this, Gérard Wajcman had to withdraw any form of assent to the images of Birkenau, to the point of not even wanting to look at them. Was it that he expected "true images"—which in his opinion don't even exist—to show the dust and smoke to which the bodies were reduced? Well, that is precisely what the *Sonderkommando* member photographed in 1944. And his photographs show this much better than what Wajcman describes with his vague notion of "obliteration," for they show both the bodies and the smoke. They show how the smoke rises from the mass grave rather than showing the pure "beyond," "outside of the visible." They show the *obliteration as a process*: a concrete, horren-

dous, manipulated process, worked by men, which definitively prevents us from creating a "poetic" or "absolute" imagery. We are a long way here from the lazy obliteration—abstract rather than dialectic—that satisfies Wajcman in the "images that show nothing" of the Shoah.[6]

For all that, we are not dealing with *one image*. In each of his locations, the clandestine photographer of Birkenau pressed the shutter release twice, the minimal condition for his testimony to account, from two angles at least, for the time that he took to observe. The danger, the urgency, and technical constraints were the only reasons for not capturing other moments of the extermination process. Far from this demand, the phantasm of the *one image* is supported by a phantasm of the *absolute instant*: in the history of photography, which is true for the very notion of the snapshot;[7] it is even truer in the memory of the Shoah, where "a secret film"— Claude Lanzmann's hypothesis—about the "absolute moment," the death of three thousand Jews by asphyxiation in a gas chamber—can be dreamed of. While they are singular, the images are not unique for all that, and are even less absolute.

There is no more "one" image than there is a "unique" word, sentence, or page for saying the "all" of any reality. Let us recall the Hassidic parable of Menahem-Mendel of Kotzk, who every evening wrote his "all truth" [*vérité toute*] on a single page: the next morning, rereading it, he cried so much that the ink was erased. But in the evening, he began again on the same page, and continued on, night after night, creating a gigantic palimpsest.[8] Nor should we forget that Freud made "isolation" [*Isolierung*] a pathological equivalent to repression.[9] Wielding the two excesses of the *nothing* and the *unique*, Gérard Wajcman tries to force the notion of image into an *ordinal*, a word fixed between zero and one: a scholasticism quick to legislate on the hypothesis and the inexistence of an "all image" rather than to question the "few images" that concretely remain to us of Auschwitz.

If a serious reason were to be found for the hyperbolic comparison that Gérard Wajcman establishes between Claude Lanzmann and Moses,[10] it would no doubt be that *the Law* wants to reduce images, just as *the One* [*l'Unique*] wants to reduce without remains

the multiplicity of the lacunary singularities: "The ten Laws are laws only in reference to the Unit," writes Maurice Blanchot. "No one will violate the One. [. . .] All the same, in law itself there is a clause that recalls the exteriority of writing, when it is said: you will make no images for yourself," since making images for oneself obviously equals violating the One.[11]

This indeed is why *the image is not all*. Perceiving "remains"—of life and visibility, of humanity and banality—in the four images of Auschwitz, Gérard Wajcman declares them null and void. He would have kept them if they had been "pure" of any remains, if they had been "all" in the eyes of death as such. But *death* (the great, the absolute) is unrepresentable, beyond any image of *the dead* (those little cadavers, mere entities, wretched bodies piled in an incineration pit). Wajcman sought *the all image*, the unique and integral image of the Shoah; having found only *not-all images*, he dismisses *all images*. That is his dialectical error. Should we not treat the impurities, the lacunae of the image, as we have to treat the silences of speech, which is to unravel them, struggle with them? A psychoanalyst could understand this. When Lacan writes that "woman is *not all*," he certainly doesn't mean that there is nothing to be expected from women.[12]

Yet it seemed to be as a Lacanian that Gérard Wajcman, in another context, expected art to "show absence." But once again he made the mistake of deducing from absence that there is "nothing to see," or only invisibility, in brutal opposition to the "everything to see of images."[13] Images never give *all there is to see*; better still, they can show absence from the *not all there is to see* that they constantly suggest to us. It is not by forbidding us to imagine the Shoah that we can better show the absence of the dead. How can one be a Freudian and still expect—according to the imperative of an alienating double bind—that the movement of associations, those imaginary and symbolic *montages* with which we interminably invest this tragic history, will stop when they encounter the Shoah?[14] It is just as vain to try to stop the imagination, or to declare that there will be "no image to come," as it is to isolate four photographs by severing them from their symbolic economy (the images not existing as such, but always already taken into lan-

guage: it is not for nothing that the photographs of Birkenau were accompanied by a text [fig. 7]) and by severing them from their relation to the real (where the images are to be understood within the very act that made them possible).

Any act of the image is snatched from the impossible description of a reality. Artists, in particular, refuse to give in to the unrepresentable of which they—like anyone who has faced the destruction of humans by humans—have had an *emptying* experience [*expérience évidante*].[15] So they make a *series*, montages *in spite of all*: they know too that disasters are multipliable to infinity. Callot, Goya, and Picasso—but also Miró, Fautrier, Strzeminski, and Gerhard Richter—fiddled with the unrepresentable in every sense, so that something other than pure silence would escape from it. The historical world, in their work, becomes a *haunting memory*, a *scourge of imagining*, a proliferation of figures—of resemblances and differences—around the same vortex of time.

[]

Today we have at least two cinematographic ways of presenting this haunting memory of the destruction of the European Jews. In *Shoah*, Claude Lanzmann created a type of montage that brings faces, testimonies, and even landscapes to a center that is never reached: it is a centripetal montage, an elegy of slowness. It is a sort of basso continuo that hollows out the nine and a half hours of the film's duration. And in *Histoire(s) du cinéma*, Jean-Luc Godard created a kind of montage that makes documents, citations, and film clips whirl toward a space that is never covered: a centrifugal montage, an elegy of speed. It is a like a great fugue running through the four and a half hours of the film. Two different aesthetics are at play here, two means of montage; but also two ethics of the relation created, in these films, between image and history. Two thoughts, two writings, snaking down the pages of the two films reconfigured in book form, like very long poems.[16]

A polarity has thus been formed, even though it gives the question of the Shoah only some of the possible cinematographic responses; for there will always be unforeseen "images to come,"

whatever Gérard Wajcman may think. Looked at from a distance, or unemotionally, this polarity functions as a link of complementarity, each form naturally calling for its countermotif. Godard and Lanzmann both believe that the Shoah requires us to entirely rethink our relation to the image, and they are quite right. Lanzmann thinks that *no image* is capable of "saying" that history, which is why he tirelessly films the witnesses' speech. Godard thinks that henceforth *all images* will "speak" to us only of that history (but to say that "they speak of it" does not mean that they "say it"), which is why he tirelessly reexamines our entire visual culture in light of this question.

If we look closely, the polarity has taken the form of a polemic. A film project—which was supposed to engage Godard and Lanzmann in a cinematographic "confrontation" over the Shoah—failed to materialize. (Not by chance, the question of montage was invoked among the reasons for this failure.)[17] All of this led to a series of remarks as scathing as they were provocative, prolonged—on Lanzmann's side—by a prose from another hand that exceeds the bounds of reasoning. Thus Libby Saxton contrasts an improbable "theology of montage" in Godard (it's hard to see which deity would in fact be revered in *Histoire[s] du cinéma*) to an improbable "absence of iconic images" in Lanzmann (it's hard to see how the faces captured on the *Shoah* film could escape the status of "iconic images").[18] Gérard Wajcman turns this into a political question: he imagines Lanzmann alone against everyone else, and therefore does not hesitate to place Spielberg, Benigni, Claude Zidi, the negationists, and Godard on the same level. Then he transforms the debate into a religious affront, clothing Godard successively in cast-offs from Saint Paul, Saint John, and, of course, Saint Luke.[19] I understand better, at present—having cited a brief passage from Godard as an epigraph to part one of this book— why I might, in my turn, have been clothed in cast-offs from Saint Paul, Saint John, and, of course, Saint George.[20]

The aesthetic polarity is expressed henceforth—via the "ethics of the gaze"—in quasi-theological terms. On the one hand we have the *composite images* of Jean-Luc Godard: noisy, multiple, baroque. Which also makes them artificial. They resemble

the famous composite statue that Nebuchadnezzar dreamed of. They are idolatrous and irreverent. They boldly mix the historical archive—which is omnipresent—with the artistic repertoire of world cinema. They *show* a lot, they *make a montage of* everything with everything. So a certain suspicion arises: the suspicion that they *are lying* about everything. On the opposite end is Claude Lanzmann's *one-image*, an image "more on the side of what we *cannot* look at [. . .], the Nothing" of pure truth.[21]

Raul Hilberg described *Shoah* as a "mosaic" film.[22] He looks at the great number of witnesses and of places in Lanzmann's film from the perspective of montage and of multiplicity.[23] Gérard Wajcman confronts this stance with a viewpoint that falls back on the One, the Law, and biblical analogy: from then on, "mosaic" no longer refers to the complex *opus musaicum* of Roman artists, the "collage" décor that adorned the grottos likely to be inhabited by the Muses, but now refers to the strict law of Moses, which abhors and punishes any form of idolatry.[24] Thus, in Godard's *Histoire(s) du cinéma*, in Wajcman's view, we see *a profusion of images*, composite images, animated by the idolatrous breath of the Muses; and in Lanzmann's *Shoah* we would see *a single image*, a Tablet of cinematographic Law condemning all of the others, mainly Godard's, to the status of golden calves. *Shoah* "is radically distinct from anything that was done before it," and we are not far from seeing a new religion (the monotheism of the all image) coming into existence in defiance of the others (the polytheism of null images); *Shoah* "resists everything" in the way a belief resists; *Shoah* "tells the truth without adding anything," like the best legal text.[25] Lanzmann himself never hesitates to make the same claim:

> *Shoah* forbids many things. *Shoah* dispossesses people of many things. *Shoah* is an arid and pure film. [. . .] My film is a "monument" [. . .]. *Shoah* is not made for communicating bits of information, but it teaches everything.[26]

Things will have come full circle when the film *Shoah*—a montage of images created from interviews with survivors of the Shoah— has been invested with the very characteristics of an event, of which however, it is only an interpretation after the fact: "*Shoah* is

not a film about the holocaust; it is not a derivative, not a product, but an originary event. Whether or not this pleases a certain number of people—I will explain myself on this point soon—my film is not merely a part of the event that was the Shoah: it contributes to constituting it as an event."[27] Here we see a film director constructing the identification of his film with the reality that it both documents (via the speech of the witnesses) and interprets (via his montage of the material). Wajcman' reasoning now appears in a new light: "There are no images of the Shoah," he says in substance, because there is the image of *Shoah*, and this one "teaches everything," becoming coextensive to the phenomenon of which it will give the *all image*.

Faced with the American series *Holocaust*, with Spielberg's consensual dramatic art, or with Benigni's emotional manipulations, it was very advantageous to counterattack with a historical argument.[28] But it doesn't follow that *Shoah*, as a "unique work [. . .], has disqualified any earlier endeavors"[29] or, worse, that it disqualifies all "images to come." By offering *Shoah* as the *all image* that all other images are missing—those in archives as much as those in cinema, those of the past like those of the future—we merely confuse this film with the (political) history it deals with, and we merely exonerate this film from the (aesthetic) history from whence it came. For *Shoah*—and we cannot forget it—is certainly indebted to a history of the documentary film.

We can start with *Nuit et brouillard*. Thirty years before Lanzmann, Alain Resnais challenged everyone who watched his film to call a certain memory into question—a memory, difficult to sustain, of an event undoubtedly less understood at that time than it was in the 1980s. *Nuit et brouillard* was subjected to censorship in France (a scene in which a Vichy gendarme's kepi was seen at the Pithiviers camp had to be disguised) as well as in Germany (whose embassy managed to have it removed from the Cannes film festival in 1956).[30] However, its reception in the intellectual and artistic world exactly prefigures the role played by *Shoah* in the 1980s and 1990s. Ado Kyrou wrote in 1956 that it was the "necessary film"; he could not imagine "another film on the same subject."[31] This film showed a way, hitherto unseen, of "pushing back the limits of

MONTAGE-IMAGE OR LIE-IMAGE] 129

what we thought was attainable," and offered a masterly solution
for "finding forms adapted to the transmission of nontransmis-
sible experience."[32]

As *Shoah* would do later, Resnais's film starts with the stillness
and gloom of empty or, even worse, run-of-the-mill landscapes:
"Even a tranquil landscape, even a prairie with crows flying, har-
vests, and grass fires; even a road with cars, farmers, and couples
moving along it; even a tourist village, with a fair and a church
tower can lead very simply to a concentration camp. [. . .] Today,
on the same track, it is daylight and the sun is shining. We cover it
slowly, but in search of what?"[33] *Shoah* shocked us with that empty
clearing at Chelmno, recognized only by Simon Srebnik, the sur-
vivor.[34] *Nuit et brouillard* had shocked us with its empty fields tra-
versed by extraordinary "tracking shots with no subject" (figs.
22–23):

> [. . .] the camera, with slow tracking shots, only moves in empty
> scenery, scenery that is real and living—a slight whispering
> of the grasses—but devoid of any live creature, and with a
> reality made almost unreal by belonging to a world closer to
> that of an improbable, impossible survival. The camera seems
> to move for nothing, blankly, stripped of the drama or the
> spectacle that its movements seem to be following but that
> are no longer anything but invisible phantoms. Everything is
> empty, motionless, and silent; still photographs could capture
> the scene. But the camera itself moves, it alone moves, it is the
> only life, there is nothing to film, no one, there is only cin-
> ema, there is nothing human or living except for the cinema
> facing a few insignificant, derisory traces, and it is this desert
> that the camera covers, it is on this desert that the camera in-
> scribes a supplementary trace, soon erased, of its very simple
> journeys [. . .].[35]

Serge Daney understood how these tracking shots were the polar
opposites of the "tracking shot in *Kapo*" so violently denounced
in 1961 by Jacques Rivette.[36] Daney saw in *Nuit et brouillard* the
"obligation not to run away" in face of our history, the "stub-
born return to non-images," the "antispectacle" par excellence,

the injunction to understand "that the human condition and industrial butchery were not incompatible, and that the worst had just happened"; he saw the film as a "seismography" rather than a historical iconography and, finally, as a genuine "writing of the disaster" in Maurice Blanchot's sense of the words.[37] Daney was right, because the whole challenge of *Nuit et brouillard* rested on a shake-up of *memory* caused by a contradiction between unavoidable documents of *history* and repeated marks of the *present*. The documents of history are those famous archival images — in black and white — that left the spectators of the time mute with fear, and that Lanzmann today wants to refute because of their absence of historical rigor. The marks of the present come from the "gaze without subject" cast by Resnais on the empty landscapes of the camps filmed in color. But they also come from a desire to give the entire sound space of the film to two survivors of the Nazi persecutions: not *testimonies* in the strict sense, but *writings* deliberately distanced. In his commentary, Jean Cayrol does not tell of his per-

Figure 22. Alain Resnais. *Nuit et brouillard*, 1955. Photogram from the beginning of the film.

sonal experience of the camps; and Hanns Eisler's music impedes
any emotional paraphrasing of the images.

A formal decision—formal above all because it is radical—
always contains a correlative impasse: what is attained here is lost
there. In his choices of duration and montage, Resnais attains that
powerful feeling of the present, giving us a synthetic represen-
tation of what a "camp" in Nazi Germany would have been like.
Hence, "the camps" are not highlighted, and the dimension of his-
torical analysis is pushed into the background (let us remember
that the distinction between extermination camps and concentra-
tion camps was not yet in current usage in the historiography of
the 1950s).[38] The image of the skeletal bodies works as a "screen to
the massacre of women and children in full health, led to the gas
chambers as soon as they get off the trains."[39] But we cannot criti-
cize a work for not keeping a promise that it never made: Resnais's
film never pretended to "teach everything" about the camps and
proposed no more than *an access to the inaccessible*:

Figure 23. Claude Lanzmann. *Shoah*, 1985. Photogram from the beginning
of the film.

Regarding that reality of the camps, scorned by those who fabricate it, indiscernible to those who suffer it, it is quite in vain that we in turn try to discover its remains [. . .]. That is all that is left for us to imagine.[40]

"We who pretend to believe that all of that is from the same time," said the voice courageously in *Nuit et brouillard*.[41] In the parallelism of the archival images and the marks of the present, it was a question of convoking a *critical time*—in the manner of Brecht— that would encourage not identification but political reflection. A sharper solution was found when, in *Le chagrin et la pitié*, a kind of *critical contretemps* born of the incessant jerking between archival images and present-day testimonies was substituted for Marcel Ophuls's parallelism. Lanzmann owes to Resnais a way of breaking the historical narrative to better help us—the spectators— confront history. But his true master is Marcel Ophuls,[42] with his manner of always bringing the interlocutor to the *testimony*, that is, to the impossibility of avoiding the decisive flaw—the mark of history—in the story that is told. *Shoah* radicalizes Ophuls's solutions by means of a supplementary stage: it no longer uses the contretemps of archive images but, instead, concentrates on a single dimension (the speech and the places filmed in the present), which itself creates, by its strategic duration and its montage, the inexorable conditions for an "impossibility of avoiding."

Although Claude Lanzmann says little enough about Marcel Ophuls and is excessively violent with respect to Alain Resnais,[43] this filiation deserves to be analyzed. It shows, insofar as it needs to, that the use of the archive is in no way "out of fashion"[44] and that, in the numerous films devoted to the Shoah between 1985 and 1995, the montage of images of the past with testimonies of the present traverses an entire spectrum of formal solutions from which no general rule can be drawn.[45] But we should be under no illusion about either the archives or the montage that are produced: the former in no way give the "raw" truth of the past and exist only to be constructed on the collective basis of well-thought-out questions that we should pose to them; the latter

gives form precisely to these collected questions; hence its crucial role, both aesthetic and epistemological.[46]

[]

"There are surely things that we cannot see. And what cannot be seen must be shown."[47] Here at least is one proposition from Gérard Wajcman to which I can subscribe. But his conclusion unfortunately ruins everything: "What this shows is that there are no images."[48] To support such an affirmation, Wajcman would have been compelled, on a very general level, to restrict the *force of showing* to language alone, and, on a more circumstantial level, to declare that *Shoah*'s nine and a half hours of images are not images. (If Lanzmann had wanted to keep to speech alone, he would not have made a film but rather a book or a radio program.)

What Wajcman fails to recognize, to be specific, is that the very notion of image—in its history as well as its anthropology—is intermingled with the incessant urge *to show what we cannot see*. We cannot "see desire" as such, yet painters have played with crimson tones to show it; we cannot "see death," yet sculptors have succeeded in modeling space like the entrance to a tomb that "gazes at us"; we cannot "see speech," yet artists have succeeded in constructing their figures like so many enunciative devices; we cannot "see time," yet images create the anachronism that shows it at work; we cannot "see place," yet the apposite fables invented by artists have shown us—by means both perceptible and intelligible—the force of "*évidance*."[49] The entire history of images can thus be told as an effort to *visually transcend* the trivial contrasts between the *visible* and the *invisible*.

"What we cannot see, we must show": Gérard Wajcman believes that only an elimination, a unification, or a making absolute of the image—the *null* image, the *one* image, or the *all* image—could answer this imperative. I believe, on the contrary, that the multiplication and the conjunction of images, however lacunary and relative they may be, constitute just as many ways of showing *in spite of all* what cannot be seen. The first and simplest way to *show*

what escapes us is to *make a montage* of its figural detour by asso-
ciating several views or several time periods of the same phenom-
enon. The elementary form—cold, frightening—of this detour
can be seen in a very short film, directed by some Nazi technician
in September 1941 in Mogilov (Belarus): one shot shows naked,
scrawny men being transported in a cart, a door about to be closed
on them; the next shot simply depicts the trajectory of pipes con-
nected to an automobile's exhaust system; it is a film in which gas-
sing by carbon monoxide—the victims most likely being physi-
cally handicapped—is not seen but rather indicated by the crude
montage of two sequences.[50]

At the other end of this spectrum, Shoah does not allow us to
see what the witnesses experienced of the extermination; but it
shows the survivors themselves given to the tragic task of reminis-
cence. Through a *montage* totally organized around the economy
of the *narrative*, Claude Lanzmann allows us to snatch from these
words—of which he himself demands, word after word, as much
visual precision as possible—an imaginable for that experience.
Jean-Luc Godard, in *Histoire(s) du cinéma*, chooses to *show* cinema
itself and its own reminiscence through a *montage* totally organized
around the economy of the *symptom*: accidents, shocks, images col-
lapsing one on top of the other allow something to escape that is
not *seen* in any one fragment of film but *appears*, differentially, with
the force of a generalized haunting memory. Each image "is not a
just image [*une image juste*], it is just an image [*juste une image*],'' as
Godard said in a famous phrase.[51] But it allows one "to speak less
and to better say" or, rather, to better *speak of it* without having
to *say it*.[52]

Godard seems always to have situated his reflection on the pow-
ers and the limits of cinema in the systole and diastole of the image
itself: its essentially *defective* nature alternating with its capacity to
become, suddenly, *excessive*. It is a pulsation—our "dual system" of
the image—where the limit is able to become transgression, that
is, the power to give more than what is expected, to disrupt the
gaze, to tear the veil. How is this possible of an image that is "just
an image," in other words, the contrary of an all, of a unitary cap-

turing, of an absolute, whatever that may be? It is possible because
an image does not exist as "one":

> There is no image, there are only images. And there is a certain
> form of assemblage of images: as soon as there are two, there
> are three. [. . .] This is the foundation of cinema.[53]

If Gérard Wajcman speaks almost constantly of the image in the
singular—whether it be *null, one,* or *all*—and if he is incapable of
envisaging the sequential nature of the four photographs of Ausch-
witz, it is because the image appears to his eyes as a mere "freeze-
frame" on things. The image does not, according to him, contain
that fecundity that Lacan recognized in the signifier through its
"chain" effects. Godard, on the other hand, sees and constructs the
image only as *plural*; in other words, taken in its montage effects.
The greatness of cinema—but also of painting, which, with the
example of Eisenstein, Godard recognizes as a great "montage
maker" ["*monteuse*"]—is to have made this essential plurality blos-
som within the elapsed time of movement. Let us look at the way
he recognizes the genius of Alfred Hitchcock:

> [Hitchcock] has restored [. . .] all power to the image and to
> the sequence of images. [. . .] Hitchcock belonged to a genera-
> tion that had known the silent screen. In Hitchcock, the story
> really comes from the film, develops at the same time as the
> film, as the design develops with the painter. [. . .] He discov-
> ered montage. The history of cinema on which I am working
> is something like that of the discovery of an unknown conti-
> nent, and this continent is montage. [. . .] When Eisenstein
> speaks of El Greco in his writings, he never says "that painter,"
> but "that montage maker."[54]

The principal effect, then, of Hitchcock's skill in editing consists
in *fastening the image to fear*: "Hitchcock was the only man who
could make a thousand people tremble, not by saying to them,
like Hitler, 'I will massacre all of you,' but rather, as in *Notorious*, by
showing a row of bottles of Bordeaux. No one else has managed
to do that. Only great painters like Tintoretto."[55] It is oversimpli-

fying, of course, to contrast the political (guilty) fear of Hitler to
the aesthetic (innocent) fear of Hitchcock, the real fear of Hit-
ler to the fictitious fear of Hitchcock. Godard wanted to show
that in the images of *Notorious*, fear is a product of *fiction*, yet not a
product of *falsification*. It is fictitious—and even humorous since
Hitchcock is making the spectator anxious with a promising row
of good bottles—but it attains a phenomenological truth where
fear could actually be conceived as fear. And this is possible be-
cause *montage intensifies the image* and gives the *visual* experience a
power that our *visible* certainties or habits have the effect of pacify-
ing, or veiling.

Let it be noted in passing that Godard is not alone in defending
this kind of position. A filmmaker as different as Robert Bresson
formulates similar ideas when he refutes the "absolute value of an
image"; when he insists that "all is not there" in this domain; when
he imposes a manner of "fragmentation [that makes the parts] in-
dependent so as to give them a new dependence"; when he in-
vokes, with the "omnipotence of rhythms," the art of montage,
by virtue of which "an image is transformed upon contact with
other images like a color upon contact with other colors"; when
he looks for whatever is happening "in the joints" and observes
the strange fact "that it is the internal union of images that charges
them with emotion"; when he establishes the principle of "bring-
ing together things that have never yet been brought together and
did not seem likely to be": all of this so as to "take apart and put
back together again to the point of *intensity*," so true is it that im-
ages "are strengthened by being transplanted."[56]

Montage endows images with a status of enunciation that makes
them, in accordance with their use-value, *just* or *unjust*, in the same
way that a fiction movie—as understood by Hitchcock, Godard,
Bressons, and many others —can bring images to a degree of in-
tensity capable of suddenly producing a *truth*; and in the way a
simple televised news story can use documentary images to the
point of producing a falsification of historical reality that was
nonetheless archived. So we can see how montage is found at the
heart of the concrete question—that of singular rather than gen-
eral truth—of images. It is as naïve to assimilate montage and lie

(as Georges Sadoul did, for example)[57] as it is to remain blind to the constructive content of montage on the visible material that it elaborates and interprets.

It is no coincidence that the cinematographic services of the United States army in 1945 turned to John Ford to reflect on the use—that is, the montage—of sequences filmed by George Stevens at the opening of the camps; and that Sidney Bernstein likewise prompted his friend Alfred Hitchcock to think about the montage of sequences filmed in the camps, especially in Bergen-Belsen, for the British army.[58] The reactions from the "master of fear," as reported by several witnesses—including Peter Tanner, the editor [*monteur*] of Bernstein's film—are very significant: it wasn't a montage of investigation, a montage in the form of an *inquiry* (something Hitchcock was so good at) that ought to be put together, but rather a montage in the form of a trial (something he confessed, perplexed, "pacing back and forth," that he didn't really know how to do, above all faced with these images of an absolutely new genre).[59]

But Hitchcock understood immediately that this form needed *a montage that doesn't separate anything*. First, the victims must not be separated from the executioners, meaning that the corpses of the prisoners must be shown under the very eyes of the German officials, and the consequent decision to make minimal cuts in the long, panoramic shots of the filming, so frightening in their slowness; then, the camp itself must not be separated from its social environment, even though—or because—that environment was normal, quaint, rural, and even bucolic. From the beginning, Hitchcock and Bernstein had understood that the unbearable nature of these archives, in such total contrast to all the rest—and I mean the rest of humanity beyond the barbed wire—could arouse denial, rejection of these all too burdensome pieces of evidence; for negation of the genocide is inscribed in the very difference of the camp from its immediate vicinity. Is it not montage that, in a film, first undertakes to *demonstrate these differences*? What we cannot see must therefore be *made into a montage* so as to encourage, as far as possible, *thinking* about the differences between certain visual—separated, lacunary—monads, in such a way as *to know in*

spite of all even that which remains impossible to see entirely, that which even remains inaccessible as an *all*.

[]

Godard says nothing less: "Montage [. . .] is what makes *visible* [*ce qui fait voir*]."[60] It is what transforms the partially remembered time of the visible into a reminiscent construction, a visual form of haunting, a musicality of knowledge. That is to say, into fate: "In montage, we encounter fate."[61] Thus, montage is clearly situated at the level of *thought*. And Godard reminds us "that cinema [was] first made for thinking," that it should first of all be given as a "form that thinks."[62] Montage is the art of producing this form that thinks. It proceeds, philosophically, in the manner of dialectic (like Benjamin and Bataille, Godard likes to cite Hegel only to mislead): it is the art of *making the image dialectical*.

We can understand this in several ways. First, montage makes every image into the third of two images already joined in a montage. However, as Godard specifies—invoking Eisenstein—this process does not reduce the differences but, on the contrary, emphasizes them: it doesn't result in any kind of "fusion" of images, even in the case of superimpositions used in *Histoire(s) du cinéma*:

> Jean-Luc Godard.—The *Histoire(s)* was cinema, technically it was manual work, they are very simple things, of the forty possibilities of the production department I used one or two, mostly superimposition, which allowed for keeping the original image of the cinema [. . .].
>
> Youssef Ishaghpour.—The fact that the two images dissolve one into the other . . .
>
> Jean-Luc Godard.—The basis is usually two, always to present from the start two images rather than one, what I call the image, this image made of two [. . .].[63]

Things become complicated again since Godard is constantly summoning words to be read, to be seen, or to be heard, in his work. Dialectic must then be understood as repeated collision between words and images: images jostle together making words suddenly appear, words jostle making images suddenly appear, images and

words collide making thought take place visually. The countless textual citations used in films by Jean-Luc Godard are inseparable from his montage strategy:

> [. . .] The image you bring enters the text, and finally the text, at a given moment, ends up bringing out images; no longer a simple relationship of illustration, and this allows you to exercise your capacity to think and to ponder and to imagine, to create. [. . .] There it is, a bringing together and an image, and there are many in the *Histoire(s)*. [. . .] One day it hit me like an image, that it might be two words that [are] brought together.[64]

It is then that the image acquires a *readability* issued directly from the choices of montage: it is founded on a "bringing together of things incommensurable" but produces no less an authentic "phrasing of history," as Jacques Rancière put it.[65] Is Godard's *Histoire(s)* really *history*? Of course it is. And to Youssef Ishaghpour, who claims "that a historian cannot permit himself to create 'images,' which you can do with montage," Godard replies:

> For me, history is the work of works, if you like, it encompasses them all, history is the family name, there are parents and children, there is literature, painting, philosophy . . . History, let us say, is all of it together. So a work of art, if done well, is a matter of history [. . .]. It seemed to me that history could be a work of art, a notion that is generally not admitted except by Michelet.[66]

In *Cinéma cinéma*, Godard called both his work table (strewn with open books, written notes, photographs) and his montage table his *table critique*: was this not a way of affirming that *cinema shows history*, even the one it doesn't see, insofar as it can make a montage of it?[67] Is it not historical knowledge of the role played by the author of *Vertigo* in Bernstein's film that, for example, allows Godard to bring together a shot of Nuremburg and a shot from Hitchcock?

—Today, on video, I watch (and keep) ['je *(re)garde*'] more historical documents than films. But they are the same thing,

I don't distinguish between them. From this point of view, between an extract of the Nuremburg trials and a scene from Hitchcock, both tell what we have been, both are cinema.

—Is it bringing such things together that makes history?

—It's what we see, before saying it, by bringing two images together: a young woman who smiles in a Soviet film is not exactly the same as the one who smiles in a Nazi film. And the Chaplin of *Modern Times* is exactly the same, at the outset, as the Ford factory worker when he was filmed by Taylor. Making history means spending hours looking at these images and then suddenly bringing them together, creating a spark. This makes constellations, stars that come together or move away, as Walter Benjamin saw it.[68]

Here we are brought back to Benjamin's "dialectical image" and, therefore, to knowledge through montage.[69] Not only is "the age of cinema the age of history in its modern sense," as Jacques Rancière puts it, but also the cinema, thus understood, works on the same level as the *unforgettable*: in other words, it never ceases to confront the question of *Vernichtung*, annihilation.[70] By writing that "cinema is made for thinking the unthinkable,"[71] Jean-Luc Godard puts himself in the tragic position of noting at the same time that "cinema did not manage to fulfill its role":

Naïvely, it was thought that the New Wave would be a beginning, a revolution. Well, it was already too late. Everything was over. It ended the moment the concentration camps were not filmed. At that very instant, the cinema totally failed in its duty. Six million people were killed or gassed, principally Jews, and the cinema was not there. Yet, from *The Great Dictator* to *La règle du jeu*, it had announced the entire drama. By not filming the concentration camps, cinema gave up completely. It is like the parable of the good servant who died from not having been used. Cinema is a means of expression in which the expression has disappeared. It has remained the means.[72]

The *Histoire(s) du cinéma*, of course, is not a chronicle or a documentary on the camps, far from it. But one of the most powerful

leitmotifs consists in exposing how one extraordinary "means of expression," the cinema, was deprived of its very "expression"—or its central object—when, on the day the camps were opened to the world, it "gave up completely." What does Godard mean when he claims that cinema "did not film the camps"? Not only does he know the shots taken by George Stevens and Sidney Bernstein, but he even uses them in his own film. Not only does he remind us that Chaplin or Lubitsch did not avoid the subject, but he even says he is certain that the Nazis themselves filmed their sinister inventions, and that those rushes still lie among some unexplored archives.[73] Why then would he say that cinema did not film the camps?

Because filming alone does not suffice to make cinema. Because, according to Godard, no one was able to *make a montage* (that is, to *show* in order to *understand*) of the existing shots, the documents of history. Godard appears unsatisfied with the advice expounded by Hitchcock as "treatment adviser" to the editor Sidney Bernstein. And he seems no better satisfied with the tracking shots of *Nuit et brouillard* than with the testimonies of *Shoah*.[74]

It is both an unjust and an understandable position, given his particular logic. It is unjust because Alain Resnais and Claude Lanzmann in no way "resigned completely" in the face of a task that Godard often spoke of but never undertook himself.[75] It is understandable because Godard's demands are coherent and concrete: the historical archives need to be explored—"They are not shown any more today, no one knows what happened [. . .]. At certain moments, we do not want to see the image, an image is difficult"[76]—and a great film needs to be made of this exploration, beyond all the "pedagogy through horror" conveyed, at the time of the Liberation, by our cinematographic newsreels.

In Godard's view, then, cinema "gave up" in the face of a task that was essential to it. The guilt of not having filmed the camps is doubled for Godard by the guilt of having let Hollywood occupy that terrain: "JLG was not capable of [. . .] *preventing* Mr. Spielberg from reconstructing Auschwitz."[77] But the *Histoire(s) du cinéma* magnificently insists on the montage *in spite of all*, this great and always wide open question: not to be afraid of the archives—avoiding the double pitfall of their sacralization and their

denigration—but not to be afraid of creating a work with them, that is, creating a *work of montage*. "And that is probably the most profound paradox of *Histoire(s) du cinéma*. It tries to show that cinema, with its vocation for presence, betrayed its historical task. But the demonstration of the vocation and of the betrayal is the opportunity for verifying quite the contrary."[78]

The question then becomes: in order to show the images of the camps, what should be used with them in order to make them into a montage? The answer from the *Histoire(s) du cinéma* is very complex, always dialectical: neither "totalitarian" (which would suppose a single "all" history [*histoire "toute"*]), nor dispersed (which would suppose multiple histories without links between them). Jacques Aumont has produced a very clear analysis of the Godardian way of making a sequential montage of time [*re-monter le temps*] in the *Histoire(s) du cinéma*.[79] In so doing, he remarks that *putting archive images to rhythm* is never accompanied by an attack on their nature as photographic recording: "There is nothing more significant than the fact that, in all their brilliance and their complexity, the *Histoire(s)* never resorts to touching up an image, but only to techniques that do not affect indexicality."[80]

In this way, *montage* is not an indistinct "assimilation," a "fusion," or a "destruction" of the elements that make it up. To place an image of the camps—or of the Nazi barbarity in general—in a montage is not to lose it in a cultural hodgepodge of pictures, film extracts, and literary citations: it is to make something else understood, by showing this image's *difference from and link with* that which surrounds it in this particular case. Masha Bruskina, a young Jewish woman of seventeen was hanged by the Germans in Minsk in October 1941: the taut rope, in the photo, is as implacable as the tilted face is shocking; Godard—whose film is literally obsessed with the disappearance of beings, of bodies—gives this image the echo of a famous photograph of Hiroshima, the shadow of a ladder still straight and a body pulverized against a wall.[81]

The same image of hanging had been associated, in the first part of the film, with some of Goya's *Disasters*. These were then extended into a detail of *Los Caprichos*: a sort of evil angel—like a monstrous version of Benjamin's angel of history—carrying on

its wings some wretched souls, decapitated heads (fig. 24).[82] The manuscript in the Bibliothèque nationale in Paris provides a brief commentary on this plate, mentioning "the vices taking flight to the land of ignorance"; the one in the Prado museum is even more explicit: "Where is it going, this infernal cohort, howling in the air, in the darkness of the night? Still, if it were day, it would be something quite different: after so many gunshots this entire cohort would be felled, but since it is night, no one can see it."[83] For Godard, no doubt, political evil is allegorized here by this grimacing night, where "no one can see it" (and where therefore, no one can stop it from acting).

We see much more in the following images: we see, in color— since real evil is in color—the corpses of the Buchenwald-Dachau convoy filmed, at the end of April 1945, by George Stevens with his 16-millimeter camera, using Kodachrome film (figs. 25–26).[84] The following scene is no more than a typical bit of Hollywood eroticism in which we recognize Elizabeth Taylor, in a swimsuit,

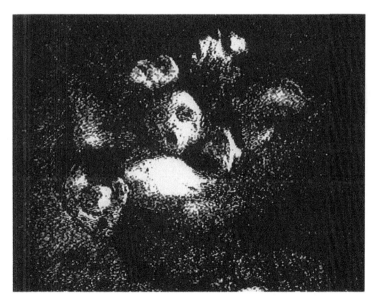

Figure 24. Jean-Luc Godard. *Histoire(s) du cinéma*, 1988–1998. Photogram from part 1a, entitled "Toutes les histoires."

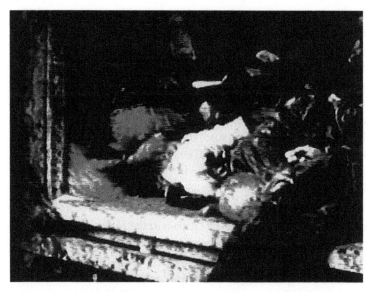

Figure 25. Jean-Luc Godard. *Histoire(s) du cinéma*, 1988–1998. Photogram from part 1a, entitled "Toutes les histoires."

Figure 26. Jean-Luc Godard. *Histoire(s) du cinéma*, 1988–1998. Photogram from part 1a, entitled "Toutes les histoires."

Figure 27. Jean-Luc Godard. *Histoire(s) du cinéma*, 1988–1998. Photogram from part 1a, entitled "Toutes les histoires."

lying with the face of the lover, Montgomery Clift, on her bosom (fig. 27). There is the brutal difference. But where is the link constructed by the montage?

It is, first of all, in the *form*, that is, in Godard's free choice. The *fiction*, if you will. Here the artist—according to western tradition—gives himself the sovereign freedom of reuse: he chooses two photograms of Dachau and associates them with the brief Hollywood shot, taking the two men's faces that cruelly respond to each as a dialectical vector. The dead one, his head inclined toward the left, appears still to be crying from an unending suffering; the living one, his head inclined toward the right, appears soothed into permanent happiness. But one continues to wonder how the real victim and the fictive lover might have reason "to respond" to one another.

Here Godard's *thought* intervenes, a thought inherent to all forms constructed in the film: we are looking at just one example, among many to be found in the *Histoire(s) du cinéma*, signifying

the extreme tensions of its great "dialectical image." In fact, we cannot *not* understand, or at least sense, that in the succession of these photograms private joys often emerge against a background of historical misfortune; that beauty (of lovers' bodies, of instants) often unfurls against a background of horror (of murdered bodies, of history); that the tenderness of a particular individual for another particular individual often stands out against a background of hate practiced by individuals in general against other individuals in general. And that this *philosophical* contrast can find, as it does here, its cinematographic expression in the paradox of a real death in color (Godard froze Stevens's film in two photograms) and of a fictitious life in black and white.

But that is not all: Godard creates *history* also. His commentary, as a voice-over, forcibly justifies the link to be established between these images: it is quite simply that they were the work of the same man, George Stevens, who had returned to Hollywood after the war and filmed all these things only five or six years later: "Had George Stevens not used the first film in sixteen in color at Auschwitz and Ravensbrück, Elizabeth Taylor's happiness would probably have never found a place in the sun."[85] What this montage allows us to think is that the differences brought into play *belong to the same history* of war and of cinema: it was simply necessary that the allies win the real war for George Stevens to be able to return to Hollywood and to his little fictional stories. It is a "history in the singular" because the corpses of Dachau remain inseparable *from the gaze of the witness* that Stevens casts *also* upon the body of Elizabeth Taylor—albeit in the mode of the unthought, which Godard hypothesizes here. They are "histories in the plural" because the two moments seek constantly to ignore one another, while wrestling with one another in the same "tragedy of culture." As recently as 1988, Godard had already said:

There is one thing that has always touched me in a filmmaker I am not particularly fond of, George Stevens. In *A Place in the Sun* I found a profound feeling of happiness, which I have seldom found in other films, sometimes better ones. A feeling of simple, secular happiness, at one moment, in Elizabeth

Taylor. And when I learned that Stevens had filmed the camps and that for the occasion Kodak had lent him the first rolls of 16-millimeter color film, I couldn't figure out how he was then able to make that great shot of Elizabeth Taylor radiating a kind of somber happiness.[86]

The "radiation" of this happiness is *composed* by Godard within a frame formed by an appealing hand, two outstretched arms, and the face of a saintly woman typical of the Italian Trecento (fig. 28). It is a detail of the *Noli me tangere* painted by Giotto in the Scrovegni chapel in Padua, a detail that Godard rotates eighty degrees, so that the Magdalene becomes, in turn, an "angel of history," whom the hand of Christ, below — from then on more human than divine — cannot reach. The voice-over commentary intones: "Thirty-nine forty-four, martyrdom and resurrection of the documentary."[87] In a philosophical commentary on these images, Jacques Rancière describes an "angel of Resurrection, who manifests, rising toward

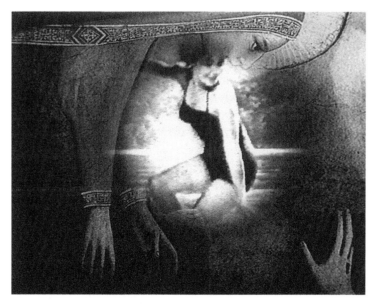

Figure 28. Jean-Luc Godard. *Histoire(s) du cinéma*, 1988–1998. Photogram from part 1a, entitled "Toutes les histoires."

us, the immortal power of the Image rising from every death," to
the effect that the Magdalene of Giotto imposes itself on Godard
by a "deliberate use of painting, which perfects the dialectic of the
cinematographic image. [. . .] Elisabeth Taylor coming out of the
water figures as cinema itself rising from the dead. It is the angel
of Resurrection."[88]

It seems that Godard stirred up trouble in the minds of his com-
mentators by returning several times to the Christian, Pauline dic-
tum: "The image will come at the time of the Resurrection."[89] This
sentence should be returned to its proper place within the im-
mense network of citations from the *Histoire(s)*, rather than seized
on as a unilateral profession of faith or theoretico-theological
dogma. Moreover, the moment the word "resurrection" appears
on the screen, Godard puts it in perspective with his voice-over
commentary, much more Freudian than Pauline: "The two great
histories have been sex and death."[90] Thus, Elizabeth Taylor as the
"angel of Resurrection" seems to me an interpretive simplification
captured by the visual as well as textual power of the Godardian
"inserts."

I see no "angel of Resurrection" at all in the *Histoire(s) du cinéma*,
least of all in the montage context we are discussing (figs. 24–29).
To say that the documentary conceals a power of "resurrection"—
"What a marvel to be able to look at what we cannot see," says
Godard[91]—is not to speak as a theologian about the end of time
but simply as someone perpetually amazed by the relationship be-
tween cinema and history: it is still troubling today to see Adolf
Hitler *moving* in the newsreels of the 1930s and 1940s. Furthermore,
the shot in which Jacques Rancière sees the "angel of Resurrection"
in Godard's work (fig. 28) is itself set, dialectically, between totally
conflicting image states: the Christian saint and the Hollywood
star, the halo defining a strictly veiled profile and the aura radiat-
ing from a pagan nymph's body. Here again, the differences are not
"dissolved" but are exposed in the same "frame."

Moreover, the ninety-degree rotation of the evangelic scene
has the visual effect of bringing this *dramatic art of the impossible
contact* closer to an allegory painted by Giotto very near his *Noli
me tangere*: a representation of *Hope*, the treatment of which in

grisaille reminds us of its affiliation with contemporary sculpture, in particular the famous version by Andrea Pisano at the Baptistry in Florence. It is this dramatic art itself—of hope and not of resurrection—that Walter Benjamin sought to comment on philosophically, from *One-Way Street* in 1928, in which he discusses Pisano's bas-relief, to "On the Concept of History," written in 1940, in which he describes Paul Klee's *Angelus Novus*. "She is seated, and helplessly raises her arm toward a fruit that remains inaccessible. Yet she is winged. Nothing is more true," said Benjamin of the former work.[92] And of the latter: "He appears to move away from something to which his gaze seems to remain tethered."[93]

In short, the function that Godard assigns the history of painting—even if it is Christian, as is almost inevitably the case in the West, at least before the eighteenth century—cannot be reduced to a movement of closure on resurrection and to a desire, as Rancière suggests, to "put the final touches to the dialectic of the cinematographic image." There is no "angel of Resurrection" because

Figure 29. Jean-Luc Godard. *Histoire(s) du cinéma*, 1988–1998. Photogram from part 1a, entitled "Toutes les histoires."

the Magdalene of Giotto will never touch Christ's hand (fig. 28);
because this image is not an end of history but a setting for intel-
ligibility for the murdered bodies and for the lovers' bodies filmed
by George Stevens (figs. 25–27); because, on the other hand, the
"angel of Resurrection" acid-engraved by Goya (fig. 24) remains,
and because a few minutes later in the film, the images by Godard
will be haunted by Luis Buñuel's very Goyaesque formula "the ex-
terminating angel."[94] All of this does no more than sketch an "an-
gel of history," decidedly very Benjaminian.[95] The angel of history
has not one single point of view to offer on the end of time, and
even less on the Last Judgment of the righteous and the damned.

There is no resurrection, in the theological sense of the term,
because there is no dialectical culmination. The film, at that mo-
ment, is only beginning. And once Liz Taylor has appeared all at
once like Venus from the waves—on a traditional iconographic
background, easily recognizable—it is a *torn image*, resistant to
any immediate reading, that in turn appears all at once (fig. 29).
Letters appear, superimposed upon it: firstly we read "End," like
at the end of all Hollywood classics. But we understand that the
word—like *Histoire(s)*, like history itself, and like dialectics ac-
cording to Godard—is not "ended" as such. Isn't *endlos* (without
end, interminable), and then *Endlösung* (Final Solution), what we
should read here? Is it not the *endlessness of the destruction* of man
by man that Godard wants to signify in this history and in this
practice of montage?[96]

SIMILAR IMAGE OR SEMBLANCE-IMAGE

If we ignore this dialectical work of images, we risk understanding nothing and confusing everything: confusing fact with fetish, archive with appearance, work with manipulation, montage with lying, resemblance with assimilation, and so on. The image is neither *nothing*, nor *all*, nor is it *one*—it is not even *two*. It is deployed according to the minimum complexity supposed by *two points of view that confront each other under the gaze of a third*. When Claude Lanzmann says he is "shocked" by the *Mémoire des camps* exhibition, "by the parallel between the swollen faces of deportees beaten black and blue, and those of their executioners beaten at the liberation of the camps,"[1] he simply refuses to see that the photographic archive put together by Eric Schwab and Lee Miller at Dachau and Buchenwald did not report the functioning of the camps but, rather, their liberation, with all the paradoxical situations, necessary denunciations, understandable vengeances, true or false hopes for prisoners still wounded, still dying, that such an event involved. In showing all of this, Eric Schwab and Lee Miller did not intend to explain the organization of the terror, nor did they have the distance necessary to judge everything they witnessed. What the exhibition *Mémoire des camps* set out to do was to question the conditions and the diffusion of these photographic testimonies rather than to retrace the working of the camps. The moral "scene" that Lanzmann claims is not in the "parallel" but rather in the confrontation of images; it is not even in the confrontation as such but rather in the viewpoint made of it.[2]

To make a montage does not mean to assimilate. In 1968, Jean-Luc Godard had already shown images of totalitarianism and of pornography together: "In *One Plus One*, there were sexual images

and a text by Hitler at the same time: there was *one* plus *one*."[3] In
Histoire(s) du cinéma, a victim of the camps is shown dead, follow-
ing a scene from a pornographic film, an opportunity for Godard
in his voice-over commentary to distinguish between the *violence
of image* done to the mind in "every creative act," and the *real bru-
tality* that a totalitarian system makes widespread in all of life: "Ev-
ery creative act contains a real threat for the person who dares to
do it, and this is why a work touches the spectator or the reader. If
thought refuses to be weighed, to be assaulted, it exposes itself to
suffering fruitlessly every brutality that its absence has set free."[4]
If death is placed in a montage with sex, it is not to debase death
but quite the contrary; nor is it to necrotize sex. It so happens
that in the camps the same German word *sonder* (special) desig-
nated both death (as in *Sonderbehandlung*, which referred to the
"special treatment" of gassing) and sex (as in *Sonderbau*, which re-
ferred to the brothel). A montage can attempt to take this into
account.

> But often we say: there must be no amalgam. It is not about an
> amalgam, things are put together, the conclusion is not given
> immediately. [. . .] They existed together, so we remember
> that they existed together.[5]

To make a montage does not mean to assimilate. Only superficial
thinking suggests that if something is adjacent, it must be the
same. Only an advertisement can attempt to make us believe that
an automobile and a young woman are of the same nature simply
because they are seen together. Only a propaganda image can at-
tempt to make us believe that an obviously minority population
can be to the entirety of Europe what a giant octopus is to its prey.[6]
In their critical reflections on images, the masters of montage —
Warburg, Eisenstein, Benjamin, Bataille — all accorded a central
place to the political power of propagandist imagery. But reject-
ing the imagery in the image, they caused *resemblances* to spread
by making *assimilations* impossible; they "tore" resemblances by
producing them; they made us think about *differences* while creat-
ing relationships between things.[7]

In order to formally demote my analysis of the photographs

of Birkenau as an "abject idea," Gérard Wajcman would have had
to systematically conflate resemblance with assimilation and the
similar with the *semblance* (hence with the artificial, with the fe-
tish, with perversion, with abjection). He scrupulously repeats
the words of Claude Lanzmann on the "photographs of prisoners
beaten by the guards and [. . .] of guards beaten on the day of the
liberation of the camps." He injects a political note: "It is the same
[identification] that today makes the Palestinians the Jews of our
time and the Israelis the new Nazis." He protests, with all of his
moral energy, that "no, the executioners were not similar to the
victims, and nor are they similar to me."[8] He is so afraid of the im-
age that he confuses *resemblance* with *identity*, while accusing that
which is *similar* of being nothing more than a *semblance*.

> The idea that "Auschwitz is inseparable" is a terrible idea.
> First, I understand the opposite, that for us it is separation
> itself. Auschwitz as the absolute Other [. . .]. This is what
> the lofty idea of thinking Auschwitz against the impossible
> comes down to: they are we, we are all victims and we are all
> executioners. [. . .] In this waltz of possibilities in which each
> is similar to the other, it was inevitable to come to this abject
> idea of infinite and reciprocal exchange of places between the
> executioner and the victim.[9]

After that, all that was needed was the final deduction or, at the
very least, a strong suspicion that this anthropological view of the
image quite simply joins the Nazi view itself: "To make the image
into the human foundation shows the ravages that the thought of
images provokes. [. . .] In the killing of six million human beings,
it was not six million images that died in the camps, six million
Figuren as the Nazis actually called the cadavers."[10] What Gérard
Wajcman seeks to express, by this last inference, this last insult, is
that the *ethical position* regarding the Shoah must be as simple as
it is radical: it suffices to posit an "Absolute Other," a separation
without remains, an impossible *without in spite of all*. And the *un-
imaginable* then appears as only one way among others to claim this
ethical position. The opposing position, which speaks of the "in-
separable" and of the "possible" in Bataille's sense, which invokes

the *imaginable in spite of all*, will then be aggressively criticized as being a *perverse position*, meaning an "abject" position.

In reality it is Wajcman who carefully perverts the meaning of the words he reads in my analysis. When I wrote, for example, that "the victims should of course not be confused with the executioners," he was content to voice, without arguing it, a unilateral doubt: "I am not quite reassured by this 'of course.'"[11] How should one respond, except by saying that before displaying one's moralist stance, one should know how to ask and situate the *ethical question* itself. The question remains: it is *as a fellow human* [*en tant que semblable*] that one human being becomes the executioner of another. The tiger will never be man's executioner precisely because he is radically other, and, as such, man can quite innocently be his prey and his meal. The relationship between an executioner and his victim is founded on their shared "human species," and it is here that is embedded the ethical problem of racial hate, humiliation, cruelty in general, and Nazi totalitarianism in particular.

In this relationship between fellow humans [*semblables*], there is nothing—barring a characterized perversion—that allows us to claim that while they are *fellows*, the victim and the executioner are *indistinguishable*, substitutable, or interchangeable. The simplest example is offered by Charlie Chaplin's *The Great Dictator*: the Jew and the dictator are more than fellows since they are the spitting image of one another; but at no moment do we find them indistinguishable. Everything sets them apart from one another at every moment. And when, in order to save his life, the Jew must dress in the robes of the dictator, the substitution itself only dissociates the elements of this structure, since it is Chaplin the artist who appears suddenly before the camera, beyond his two characters, as a citizen of the world assuming the responsibility of his ethical discourse.[12]

[]

Ethics are simplified when we throw "radical evil" onto the side of the "Absolute Other." The aesthetic of the *unimaginable* is a trivial "negative aesthetic"—born of the sublime as reinterpreted by

Lyotard—in the sense that it characterizes radical evil by every-
thing that it is not; in so doing, this aesthetic sets evil at a distance
from us and legitimizes itself through this distancing, through this
very abstraction. The *imaginable* certainly does not make radical
evil "present" and in no way masters it on a practical level: what it
does do is bring us closer to its *possibility*, always open in the open
of some familiar landscape:

> The crematorium is out of use. Nazi ruses are out of fashion.
> Nine million dead haunt this landscape.
>
> Who among us watches over this strange observatory to
> warn us of the coming of new executioners? Do they really
> have a different face from our own?
>
> Somewhere, among us, there remain some lucky capos, re-
> habilitated bosses, unknown informers.
>
> There we are, we who look sincerely at these ruins as though
> the old concentration camp monster were dead under the
> rubble, we who pretend to regain hope before this image that
> grows distant, as though we were curing the concentration
> camp plague, we who pretend to believe that all of this is of one
> single time and of one single country, and who do not think of
> looking around us and who do not hear the endless cries.[13]

To study an image of the Shoah is not "to pretend to regain hope in
front of the image that grows distant." It is to persist in approach-
ing *in spite of all*, in spite of the inaccessibility of the phenomenon.
It is to *not* console oneself in abstraction; it is to seek to understand
in spite of all, in spite of the complexity of the phenomenon. It is to
tirelessly ask the question of *how*: "After continuously considering
the Nazi crimes as unrepresentable, and the massacre of millions
of innocent beings as definitively unintelligible, we end up no lon-
ger asking *how* the camps functioned," writes Wolfgang Sofsky.[14]
It is not a matter of unilaterally positing the unsayable and the un-
imaginable of this story; rather, it is a matter of working *with* it, yet
against it: by making the sayable and the imaginable into infinite
tasks, necessary yet inevitably lacunary.[15] It is because it is badly
posited that the question of image unbalances the violent debates
on the "specificity" or the "universality" of the Shoah.[16]

Jean-Luc Nancy and Jacques Rancière recently added philo-
sophical clarity to the motif of the *unrepresentable* that is so often
trotted out. Nancy discerns "an ill-determined but insistent prop-
osition" in the "opinion" discourse, a "confused" slogan, incapable
as such of giving a coherent answer to the "ultimate crisis of repre-
sentation" into which the Shoah has thrown us. The dogma of the
unrepresentable mixes impossibility with illegitimacy and makes
every image an object of prohibition and of eradication. Nancy
proposes to deconstruct this "prohibition" and henceforth, with
respect to the Shoah, to understand representation as "prohibited
in the sense of surprised, taken aback, paralyzed, confused, or dis-
concerted by this digging at the heart of presence." Now, *prohibi-
tion* no longer indicates *revocation*, banishment, but instead the
intrinsic *gesture* by which representation itself—in the suspense
of surprise—is animated.[17]

The *gesture of the image* certainly constitutes the object of mon-
tage par excellence according to Godard: to make a montage of
images, animated one with the other—for example Hitler's hands,
the dive bombing, and the flight of civilians[18]—is not only to cre-
ate an abstract synthesis of the totalitarian process: it is also to
produce a *gesture* as *complex* as it is concrete, an "unsummarizable"
gesture. In this sense, Godard is indeed the (conscious) heir of
Nietzsche and Eisenstein, the (unconscious) heir of Burckhardt
and Warburg: his reflection on history delivers an *energetics* that
Jacques Aumont appropriately called a "new *Pathosformel*."[19] As
in Warburg's work, indeed, the gesture is understood (and pro-
duced) by Godard as a *symptom*, that is, as a montage of heteroge-
neous times in which representation is "surprised," "suspended,"
even "prohibited"—in Jean-Luc Nancy's sense—insofar as its
proliferation outlines something less like an iconography than a
seismograph of history.[20]

"Postmodern disenchantment" ignores such an energetics.
Jacques Rancière saw the motif of the *unrepresentable* as constituted
both from this ignorance and from the nihilism that goes with it:
"Postmodernism has become the grand threnody of the unrep-
resentable/untreatable/unredeemable, denouncing the modern
madness of the idea of a self-emancipation of the humanity of man

and its inevitable and interminable culmination in the extermina-
tion camps."[21] More recently, Rancière introduced the question
from the perspective of "sacred terror" in a passage virtually point-
ing to Wajcman's *absolute object*:

> [There is an] inflationist usage of the notion of the unrepre-
> sentable and of an entire series of notions to which it is will-
> fully connected: the impenetrable, the unthinkable, the un-
> treatable, the irredeemable, etc. This inflationist usage in effect
> makes all kinds of phenomena, processes, and notions fall un-
> der one same concept and encircles them within the same aura
> of sacred terror, from the Mosaic interdiction of representa-
> tion to the Shoah, through the Kantian sublime, the Freud-
> ian primal scene, Duchamps' *Grand Verre*, or Malevitch's *White
> Square on White*.[22]

In this blurred theoretical landscape, the notion of the unrep-
resentable, according to Rancière, has "a very precise effect: it
transforms the problems of regulating representative distance
into problems of the impossibility of representation. The inter-
diction then slips into this impossibility, all the while denying it-
self, offering itself as a simple consequence of the properties of the
object."[23] We might think we are reading an analysis of Wajcman's
texts when, for example, a few lines later, Rancière writes: "To
represent nothing of the Shoah is not a free choice but, rather,
a forced one. It is not a question here of interdiction [. . .], it is
simply that there are things that are impossible to see." Then: "If
there is *Shoah*, then there is no image to come."[24]

To this, Rancière responds: "This fable is convenient, but it
is inconsistent"—recalling that *Shoah*, like any work inscribed
in the history of cinema, arises from a system of representation
regulated on the basis of the specific problem of its object: "*Shoah*
posits only problems of relative unrepresentability, of adaptation
of the means and the ends of representation. [. . .] There is no un-
representable as a property of the event. There are only choices."[25]
By superimposing an "unthinkable at the heart of the event" on
an "unthinkable at the heart of art," we merely—according to
Jacques Rancière—prolong the "speculative hyperbole of the

unrepresentable" proposed by Jean-François Lyotard on the basis of a certain conception of the sublime and of the "originary
unthinkable."[26] Like the unrepresentable and the unthinkable, the
unimaginable can be summarized in many cases as a simple *refusal to
think the image*, legitimizing itself by means of hyperboles.

[]

The thesis of the unimaginable has bunched together three concomitant hyperboles. The first: if we want to *know* something
of the Shoah, we will have to get rid of images. "If there were
any images of the gas chambers, there would still be a question
of knowing what they could show of the truth," writes Gérard
Wajcman, for example. Against what he calls the "promotion of
the imagination as an essential instrument of knowledge," he posits that the image is merely an "invitation to hallucinate." Against
the exploration of archives, he posits that with *Shoah* "we know,
and therefore we know all, and we are on the same level as all of
the knowledge."[27] On the one hand, Wajcman ignores the fact
that any knowledge to be grasped from the *experience* of others
must, phenomenologically, pass through the *imagination*.[28] On the
other hand, he admits this, but only for Lanzmann's film, which
indeed, and powerfully, solicits the imagination of its witnesses
(so that they are able to enunciate something of their experience)
as of its spectators (so that they are able to hear something of that
experience).

The second hyperbole: if we want to convoke a proper *memory* of the Shoah, we will have to dismiss all images. This speaks
against a long philosophical tradition of memory that runs from
Aristotle to Bergson, Husserl, Freud, and beyond.[29] It is true that
Gérard Wajcman attempts—as sincerely as he does naïvely—to
raise his memory of the Shoah to the level of the event itself: he
wants it absolute, not relative to points of view; in short, he wants
it to be clear of all images.

The third hyperbole seeks to draw the moral consequences of
such a demand: *ethics* disappears, according to Wajcman, wherever
the image appears. Hence those tiresome amalgams of the "buli-

mia of images" and "fetishistic" perversion, the "generalized love of representation" and "thought infiltrated by Christianity," all of this dissolved into a "televisual ideal," summarized as the "idea that everything [is] representable *in spite of all*" in the "universal church of images," that is to say in the successive chapels of Saint Paul, Saint John, Saint Luke—Saint Jean-Luc—and Saint Georges.[30]

All of this focused on—or bristling at—the proposition that opened my analysis of the four photographs from August 1944: "To know, we must *imagine for ourselves*" was interpreted as though I had written: "To know, it suffices to imagine for ourselves." To be content with images would be, of course, to deprive oneself of the means of understanding them, and this is why I had to call upon other sources, other testimonies, even "the entire library of the twentieth century," for which Wajcman reproaches me in total exaggeration and total incoherence.[31] Images become precious to historical *knowledge* the moment they are put into perspective, in *montages* of intelligibility. The *memory* of the Shoah should continually be reconfigured—and, one hopes, clarified—as new relationships are established, new resemblances are discovered, and new differences are underlined.

Moreover, I did not choose to write: "To know, we must *imagine something.*" I said: "To know (to know this story from the place and the time in which we find ourselves today), we must *imagine for ourselves.*" The casting of the subject into the exercise of *seeing* and *knowing* begins with an epistemological concern: we should not separate the observation from the observer. Wajcman, as I have already emphasized, confuses *imagining for oneself* with *believing oneself to be there*. Thus his ethical conclusions regarding the "perversion" and the "abjection" of such an attitude are completely unfounded. I believe it useful, however, to clarify just how the gaze cast upon (the) images, as well as the exercise of the imagination itself, has nothing of the immoral "passion" or the fatal "outlet" diagnosed by Gérard Wajcman.[32]

The *image*, in the anthropological sense of the term, is at the heart of the ethical question. This did not escape the attention of those men and those women who, as survivors of the Shoah, would not abandon themselves to pure helplessness, to the "fail-

ing of politics," and who attempted, however difficult the task, to "think what is happening to us." A current problem if ever there was one.[33] The "exemplary singularity" of the camps is recognized in the fact that *humanity* itself was systematically denied, destroyed, crushed, and abolished. What is to be done now? "What should we remember so that we might be able to act?" That is the question asked by Myriam Revault d'Allonnes in the course of a remarkable philosophical development on the difficult question—both ethical and anthropological—posed by the experience of concentration camp and genocidal *dehumanization*.[34]

We cannot think the inhuman condition of those submitted to the terror of the camps, without recognizing "a crisis of identification and a failure of the recognition of one's fellow human."[35] Myriam Revault d'Allonnes evokes the testimonies of Primo Levi and of Chalamov, as well as a famous passage in *L'espèce humaine* [*The Human Race*] in which Robert Antelme cruelly expresses how that failure was found even at the heart of the relations between prisoners:

> When, arriving at Buchenwald, we saw the first men in striped uniforms, bearing rocks or pulling barrows to which they were roped, their shaved heads bare under the August sun, we did not expect them to speak. We expected something else, perhaps wailing or whining. Between them and us was a distance that we could not cross, which the SS had long filled with their contempt. We did not even imagine approaching them. They laughed as they looked at us, and we could not yet recognize that laughter, or name it.
>
> Yet we would ultimately have to make it coincide with the laughter of men condemned soon to no longer recognizing themselves. This happened slowly, while we became like them.[36]

Not only does the camp destroy men and invent, in the relationship between executioners and victims, a radical dissimilarity between "humans" and "subhumans" (a dissimilarity that relieved the torturers of any guilt); but the camp also attempts to destroy the possibility for prisoners to recognize their own companions

as other men, their fellows. When this happens, the "condition that makes the human possible" crumbles.[37] The four images of Birkenau are precious to us only because they offer the *image of the human in spite of all*, the resistance by means of the image—a scrap of film—to the destruction of the human, which is documented nonetheless. As though the gesture of the clandestine photographer addressed us with some sort of unformulated message: look at what my (our, your) fellows are forced to do (fig.9); look at what my (our, your) fellows are reduced to (fig.12); look at how the already dead and the still living who drag them through the furnace are my (our, your) fellows; look how they are together annihilated by the Final Solution; may you look at it, attempt to understand, when the Final Solution, beyond our own death, is brought to an end; and may you never stop protesting against this history. That is why these photographs are important to us, why they concern us, why they look at us from the specific situation to which they bear witness.

We must now think this from our own survival situation with respect to that history. "To elaborate the terrible," as Myriam Revault d'Allonnes has put it. It is not a question of "believing oneself to be there," of course. Rather, it is a question of engaging a "process of recognition of the similar," which grounds the very *ethics* of our relation to the experience of the camps.[38] This process is *imagination*, of which Robert Antelme warned us from the very opening of his book:

> Hardly had we begun to tell our story before we began to suffocate. To ourselves, what we had to say began to seem *unimaginable*.
>
> This disproportion between our experiences and the narrative that could be made of them was only confirmed by what followed. We were indeed dealing with one of those realities that are said to exceed the imagination. Henceforth it was clear that it was only by choice, *that is to say, again by the imagination*, that we could try to say something about it.[39]

Imagination doesn't give an event "proportionality." It works at the very heart of the *disproportion* between the experience and its

narrative. It is in this sense that Gilles Deleuze—going against
Adorno's famous dictum but borrowing directly from Kafka—
asked: "The shame of being a man, is there any better reason to
write?"[40] As though the imagination were animated precisely by
the arrival of the "unimaginable," a word often used to express our
disarray, our difficulty in understanding: that which we don't un-
derstand but won't give up trying to understand—that which in
any case we don't want to shove into an abstract sphere that would
rid us of it easily—we are bound to imagine, as a way *of knowing it
in spite of all*. It is also a way of knowing that we will certainly never
grasp it in its exact proportionality.

How does this concern ethics? The whole thrust of Myriam
Revault d'Allonnes's analyses is to remind us—following Hannah
Arendt and, before her, a long philosophical tradition—that the
imagination "is also a *political* faculty. [. . .] We are neither in com-
munial fusion, nor in consensual truth, nor in sociological prox-
imity. We attempt, on the contrary, to *imagine* what our thought
would resemble if it were *elsewhere*."[41] The attempt, according to
Hannah Arendt, to think both the *radicality* and the *banality of evil*
at the same time results from putting political imagination into
motion.[42] The judgment of Adolf Eichmann—the judgment of a
whole history of which she was the survivor—prompted Arendt
to reinterpret politically the Kantian "faculty of judgment," which,
as we too often forget, seeks to establish a bridge *between aesthetics
and ethics*, which concern the two greater parts of the work.[43]

This is why it was necessary *in spite of all* to cast an aesthetic
gaze on the four photographs of Auschwitz: in order to shed
light on the *ethical* and anthropological content of the trust ac-
corded to those images by the members of the *Sonderkommando*.
Images made, paradoxically, to show the crumbling of the similar
within the organization of the massacre. Images to show, with a
disconcerting crudeness—some shadow and some light, some
naked bodies and some clothed bodies, some victims and some
"workers," some boughs of trees and some curls of smoke—what
the organization of Auschwitz sought to abolish definitively: the
recognition of one's fellow, the similar, upon which the social link is
founded, of which Arendt looked for diverse philosophical ex-

pressions in Plato's *koinōnia*, Aristotle's *philanthropia*, and Spino-
za's *similis affectus*.[44]

Gérard Wajcman takes none of this into account when, under
the pretext of an "ethics of the visible" and armed with his single
reference to *Shoah*, he demands that all "images of Auschwitz," as
he calls them, be purely and simply dismissed; when he states that
the memory of the Shoah must be, like the Shoah itself, "the pro-
duction of an Unrepresentable"; when he persists in seeing in each
image no more than a "denial of absence," a singularity incapable
of reporting the terrible "all" of the extermination.[45] Yet it is pre-
cisely as singularities—incomplete, incapable of all—that we find
the images *in spite of all* necessary.

"And what then are images?" asked Paul Celan: "That which
once, each time being the only time, only here and only now, is
perceived and to be perceived (*Wahrgenommene und Wahrzuneh-
mende*)."[46] An image is not "the denial of absence" but, rather, its
very attestation. To hold one of the four photographs of Birkenau
in one's hands is to know that those who are represented in it are
no longer there. When Zalmen Gradowski asks the discoverer of
his manuscript to see that the photographs of his family be joined
to his text, it is not to delude himself about the presence of beings
that he himself saw incinerated: "Here is my family, burned here
on Tuesday, December 8, 1942, at nine o'clock in the morning." It
is because, he says (as a member of the *Sonderkommando*): "Alas! I,
their child, cannot cry here in my hell, because I am drowning each
day in an ocean, an ocean of blood [and] I must live here still," in
this slavery of death. And he signs: "He who is on the threshold of
the tomb."[47]

[]

The final argument made against the (historical and phenomeno-
logical) attention given to the four images of Birkenau consisted,
on a very general level, in rejecting any kind of trust in photog-
raphy's powers of testimony. Such trust is dismissed as nothing
more than an obscurantist "belief." A *religious paradigm* ends up
commanding the whole debate. The image consoles, it "relieves

our horror of seeing nothing by giving us images of horror to see"
writes Gérard Wajcman. "Even the crudest photograph, even the
most exact with respect to what happened, every image of horror
is a veil to horror; every image, because it is an image, protects
us from horror."[48] I have already said what should be thought of
this unilateral notion of the *veil-image*. But here a new metaphor is
brought to the aid of the argument: it is that of a *mirror-image*—as
is photography—that is simultaneously a *shield-image*:

> The Greeks in times past had invented a myth that revealed
> the pacifying power of images with regard to the real. It was
> the myth of the Gorgon Medusa, a monster whose face could
> not be looked at directly: all those who raised their eyes to
> look upon her were instantaneously turned to stone, truly
> petrified. Therefore, when Perseus, having come to kill the
> Gorgon Medusa, found himself facing her, he made sure never
> to look at her face. To observe her movements, he raised his
> metal shield and, using it like a rearview mirror, his eyes fixed
> on the reflection, was thus able to cut off her head with one
> sword stroke. The mirror, the image, is a real shield against the
> Real that cannot be looked at, and this is what a myth, among
> other things, came to reveal.[49]

Moving on quickly from this pagan parable, unfit for the ideologi-
cal confrontation regarding the Shoah, Wajcman hung another
shield onto me, a different armor from that of Perseus. With the
facility that my first name afforded him, he figured me as "Saint
Georges [. . .] facing the dragon of the Unrepresentable": at once
a "secular saint" and an "adventurer of thought" bent on a "crusade
for reconquering the Shoah [and] unable not to plant his flag."[50]
On the flag? A cross, of course. In my fist? Images and, primar-
ily, "Photography, striking down the Unrepresentable." In the
back of my mind? A religion close to that professed by Jean-Luc
Godard (for the epigraph), which would allow me to be figured
also as Saint John (for the apocalypse) and as Saint Paul (for the
resurrection).[51]

Not only is "every image [. . .] a call to faith," but also "the Chris-
tian passion of the image infiltrates and adheres to everything."

Gérard Wajcman, who claims "an original and inveterate athe-
ism," thinks he has diagnosed "a rampant anti-Semitism [. . .] even
in declared Jews" who, in their "passion for the image," merely
"Christianize" the Shoah.[52] In this debate, therefore, the image
is expected to rhyme with "belief" in general and, worse, with
"Christianity" in particular. On the *cultural* side, this results in
"the elevation of an image to a relic," the "litanies" of its exegesis,
and other baggage that is "fetishistic" and therefore perverse in
the clinical as much as the moral sense.[53] On the *theological* side,
Wajcman claims that "the image would truly be Salvation" as well
as an "epiphany of truth," a truth whose basis is "religious, inti-
mately Christian, in fact."[54]

Insofar as my analysis of the Birkenau photographs called for no
paradigm on the theological level, we can hypothesize that the en-
tire diagnosis proposed by Wajcman is founded on a simple—but
powerful—effect of association, notably illustrated in Godard's
words cited in the epigraph to part one of this book:

> even scratched to death
> a simple rectangle
> of thirty-five
> millimeters
> saves the honor
> of all of the real.[55]

The idea of "honor" is not, in itself, religious; we should rather re-
fer it to the ethical world or the political paradigm of "resistance."
But, insofar as Godard himself, earlier in his *Histoire(s) du cinéma*,
cites a famous Pauline motif—"the image will come at the time
of the resurrection"[56]—it seems possible to unite the motifs of *re
demption* by the image, the "saved honor" of the real, and, finally,
the *resurrection* of the dead. Hadn't Gérard Wajcman already found
in Godard "a supposed politics of [claimed] images in order to
produce more junk, a real theology [that] allows him to preserve
a little belief in the resurrection of the Image"?[57]

It seems logical to unite within the same theological "junk," the
redemption of history and Christian *resurrection*. That, however, is
a philosophical misinterpretation. To begin with, Wajcman is not

sensitive to Godard's irony. Is saying that "the image will come at the time of the resurrection" the same as saying, in a film as melancholy as *Histoire(s) du cinéma*, that the time of the resurrection will come? Isn't it rather to say that the "image"—that is, the Image with a capital "I," the *one* image, the *all* image—is *not* given to us, that there is to be *no* awaiting it? We are given only the "simple rectangle of thirty-five millimeters," which does not form the *all image* but rather the *lacuna-image*, the scrap ("scratched to death": unable to be wholly reconstituted) of an aspect of the real. Looking at this scrap of an image, we have no hope (even less the illusion) of resurrection. While the voice-over resonates—"even scratched to death . . ."—we only see, on the screen of *Histoire(s)*, the charred remains of a man: the work of some *Endlösung* from which the man, here in this partial view with the millions of others that form the space outside of the frame, will never be resuscitated, even though his *resemblance in ashes* still "clings," beneath our gaze, to the photogram (fig. 30).

Figure 30. Jean-Luc Godard. *Histoire(s) du cinéma*, 1988–1998. Photogram from part 1a, entitled "Toutes les histoires."

The *lacuna-image* is a *trace-image* and a *disappearance-image* at the same time. Something remains that is not the thing, but a scrap of its resemblance. Something—very little, a film—remains of a process of annihilation: that something, therefore, bears witness to a disappearance while simultaneously resisting it, since it becomes the opportunity of its possible remembrance. It is neither full presence, nor absolute absence. It is neither resurrection, nor death without remains. It is death insofar as it makes remains. It is a world proliferating with lacunae, with singular images which, placed together in a montage, will encourage *readability*, an effect of knowledge, the kind Warburg called *Mnemosyne*, Benjamin called *Arcades*, Bataille called *Documents*, and Godard today calls *Histoire(s)*.

To conflate the *Histoire(s)* with a resurrection is to profoundly misrecognize the work of *time*: Wajcman always reasons in a trivial "either-or" fashion, which is refuted by the very existence of images, signs in general, and their memory. Death makes *remains*, I repeat. (Although every murderer dreams that his victims will die without leaving remains, the Nazis did not succeed, as we know, in erasing *all*.) There is therefore no reason to call upon *resurrection* in order to observe the survival of which the world of memory is woven, to which images contribute.[58] As though it were not enough to confuse what is opposed, Wajcman shows ignorance as well regarding the philosophical *history* in which the word *redemption* has taken meaning in the context—Auschwitz—of our interrogations.

How is it that a "simple rectangle of thirty-five millimeters" can *redeem*, can "save" anything from the Real of Auschwitz? Is it only the guilt of not having been *there*—the insert that precedes the photogram of the body in ashes in the *Histoire(s) du cinéma* carries the inscription *Dasein*?[59] Is it the guilt of cinema in general that Godard attempts to redeem through his immense labor of mnemonic montage? Not only that. The *redemption of the real* is found to be one of the most profound notions for those whom Walter Benjamin called, including himself, the "generation of the downtrodden."[60] They were Jewish thinkers and revolutionary thinkers, among the first to be persecuted, tempted to flee or to

commit suicide, who had decided, however, *to rethink history in spite of all* while history in fact was closing around them and demonstrating the futility of progress, the crumbling of utopias, the power of totalitarianisms.[61] *Erlösung*, or "redemption," was to these German-speaking thinkers a poor but necessary response to the great machines of terror denoted, among other things, by the technical term *Endlösung*, "Final Solution."

A few reference points, a few dates, will suffice. Franz Kafka began writing *The Trial* in 1914—he had finished *The Verdict* in 1912—as a great question addressed to *Erlösung*, which he saw as a persistent "negative utopia."[62] In 1910, Franz Rosenzweig had written that "every act becomes guilty as soon as it enters history."[63] By publishing *Der Stern der Erlösung* (*The Star of Redemption*) in 1921, Rosenzweig attempted to give *Erlösung* a philosophical meaning as a "violent rupture of the historical tissue, the irruption at the heart of the time of an absolute otherness, of a radically different form of experience"; redemption thus understood no longer concerned the relationship of man to God but, rather, an *"aesthetic relationship" of man to history*, at the very moment when history was revealing its incapacity to maintain the illusion of progress.[64] For Rosenzweig, redemption no longer denotes definitive salvation, the "end of time," let alone the resurrection of anything. Redemption is "waiting for a disruption that can occur at any moment," or a *moment of resistance* to the claws of history when they close in on us. It is "the Yes in the blink of an eye" writes Rosenzweig, while the No reigns as absolute sovereign over what is to come.[65]

In 1931, Gershom Scholem commented on Rosenzweig's thesis from the point of view of a "dialectical historical essay on the concept of redemption."[66] Five years later, when the Nazi system was already reigning with absolute sovereignty, Scholem undertook a historical study of the concept of redemption in Jewish mysticism. First, he described "redemption through sin," extolled in the Sabbath-heresy and in the nihilism of Jacob Frank.[67] Then, in 1941, he wrote the first version of a study that has become a classic on the "idea of redemption in the Kabala." A study anchored in the most immediate history—his friend Walter Benjamin had just killed himself, fleeing the Gestapo:

Faced with the essential problem of life, meaning deliverance
from the chains of the chaos that is history, we can hesitate
between two paths. We can focus our attention on the "end"
of time, on messianic redemption; we can place our hope in
this end of time, strive to accelerate it, and consider salvation
a race toward this end [. . .]. But we can also choose the opposite
path and seek a way out of the stain, the confusion, the chaos,
and the cataclysms of history by *a flight toward the beginning.*
[. . .] Hence the importance of the problem of creation.[68]

Scholem showed that the Jewish notion of redemption (*ge'ulah*)
forms a harsh contrast to the notion—a Christian notion, then a
Hegelian one, even a Marxist one—of historical salvation. It is a
response to the condition of *exile*, but a response guided by an "ab-
solute pessimism" as regards history and its progress. "The classi-
cal Jewish tradition," writes Scholem, commenting on a chapter of
the treatise of *Sanhedrin*, "likes to highlight the *catastrophic* aspect
of redemption [. . .]: redemption is a destruction, a titanic collaps-
ing, a subversion, a calamity; there is no room for favorable evolu-
tion or any progress. This results from the dialectical character of
redemption in this tradition."[69]

We know that in 1940, just before committing suicide, Wal-
ter Benjamin was able to reformulate, to *retrace and reassemble,*[70]
all of his sources, from the Kabala to Kafka, from Karl Marx to
Rosenzweig, in a notion of *Erlösung* understood from the point
of view of the catastrophe and in the absence of any "salvation"
either historical (definitive victory over the forces of totalitarian-
ism) or religious (resurrection, definitive victory over the forces of
death). The "theses on the concept of history" represent at once
the *testimony* of an historical experience and a disruptive and
totally new philosophical *development* of historicity. They were
surely a direct source for Jean-Luc Godard's *Histoire(s) du cinéma*,
in particular when Godard sees in a "simple rectangle of thirty-five
millimeters"—a simple photogram that appears, only to disappear
in a flash—a possibility of "redemption" from the historical real.

"To do the work of a historian," wrote Benjamin, "does not
mean to recognize things 'the way they really were.' It means to

seize a memory, just as it appears at the instant of danger. For his-
torical materialism it is a question of retaining an image of the past
(*ein Bild der Vergangenheit festzuhalten*) that is offered unexpectedly
to the historical subject at the instant of danger (*im Augenblick der
Gefahr*)."[71] What does this mean? First, that there is no possible "re-
demption" without being situated in a certain relation to *history*:
We cannot invent the future without summoning a recollection
(*Eingedenken*), according to the strange law of anachronism that
we could call the "subconscious of time": "The past is marked by
a secret sign, which sends it back to redemption. Do we not, our-
selves, feel a faint breath of the air in which the people of yesterday
lived? Do not the voices to which we lend our ears carry an echo
of voices now extinguished?"[72]

The "breath of air" and the "echo": Benjamin called them *im-
ages*. To do the work of a historian, he says, entails "retaining" that
breath and that echo, suspending the "image of the past that is
offered unexpectedly [. . .] at the instant of danger." The image
is initially thought only according to the phenomenology of its
apparition, its peril, its passage. And this is what we ought to "re-
tain" (*festhalten*). This model, therefore, contains an *impossible* that
strongly resembles our incapacity, when watching a film, to retain
the images that appear and disappear, that seize us and then flee,
that touch us for a while, though they vanish in an instant. "The
true image of the past passes *in a flash*. We can only retain the past
in an image that appears and that withers forever in the very in-
stant it offers itself to knowledge."[73]

From this perspective, then, we understand that the image does
not reawaken anything, nor does it console. It is "redemption"
only in precious moment of its disappearance: it expresses the
tearing of the veil *in spite of all*, in spite of the immediate re-veiling
of everything in that which Benjamin would call the "desolation of
the past."[74] In the manner of Godard, the photograms of George
Stevens (figs. 25–26) "save the honor of all of the real" in the single
instant that they appear in order to "save" themselves, that is, to
flee almost immediately from our visual field. Montage will at least
have created the mnemonic conditions for these ever so *fleeting*
yet pregnant images. The fiction of happiness that embraces Eliza-
beth Taylor and Montgomery Clift (figs. 27–28) is shown only in

counterpoint to this "desolation of the past": "redemption" is thus, more profoundly, that which enlightens us regarding the *dialectical* manner in which both of these states exist on the foundation of the possibility of the other.

So we can understand nothing of the anachronistic idea of "redemption" if we reduce it to a definitive salvation of the past in some radiant future. Benjamin could not have found stronger words against the way the "old protestant ethic" and "vulgar Marxism" make the idea of work the "messiah of modern times."[75] If, ultimately, he evokes the Jewish practices of commemoration, it is because those practices, in the principal festivals of the religious calendar, recall the "redemptive events" as memories of exile.[76] The "Benjaminian aesthetic of redemption," as Richard Wolin chose to call it, is proposed *in spite of all* only as a last-gasp resistance—but a long-term lesson for us—to nonconsolation in the face of history: "We ask of those who will come after us, not gratitude for our victories, but the recollection of our defeats. This is consolation: the sole consolation that is given to those who no longer have any hope of being consoled."[77]

[]

The "scratched to death" photogram by George Stevens, made while he was filming the opening to the camps, therefore only "saves" the "honor" of the historical real at the very time of its flight—but of a flight that must constantly be recollected. This photogram, testimony to a time that was impossible to reconstitute as an *all image*, gives, in spite of all, the *lacuna-image* of a history of which we are the legatees. It is merely a singularity, but one whose montage should permit articulation and elaboration. The task that Benjamin assigns the historian—one that Aby Warburg had already assigned to himself, and to the point of madness—is, by right, impossible: in order for "all of the real" to be redeemed, "all the past" would have to become citable:

A chronicler who recites events without distinguishing between major and minor ones acts in accordance with the following truth: nothing that has ever happened should be

regarded as lost for history. To be sure, only a redeemed man-
kind receives the fullness of its past—which is to say, only
for a redeemed mankind has its past become citable in all its
moments.[78]

But what the philosopher knows to be impossible *by right*, the
historian and the artist experiment with as a possibility *in spite of
all*. A clearly incomplete, erratic possibility, always to be taken up
again, restarted, and reconfigured. It is for this reason no doubt,
that *Histoire(s) du cinéma*, in the multiplicity of its variants, is given
as a work never really finished. This too is why "redemption" is
in no way concerned with an "end of time" but, rather, with each
instant of our open present. If the philosophical thought of the *Er-
lösung* found a certain echo in a few of Benjamin's contemporaries
who, being in exile, survived the *Endlösung*—I am thinking, in
particular, of Ernst Bloch and Karl Löwith[79]—it is with Siegfried
Kracauer that those concomitant theses of Benjamin on history
and on the image met what we might call their "friendliest" fate.
The closeness of their approach to the issues resulted in nothing
less than a theory of cinema, expressed by Kracauer in terms that
were almost those of Benjamin and would be almost those of Go-
dard: "the redemption of physical reality."[80]

Siegfried Kracauer is known mainly for being the first to use
cinema in his analysis of Nazism as a mass phenomenon. He held
that the art of cinema, "from Caligari to Hitler," had anticipated,
described, denounced, and sometimes served the state of Nazi ter-
ror.[81] In the 1920s, Kracauer began to develop an analysis of images
that is as similar to a "material aesthetic" as it is to an anthropol-
ogy of the visual.[82] Benjamin describes him as an eternal "discon-
tent," a "moaner" who never stops protesting against the numer-
ous instances of cowardliness in history—Carl Einstein comes to
mind—but also as a historian in his own right, a *historian of part
objects*, of scraps, of images. A "rag-and-bone man," let us say:

> A malcontent, not a leader. Not a founder: a spoilsport. And
> if we wished to represent him in our minds as he is in himself,
> in the solitude of his occupation and of his designs, we would
> see the following: a rag-and-bone man in the early morning,

raging and slightly drunk with wine, picking up the debris of discourses and the scraps of language with the end of his stick and loading them, grumbling, into his cart, but from time to time he would sardonically hold out to the morning breeze one or other of these rags dubbed "humanity," "interiority," "deepening." A rag-and-bone man of the early morning—in the dawn of the day of revolution.[83]

Kracauer never stopped exploring the question that constitutes the very basis of our debate: that of the relations between *image* and *real*, when their coming in contact with each other puts the most crucial aspect of *history* at stake. His thinking constantly revolves around the problems of *realism*: he aims to interrogate its "critical value" while, from the outset, he has philosophically dismissed every "theory of reflection"—every referential illusion—as a false problem, a vicious circle, an idealist prejudice.[84] His point of departure is a vehement *critique of the continuous*, which rests, most notably, on an acute observation of the photo journals and the cinematographic news of the 1920s and 1930s. Thus Kracauer, in 1927, took on photography when it claims to restore for us a *continuum* of the space and time that it documents: it then becomes the affiliate of the reigning historicism; then, "behind the photograph of a human being, his history is buried as though under a blanket of snow"; then the image chases away the idea and, "in the hands of the reigning society, [becomes] one of the most powerful means of attack against knowledge"; then the reality it represents is, in Kracauer's words, "undelivered," incapable of any authentic memory. When the world becomes "photogenic" in this way, history is *mortified*, rendered impotent, and reduced to "indifference toward what things want to say."[85]

It is the same with the film newscasts of Universum-film AG, Fox, or Paramount: they claim "to embrace the whole world"; they smother us with natural catastrophes and with sports events, while "all the important events are pushed aside." Kracauer is referring to the *historical symptoms* that split society, that tear up consensus, that make relics of the past rise up and render visible the discontents of our civilization. Only an analysis, a *fragmenting*

followed by a *reconstruction*, can reveal a symptom. Thus Kracauer evokes the significant—but quickly censored—experience of a "cinematographic association" which, on the basis of the "material available in image archives," had attained "a greater sharpness of vision" simply by showing images "differently composed," that is, *reassembled in montage* in the light of a concurrent problem.[86]

The *critical realism* aimed at by Kracauer is obtained only by *breaking the continuity* artificially presented by photographic or cinematographic "historicism." In the montages of Eisenstein and Dziga Vertov, Kracauer admires the manner in which the historic real is deconstructed and then brought back to its true "cause." Discussing *Battleship Potemkin*, he writes that the film "does not capture our attention, as films from the West do, with feelings behind which boredom lies. In it, it is the cause that captures us, because it is true."[87] What fascinates Kracauer in *The Gold Rush* is that Chaplin is a Kafkaesque character, entirely fragmented, that is, revealed through his most secret components: "Other men have a consciousness of self and can experience human relations; but he lost his self, and this is why he cannot experience what we call life. There is a hole into which everything falls; what is usually a con- nected whole breaks up when it hits the bottom and separates into pieces of itself."[88] What especially interests Kracauer in the work of René Clair and Jean Vigo is "the logic of the dream" grafted onto the logic of the Real (in *Entr'acte* and *Sous les toits de Paris*); it is also the manner in which (in *L'Atalante*, for example) the fable becomes "porous," with no declared purpose, yet open to the ir- ruption of either an unperceived or a profound "cause."[89]

With *Westfront 1918*, produced in 1930 by G. W. Pabst, Kracauer encountered a crucial difficulty in judging the ethical and memory value of a "war realism" pushed to the extreme. On the one hand, he criticizes the facility of the "genre tableau" when it seeks to em- bellish the "monotony of the hell" in the trenches, and he deplores the incapacity of film to represent the "precursory signs" of his- tory. On the other hand, he admires the "landscape of barbed wire [that] dominates the space [and to which] all human existence is rendered subordinate."[90] But, above all, he acknowledges the *aes- thetic* risk taken by Pabst, the stakes of which are revealed on the

ethical level of historical memory, or even of political attitude toward the war:

> Without a doubt, the film takes a very important risk on the aesthetic level. It destroys, in the places mentioned, the limits allowed to imitation, and like any panoptic figure it creates the appearance, contrary to nature, of an extra-artistic nature. The question is knowing whether it is right to make the jump into the three-dimensional. I would lean toward replying in the affirmative in this precise case, where it is a matter of keeping the memory of the war alive at any cost. [. . .]
>
> During the screening—the film is being shown at the Capitole—many spectators fled the theater. "It is absolutely unbearable," I heard behind me; and "How could they dare present us with something like that?" If only they would declare, in the case of a war, that it is unbearable and that they will no more allow themselves to be presented with such a thing. But just as they dread the spectacle of war, they generally flee the knowledge which, once acted upon, could prevent it.[91]

Three years later, Kracauer experienced the advent of Nazism, and then a war that the scandalized spectators of 1930 would not have known how to prevent. After the appearance of his 1947 book on the symptomatic value of cinema in this history,[92] Kracauer was not afraid of formulating the ethical prerogatives of the image from the point of view of a *redemption in spite of all*, even if this hope—as it did for Walter Benjamin—met with Adorno's incomprehension.[93] One of the great strengths of *Theory of Film*, which may be described as Kracauer's ethical testament, lies in its refusal to renounce either *constructivism* or *realism*: instead of playing one against the other (a trivial position, the cliché of the history of styles), Kracauer attempts to play one *with* the other, with the view, precisely, of developing a certain experience of history in the image.

On the one hand, therefore, *the image deconstructs reality*, thanks to its own effects of construction: unobserved objects suddenly invade the screen; the changes of scale change our view of the world; the novel arrangements produced by montage make us

understand things differently. Familiar situations are emptied of their meaning, but "suddenly the void explodes," and then empirical chaos becomes "fundamental reality." It is by its construction of strange things—something Kracauer calls *extraterritoriality*—by its "cross-sections" in the spatial and temporal continuum, that the image touches a real that reality itself kept veiled from us.[94]

And that is precisely how *the image touches time*: by deconstructing the narratives, the "historicist" chronicles, it becomes capable of a "critical realism," that is, a power to "judge" history, to bring to the surface what survives of a hidden time, to make visible the "return of the absent" in the extraterritoriality and the very strangeness of cinema.[95] Kracauer does not hesitate to speak of the "revealing functions" of cinema: we reach, by these artifices, "things normally unseen," "blind spots of the mind." What are these things? They range from small "elemental catastrophes" of physical or psychic life to great catastrophes of history and of society, foremost among these being, for Kracauer, "atrocities of war, acts of violence and terror."[96]

It is certainly not by chance that Kracauer's book should give pride of place to the "factual film" (or the documentary).[97] Or that he should conclude with a reflection that attempts to draw—in terms of "redemption"—the theoretical consequences of the disruption experienced at the sight of Georges Franju's *Sang des bêtes* and, above all, the "films produced about the Nazi camps," those documents filmed after the Liberation, though Kracauer very probably has Alain Resnais's *Nuit et brouillard* in mind also.[98] In his last work on history, eloquently subtitled *The Last Things before the Last*, Kracauer would compare the "researcher of time"—at once a rag-and-bone man and a montage maker, or a history filmmaker—to Orpheus descending into hell in order to bring, although it is impossible, Eurydice back to life.[99]

It is impossible, indeed. The image—and the same applies to history—*does not resuscitate anything*. But the image "redeems": it saves a piece of knowledge, it *recites in spite of all*, and, in spite of the little it can, the memory of time. Kracauer knows very well that Pabst's realism, in 1930, prevented nothing in 1933. He knows very well that *Nuit et brouillard* will not prevent other nights from falling, or other fogs from taking hold of us. But the image "re-

deems": in it, he says, the great energy of Perseus is unfurled. And his book concludes, or almost does, with the parable of the Gorgon's head:

> We have learned in school the story of the Gorgon Medusa whose face, with its huge teeth and protruding tongue, was so horrible that the sheer sight of it turned men and beasts into stone. When Athena instigated Perseus to slay the monster, she therefore warned him never to look at the face itself but only at its mirror reflection in the polished shield she had given him. Following her advice, Perseus cut off Medusa's head with the sickle which Hermes had contributed to his equipment.
>
> The moral of the myth is, of course, that we do not, and cannot, see actual horrors because they paralyze us with blinding fear; and that we shall know what they look like only by watching images of them which reproduce their true appearance. [. . .] The film screen is Athena's polished shield.
>
> This is not all, however. In addition, the myth suggests that the images on the shield or screen are a means to an end; they are to enable—or, by extension, induce—the spectator to behead the horror they mirror. [. . .] They becken the spectator to take them in and thus incorporate into his memory the real face of things too dreadful to be beheld in reality. In experiencing [. . .] the litter of tortured human bodies in the films made of the Nazi concentration camps, we redeem horror from its invisibility behind the veils of panic and imagination. And this experience is liberating in as much as it removes a most powerful taboo. Perhaps Perseus' greatest achievement was not to cut off Medusa's head but to overcome his fears and look at its reflection in the shield. And was it not precisely this feat which permitted him to behead the monster?[100]

This parable is all the more important in Kracauer's thought since it returns—but with the weight of subsequently lived history—to the childlike and enchanted conditions of a cinematographic experience, recounted in a very Proustian manner at the beginning of the work: he speaks of a reality that was reflected in a puddle of water whose surface, and the image with it, was rippled by a gust

of wind.[101] What then does this parable teach us? That the image is
not only that "dialectic at a standstill" that Walter Benjamin spoke
of: it is up to us, adds Kracauer, to keep setting it in motion again.
Here, if we understand this motion correctly, resides all that we
can call an ethics of the image.

The myth of the Medusa reminds us first of all that real hor-
ror is a *source of impotence* for us. What happened as the "clandes-
tine photographer" of Auschwitz watched was no more than the
executioners' power of terror. This power annihilates the victim
and petrifies, rendering blind and mute, the witness who looks
with unprotected eyes. Yet the horror when reflected, renewed,
reconstructed as an image—Kracauer, like Godard later, thinks
first of archival images—can be a *source of knowledge*, but on condi-
tion that its responsibility be engaged with the formal mechanism
of the image produced. The *hybrid* of the reflection, suggested
by Athena to Perseus in the fable, is incarnated in the history of
August 1944 as the *ruse* of "staging"—which is also the risk of
death—organized by the *Sonderkommando* team so that Alex can
take his four photographs. There is indeed, says Kracauer in refer-
ence to Perseus, a *courage to know*: it is the courage to "incorporate
into our memory" a knowledge that, once recognized, removes a
taboo that horror, still paralyzing, continues to exert on our un-
derstanding of history.

In this courage alone, writes Kracauer, resides the capacity
of the image to save the real from its cloak of invisibility. "Re-
demption" in the fullest sense survives only when the courage
to know becomes a *source of action*. "Honor" is saved when impo-
tence, and paralysis in face of the worst, become—albeit desper-
ate—"resistance" (and this is the meaning of *in spite of all*). The
Sonderkommando's undertaking in August 1944 can be recognized
as an inversion of impotence, discussed also by Maurice Blanchot
when, in reference to *L'espèce humaine*, he dares to speak to us *in
spite of all* of the "indestructible" humanity of man.[102] Is it surpris-
ing that Kracauer, for his part, should end his book with a para-
graph entitled "The Family of Man"?[103]

The "aesthetic of redemption" pits Benjamin and Kracauer
against Adorno, who is hostile to images.[104] It doesn't imply that
the film "saves those that it shows," as Jean-Michel Frodon be-

lieves:[105] it is not about exculpating the actors of history or the ac-
tors of cinema but, rather, about opening sight itself to a start-up
of knowledge and to an orientation of ethical choice. Nor is it
a question of "learning to look at the Gorgon" with the eyes of
its victim, as Giorgio Agamben imputes to the *Muselmann* of the
camps: we cannot, in effect, learn anything from a paralyzed and
petrified gaze, from an "absolute image"—as Agamben calls it—
that wastes and puts to death, delivering us only to an "impossi-
bility of seeing."[106] What we should learn, on the other hand, is to
manage the mechanism of images so as to know what to do with
our sight and with our memory. To know, in short, how to handle
the shield: the *shield-image*.

Gérard Wajcman failed to understand, right up to his evo-
cation of the Medusa, that the shield in this myth is not an in-
strument of flight from the real. Every image, for Wajcman, is a
"shield" that functions merely as a veil, a "cover," something like
a "screen memory" that we retreat behind, for lack of anything
better. The fable and its commentary by Kracauer say quite the
contrary: Perseus does not flee the Medusa, *he confronts her in spite*
of all, in spite of the fact that a face-to-face confrontation might
have signified neither the gaze, nor knowledge, nor victory, but
simply death. Perseus confronts the Gorgon in spite of all, and
this *in spite of all*—this de facto possibility, despite a legitimate
impossibility—is called *image*: the shield and the reflection are not
only protection but weapons, ruse, technical means for beheading
the monster. The initial impotent fatalism ("one cannot look at the
Medusa") is replaced by the *ethical response* ("well, I will confront
the Medusa all the same, by looking at her *differently*").

To present this fable as an illustration of the "pacifying power
of images in the gaze of the real"[107] is therefore an error. The story
of Perseus teaches us, on the contrary, of the power of confronta-
tion of this Real, by means of a formal mechanism used against
any fatalism of the "unimaginable" (that taboo in which Wajcman
would have us remain petrified). It is not surprising that Aby War-
burg should have cast Perseus fighting the Medusa as an exemplary
personification of the "sum of European intellectual history," as a
ceaseless struggle of *ethos* against the powers he called the *mon-*
stra, the monsters of savagery.[108] It is no more surprising that Paul

Celan should have seen in the poetic act a "turning of the breath" (*Atemwende*) against the "abyss of the Medusa's head" that every word, every moment of the *Endlösung*, bears within it.[109]

Thus a "rectangle of thirty-five millimeters," albeit "scratched to death" in its contact with the real (as a testimony or an archival image), and however little it might be made recognizable when placed in relation to other sources (as a montage or constructed image), nonetheless "saves the honor": that is, it saves, at least from forgetting, a historical Real threatened with indifference. The ethical dimension does not disappear in images: on the contrary, it is exacerbated, splitting itself; into the *dual system* demanded by images. So it is a *question of choice*: in the face of every image we have to choose whether, or how, to make it participate in our knowledge and action. We can accept or reject this or that image; take it as a consoling object or as a worrying object; make it ask questions or use it as a ready-made response. On this last point, for example, Adorno's reflection on the world at war having become a great documentary of propaganda, smothering all experience and every question, remains strikingly topical:

> The fact that the war should be so completely covered in information, propaganda, and commentary, that there are cameramen in tanks on the frontline and war correspondents dying as heroes, as well as the blurred mix between manipulating information benefiting public opinion, and the unconsciousness of actions carried out—so many expressions to translate a draining of experience, a void hollowed out between men and the fatality that drags them on, in which Fatality properly resides. The mold of events, hardened and reified, seems to substitute for men. Men are reduced to the role of actors in a monstrous documentary, for which there are no more spectators because all, to the very last person, have a place on screen. [. . .] This war is indeed a phony war, but its "phoniness" is more horrible than all horrors, and those who laugh at it are the first to contribute to the disaster.[110]

But the image is not only that, or like that. There are other kinds of documentary. Other choices are possible, as it is possible, when

we speak, to show the marks of an inquiring mind rather than re-
main behind the prison bars of ready-made slogans. An *ethics of
the image* today, as in 1944 — the year Adorno wrote the words just
quoted — must account for an always *divided* situation. When Rob-
ert Antelme came back from the camps, he had to admit that what
he had to say "was beginning to seem *unimaginable*"; thus he stated
in spite of all the necessity of "choice, *that is, again, of imagination*."[111]
After him, Beckett would say: "Imagination dead" — but to bring
us back *in spite of all* to the injunction: "Imagine."[112]

To imagine *in spite of all*, then. But why *in spite of all*? This ex-
pression denotes tearing: the *all* refers to the power of historical
contradictions to which we cannot yet find an answer; the *in spite
of* resists this power solely by the heuristic power of the singular.
It is a "flash" that tears the sky when everything seems lost. It is the
situation that seems to exemplify the gesture of the clandestine
photographer of Auschwitz. Did it not deserve this minimal hom-
age: that we cast our eyes for a moment at the object of his risk,
the four photographs snatched from that hell? We know better
today what happened there. The knowledge deprives us of any
consolation: should it also deprive us of any consideration for this
gesture of resistance?

We are experiencing *the image in a time of the torn imagination*.
That which, in his irritation, Gérard Wajcman often calls "fetish-
ism," therefore *perversion*, closely resembles what Hegel describes
in the *Phenomenology of Mind*, the bitterness manifested by "hon-
est consciousness" [*das ehrliche Bewusstsein*] with regard to "torn
consciousness" [*das zerrissene Bewusstsein*] (it is clear that Godard
represents a torn consciousness par excellence concerning the his-
tory of his own art):

> The honest consciousness takes each moment as a permanent
> and essential fact, and is the uncultivated thoughtless condi-
> tion that does not think and does not know that it is likewise
> doing the very inverse. The torn consciousness is, however,
> aware of inversion; it is, in fact, a consciousness of absolute
> perversion: the conceptual principle predominates there,
> brings together into a single unity thoughts that lie far apart

in the case of the honest soul, and the language conveying its meaning is, therefore, full of *esprit* and wit (*geistreich*).[113]

We should understand this "perversion" in the sense of the Latin *perversio*; that is, the act of disrupting, of deliberately putting things back to front, as the *Histoire(s) du cinéma* does with history in general. Let us understand the concept that "brings together [. . .] thoughts that lie far apart" as an activity of montage, as, for example, when Godard asks us to bring together in our mind an allegory of Goya, a victim of Dachau, a Hollywood star, and a gesture in a Giotto painting (figs. 24–29).

This "torn consciousness" was often claimed or observed by Jewish thinkers who survived the Shoah, from Cassirer or Ernst Bloch to Stefan Zweig or Kracauer. At the end of his work *Weltgeschichte und Heilsgeschehen* [*Meaning in History*], Karl Löwith noted the fundamental "indecision" of what he called "the modern spirit" in its relation to history.[114] Hannah Arendt went further in her analysis of this historical tearing: on the one hand, she placed the artist, the poet, and the historian together as "builders of monuments" without whom "the history that mortals play and recount would not survive an instant."[115] On the other hand, citing René Char—"Our heritage is not preceded by any testament"—Arendt observes the difficulty in our time of naming its own "lost treasure." The "breach between the past and the future," as she calls it, resides entirely in the impossibility of recognizing and of *bringing into play* the heritage of which we have become guardians:

> It seems then that no single continuity in time is assigned, and that consequently there is, humanly speaking, no past nor future.[116]

The question of images is at the heart of the great darkness of our time, the "discontent of our civilization." We must know how to look into images to see that of which they are survivors. So that history, liberated from the pure past (that absolute, that abstraction), might help us *to open* the present of time.

(2002–2003)

NOTES

For explanation of asterisk () following certain references, see Translator's Note, p. xi.*

Four Pieces of Film Snatched from Hell

1. And with them, all the sophisms regarding which, I believe, there are no grounds for philosophical ecstasies. See J.-F. Lyotard, *Le différend* (Paris: Minuit, 1983), 16–17, analyzing in this form the negationist argument: "In order to identify that a place is a gas chamber, I will accept as witness only a victim of this gas chamber; but, there must be, according to my adversary, no victim other than a dead one, or else this gas chamber would not be what it purports to be; there is therefore no gas chamber."

2. P. Levi, *The Drowned and the Saved*, trans. R. Rosenthal (New York: Vintage Books 1989), 52.

3. Ibid., 50.

4. F. Müller, *Eyewitness Auschwitz: Three Years in the Gas Chambers*, trans. S. Flatauer (New York: Stein and Day, 1979), 39. Filip Müller represents the extremely rare case of a member of the *Sonderkommando* who escaped five successive liquidations. On this function and its secrecy, See G. Wellers, *Les chambres à gaz ont existé: Des documents, des témoignages, des chiffres* (Paris: Gallimard, 1981). E. Kogon, H. Langbein, and A. Rückerl, *Les chambres à gaz secret d'État* (1983), trans. H. Rollet (Paris: Minuit, 1984; reprinted Paris Le Seuil, 1987). J.-C. Pressac, *Auschwitz: Technique and Operation of the Gas Chambers*, trans. P. Moss (New York: Beate Klarfeld Foundation, 1989). Id., *Les crématoires d'Auschwitz: La machinerie du meurtre de masse* (Paris: CNRS Editions, 1993); (p.35: "To kill men by the hundreds by gas with one go, and in an enclosed space, was without precedent, and the secret in which the operation was wrapped struck even more the imagination of the nonparticipants, SS or prisoners, who had received the formal interdiction against observing its working"). U. D. Adam, "Les chambres à gaz," *L'Allemagne nazie et le génocide juif: Colloque à l'EHESS, Paris, juillet 1982* (Paris: Gallimard–Le Seuil, 1985), 236–261. F. Piper, "Gas Chambers and Crematoria," in *Anatomy of the Auschwitz Death Camp*, ed. Y. Gutman and M. Berenbaum (Bloomington: Indiana University Press, 1994), 157–182.

5. H. Langbein, *Hommes et femmes à Auschwitz* (1975), trans. D. Meunier (Paris: UGE, 1994), 202.

6. Müller, *Eyewitness Auschwitz*. Langbein, *Hommes et femmes à Auschwitz*, 191–202.

7. Langbein, *Hommes et femmes à Auschwitz*, 193.*

8. Ibid., 194–195.*

9. Levi, *The Drowned and the Saved*, 59. "No one has the right to judge them, not those who experienced the camps, and even less those who did not."

10. G. Agamben, *Remnants of Auschwitz: The Witness and the Archive, Homo Sacer III*, trans. D. Heller-Roazen (New York: Zone Books, 2002).

11. Müller, *Eyewitness Auschwitz*. The documentation on the effects of the revolt has been gathered by Pressac, *Les crématoires d'Auschwitz*, 93. On the public execution of the last rebels, see P. Levi, *Si c'est un homme*, trans. M. Schruoffeneger (Paris: Julliard, 1987; 1993 ed.), 159–161.

12. Müller, *Eyewitness Auschwitz*, 82.

13. Ibid., 122.

14. See L. Poliakov, *Auschwitz* (Paris: Julliard, 1964), 62–65 and 159–171. B. Mark, *Des voix dans la nuit: La résistance juive à Auschwitz-Birkenau* (1965), trans. E. and J. Fridman and L. Princet (Paris: Plon, 1982). N. Cohen, "Diaries of the *Sonderkommando*," in *Anatomy of the Auschwitz Death Camp*, 522–534.

15. On the physical description of the *Scrolls of Auschwitz* ravaged by humidity and therefore partially illegible, see Mark, *Des voix dans la nuit*, 179–190.

16. Cited by Langbein, *Hommes et femmes à Auschwitz*, 3.*

17. A. Wieviorka, *Déportation et génocide: Entre la mémoire et l'oubli* (Paris: Plon, 1992; 1995 ed.), 255–259.

18. Pressac, *Les crématoires d'Auschwitz*, 90.

19. Ibid., 91

20. Müller, *Eyewitness Auschwitz*, 124.

21. Ibid., 125.

22. Ibid., 124–136.

23. The documentation on crematorium V can be found in J.-C. Pressac, "Étude et réalisation des *Krematorien* IV et V d'Auschwitz-Birkenau," in *L'Allemagne nazie et le génocide juif*, 539–584. Id., *Auschwitz: Technique and Operation* . . . , 379–428. Léon Poliakov (*Auschwitz*, 51–52) had already cited a letter from November 6, 1943, in which the SS of Auschwitz ordered green plants for the camouflage of crematoria I and II. On June 16, 1944, Oswald Pohl was still putting aside a sum for "the erecting of a second interior hedge, in order to hide the buildings from the prisoners." Pressac, *Les créma-*

toires d'Auschwitz, 91. On the subject of the camouflage of the "communica-
tion trench" of Treblinka, see SS Franz Suchomel's very precise testimony,
gathered by C. Lanzmann in *Shoah* (Paris: Fayard, 1985), 123–124.

24. Testimony by Filip Müller cited in ibid. He continues: "We were
henceforth the 'bearers of the secret,' the condemned. We were not to
speak to anyone, not to come into contact with any prisoner. Not even
with the SS. Except those that were in charge of the *Aktion*."*

25. Müller, *Eyewitness Auschwitz*, 133.

26. Ibid., 136–139. See also, among others, the testimony of G. Wellers,
L'étoile jaune à l'heure de Vichy. De Drancy à Auschwitz (Paris: Fayard, 1973),
286–287. Kogon, Langbein, and Rückerl, *Les chambres à gaz secret d'État*,
214–215, specifies that the pits were 12 meters in length, 6 meters wide,
and 1.5 meters deep. One thousand people were burned there in one hour.
See also Pressac, "Étude et réalisation des *Krematorien* IV et V," 539–584.
A discrepancy remains between certain testimonies of the members of
the *Sonderkommando* and Pressac's analyses on the question of knowing
whether the pits were dug because the ovens of crematorium V were not
working or were too full.

27. H. Langbein, *La résistance dans les camps de concentration nationaux-
socialistes, 1938–1945* (1980), trans. D. Meunier (Paris: Fayard, 1981), 297
(and passim, 297–315).

28. Langbein, *Hommes et femmes d'Auschwitz*, 253: "Stanlislaw Klodzin-
ski claimed that a Polish civilian worker called Mordarski, whose work
yard was not far away, smuggled a camera into the camp. Hidden deep
within the false bottom of a tub of soup, it passed into the hands of the
Sonderkommando." Since Langbein's reconstitution is not without inaccu-
racies, we can also speculate that the camera might have been obtained in
the "Canada" section of Auschwitz, the gigantic storehouse of the victims'
stolen personal effects.

29. See Pressac, *Auschwitz: Technique and Operation . . .* , 422–424, where
we find a minutely detailed reconstitution of these images. He specifies
that among the people photographed is an SS member, whose back is
turned (we understand, therefore, even more clearly the risk taken).

30. Levi, *The Drowned and the Saved*, 79.

31. See Pressac, *Auschwitz: Technique and Operation . . .* , 424, in which
the testimony of Szmulewski himself—survivor of the squad—is cited.

32. See Langbein, *Hommes et femmes à Auschwitz*, 253.

33. Cited and translated by R. Boguslawska-Swiebocka and T. Ce-
glowska, *KL Auschwitz: Fotografie dokumentalne* (Warsaw: Krajowa Agencja
Wydawnicza 1980), 12. The code name "Tell" belongs to Teresa Lasocka-
Estreicher, a member, in Krakow, of a clandestine committee of aid to the

prisoners in concentration camps. See also R. Boguslawska and T. Swie-
bocka, "Auschwitz in Documentary Photographs," trans. J. Webber
and C. Wilsack, in *Auschwitz: A History in Photographs*, ed. T. Swiebocka
(Oswiecim, Warsaw, and Bloomington: Auschwitz-Birkenau Museum,
Ksiazka I Wiedza, and Indiana University Press, 1993), 42–43 and
172–176, in which the names of other prisoners who took part in this op-
eration are specified: Szlomo Dragon, his brother Josek, and Alter Szmul
Fajnzylberg (known in the camp under the name of Stanislaw Jankowski).
According to the testimony of Alter Fajnzylberg, the camera could have
been a Leica (Clément Chéroux has told me that this is impossible, since
the format of the images is 6 × 6).

Against All Unimaginable

1. See H. Arendt, "Le procès d'Auschwitz" (1966), trans. S. Courtine-
Denamy, in *Auschwitz et Jérusalem* (Paris: Deuxtemps Tierce, 1991; 1997
ed.), 235.*

2. See R. Aron, *Mémoires* (Paris: Julliard, 1983), 176: "About the geno-
cide, what do we know about that in London? On the level of clear
conscience, my perception was roughly the following: the concentration
camps were cruel, directed by martinets recruited not among the politi-
cally minded, but rather among common-law criminals; mortality there
was high, but the gas chambers, the industrial murder of humans, no,
I must admit, I did not imagine them, and because I could not imagine
them, I did not know about them [*je ne les ai pas sus*]."

3. H. Arendt, "Les techniques de la science sociale et l'étude des camps
de concentration" (1950), trans. S. Courtine-Denamy, in *Auschwitz et
Jérusalem*, 207.*

4. Levi, *The Drowned and the Saved*, 11–12. See also the narrative of
Moché-le-Bedeau with which E. Wiesel's book, *La nuit* (Paris: Minuit,
1958, 17–18) practically begins.

5. Testimony by Simon Wiesenthal, cited by Levi in *The Drowned and
the Saved*, 11–12.

6. See W. Laqueur, *Le terrifiant secret. La "Solution finale" et l'information
étouffée* (1980), trans. A. Roubichou-Stretz (Paris: Gallimard, 1981).
S. Courtois and A. Rayski, eds., *Qui savait quoi? L'extermination des juifs,
1941–1945* (Paris: La Découverte, 1987), 7–16 ("Stratégie du secret, straté-
gie de l'information").

7. Laqueur, *Le terrifiant secret*, 238.

8. H. Arendt, "L'éloquence du diable" (1942), trans. S. Courtine-
Denamy, in *Auschwitz et Jérusalem*, 33–34.*

9. B. Bettelheim, "Individual and Mass Behavior in Extreme Situations" (1943), in *Surviving and Other Essays* (New York: Alfred A. Knopf, 1979), 83.

10. Arendt, "Les techniques de la science sociale et l'étude des camps de concentration," 212. The "saved" themselves often referred to the camps as "laboratories": see Levi, *Si c'est un homme*, 93. D. Rousset, *L'univers concentrationnaire* (1945; Paris: Minuit, 1965), 107–111. See W. Sofsky's study, *L'organisation de la terreur: les camps de concentration* (1993), trad. O. Mannoni (Paris: Calmann-Lévy, 1995), *passim*.

11. Levi, *The Drowned and the Saved*, 97.

12. See Langbein, *Hommes et femmes à Auschwitz*, 11–17.

13. See V. Klemperer, *LTI, la langue du IIIe Reich, Carnets d'un philologue* (1947), trans. E. Guillot (Paris: Albin Michel, 1996).

14. See Pressac, *Auschwitz: Technique and operation . . .* , 446. This is a double slip in fact, since the SS wrote *Gasskammer* instead of *Gaskammer*. See also Kogon, Langbein, and Rückerl, *Les chambres à gaz secret d'État*, 13–23 ("Un langage codé").

15. See in particular Poliakov, *Auschwitz*, 49–52. See also, among other examples, Y. Arad, "Treblinka," trans. J. Benson, *La déportation: Le système concentrationnaire nazi*, ed. F. Bédarida and F. Gervereau (Nanterre, BDIC, 1995), 154: "End of February beginning of March 1943, Heinrich Himmler visited Treblinka. Following this visit, in accordance with his orders, an operation was launched to incinerate the bodies of the victims. The common graves were reopened, and the corpses were taken out so that they could be incinerated in enormous furnaces (the "pyres"). The bones were ground and buried again in the same graves, with the ashes. This incineration of the corpses, in order to make all traces of the murders disappear, continued into July 1943." On the subject of this episode, see the both technical and unbearable testimony of SS Franz Suchomel, gathered by Lanzmann, *Shoah*, 64–70. There it is specified that the *Sonderkommando* of Treblinka was changed—i.e., murdered—every day.

16. See Pressac, *Auschwitz: Technique and Operation . . .* , 390–391.

17. This makes the strictly *archeological* approach of the work undertaken by Pressac all the more precious—and to which P. Vidal-Naquet paid hommage in "Sur une interprétation du grand massacre: Arno Mayer et la 'solution finale'" (1990), in *Les Juifs, la mémoire et le présent*, II (Paris: La Découverte, 1991), 262–266. On the question of the "ruined" place and of its use (equally archeological) in the film *Shoah*, see G. Didi-Huberman, "Le lieu malgré tout" (1995), in *Phasmes: Essais sur l'apparition* (Paris: Minuit, 1998), 228–242.

18. Müller, *Eyewitness Auschwitz*, 161–162.

19. Arendt, "On ne prononcera pas le kaddish" (1942), trans. S. Courtine-Denamy, in *Auschwitz et Jérusalem*, 39–41.

20. J.-L. Godard, *Histoire(s) du cinéma* (Paris : Gallimard-Gaumont, 1998), I, 109.

21. See the despairing testimony of the Jewish historian Itzhak Schipper, just before being deported to Majdanek: "History is written, in general, by the victors. All that we know about murdered peoples is that which their murderers were willing to say about it. If our enemies win, if it is they who write the history of this war [. . .] they can decide to erase us completely from world memory, as though we never existed." Cited by R. Ertel, *Dans la langue de personne: Poésie yiddish de l'anéantissement* (Paris: Le Seuil, 1993), 23. See also S. Felman's theses in "À l'âge du témoignage: *Shoah* de Claude Lanzmann," trans. C. Lanzmann and J. Ertel, in *Au sujet de* Shoah, *le film de Claude Lanzmann* (Paris, Belin, 1990), 55–145.

22. This also allowed for the precise reconstitution of the extermination machine in the crucial work of R. Hilberg, *The Destruction of the European Jews* (Chicago: Quadrangle Books, 1961). See, more recently, J. Fredj, ed., *Les archives de la Shoah* (Paris: CDJC-l'Harmattan, 1998).

23. See the important bibliography by U. Wrocklage, *Fotografie und Holocaust: Annotierte Bibliographie* (Frankfurt: Fritz Bauer Institut, 1998). Among the principal studies, see Boguslawska-Swiebocka and Ceglowska, *KL Auschwitz*. Swiebocka, ed., *Auschwitz: A History in Photographs*. S. Milton, "Images of the Holocaust," *Holocaust and Genocide Studies* 1 (1986), no. 1:27–61, no. 2:193–216. D. Hoffmann, "Fotografierte Lager: Überlegungen zu einer Fotogeschichte deutscher Konzentrationslager," *Fotogeschichte*, no. 54 (1994): 3–20. It is worth noting the exceptional case of the "Auschwitz Album": P. Hellman, *L'album d'Auschwitz: D'après un album découvert par Lili Meier, survivante du camp de concentration* (1981), trans. G. Casaril, completed by A. Freyer and J.-C. Pressac (Paris: Le Seuil, 1983).

24. See G. Didi-Huberman, *Mémorandum de la peste: Le fléau d'imaginer (Paris:* Christian Bourgois, 1983).

25. See Hilberg, *The Destruction of the European Jews*, 214, n.140: "[Heydrich] forbade his own men to take pictures. 'Official' photographs were to be sent undeveloped to the RSHA IV-A-1 as secret Reich matter (*Geheime Reichssache*). Heydrich also requested the Order Police commands to hunt up photographs which might have been circulating in their areas."

26. Inscription on a warning sign placed around the Natzweiler camp.

27. Cited by Boguslawska-Swiebocka and Ceglowska, *KL Auschwitz*, 11.

28. See the exhibition entitled *Vernichtungskrieg: Verbrechen der Wehrmacht 1941 bis 1944* (Hamburg: Hamburger Edition, 1996; rev. ed.,

Verbrechen der Wehrmacht: Dimensionen des Vernichtungskrieges 1941–1944 (Hamburg, Hamburger Edition 2002).

29. See Hilberg, *The Destruction of the European Jews.*

30. See Boguslawska-Swiebocka and Swiebocka, "Auschwitz in Documentary Photographs," 35–42. U. Wrocklage, "Architektur zur 'Vernichtung durch Arbeit': Das Album der 'Bauleitung d. Waffen-SS u. Polizei K. L. Auschwitz,'" *Fotogeschichte*, no.54 (1994): 31–43. This archive of the *Bauleitung* is the main source for Pressac's works *Auschwitz: Technique and Operation . . .* , and *Les crématoires d'Auschwitz.* It must be pointed out that, of the 40,000 photos conserved, 39,000 are identification photographs.

31. See R. J. Lifton, *The Nazi Doctors: Medical Killing and the Psychology of Genocide* (New York: Basic Books, 1986).

32. See Boguslawska-Swiebocka and Cegowska, *KL Auschwitz*, 12, where Bronislaw Jureczek's testimony is cited: "Almost at the very last moment we were told to burn all the negatives and photographs kept in the *Erkennungsdienst.* There was a coal stove in the laboratory into which we first began to put wet photographic paper and pictures, and then loads of photos and negatives. The enormous amount of material shoved into the stove closed off the chimney. When we set the material afire, we were convinced that only a part of the photos and negatives near the opening would burn, and that the remaining part would not, as the fire would die out for lack of air. After the war I found out that our intentions were carried out, and at least a large percentage of the photos and negatives fell into the hands of the right people. [. . .] We deliberately scattered some of the pictures and negatives in the rooms of the laboratory, faking nervousness. I knew that the evacuation was being carried out in such a hurry that no one would have time to clean away everything, and that something would survive."

33. See Wieviorka, *Déportation et génocide*, 165: "As a historical matter, the notion of the unsayable seems a lazy notion. It has exonerated the historian from his task which is precisely to read the prisoners' testimonies, to examine this major source for the history of the deportation, including even its silences"—and I would add, for my part: including even its images.

34. See H. Arendt, "L'image de l'enfer" (1946), trans. S. Courtine-Denamy, in *Auschwitz et Jérusalem*, 152. Id. "Le procès d'Auschwitz," 233–259. These thoughts are taken up by G. Agamben in "Qu'est-ce qu'un camp?" (1995), trans. D. Valin, in *Moyens sans fins: Notes sur la politique* (Paris: Rivages, 1995), 47–56.

35. See Arendt, "L'image de l'enfer," 152–153. Id, "Les techniques de la science sociale et l'étude des camps de concentration," 203–219.

36. P. Vidal-Naquet, "Préface" to G. Decrop, *Des camps au génocide: La politique de l'impensable* (Grenoble: Presses universitaires, 1995), 7.

37. Levi, *The Drowned and the Saved*, 88–104. On Levi's—exaggerated—critiques regarding the "obscurity" of Paul Celan, see E. Traverso, *L'Histoire déchirée: Essai sur Auschwitz et les intellectuels* (Paris: Le Cerf, 1997), 153. C. Mouchard, "'Ici'? 'Maintenant'? Témoignages et œuvres," in *La Shoah: Témoignages, savoirs, œuvres*, ed. C. Mouchard and A. Wieviorka (Saint-Denis, Presses universitaires de Vincennes-Cercil, 1999), 225–260. F. Carasso, "Primo Levi, le parti pris de la clarté," in ibid., 271–281.

38. On testimony, See Wieviorka, *Déportation et génocide*, 161–166. Id. *L'ère du témoin* (Paris: Plon, 1998).

39. See Agamben, *Remnants of Auschwitz*, 32–33, and 157: "But why unsayable? Why confer on extermination the prestige of the mystical? [. . .] To say that Auschwitz is "unsayable" or "incomprehensible" is equivalent to *euphemein*, to adoring in silence, as one does with a god. [. . .] That is why those who assert the unsayability of Auschwitz today should be more cautious in their statements. If they mean to say that Auschwitz was a unique event in the face of which the witness must in some way submit his every word to the test of an impossibility of speaking, they are right. But if, joining uniqueness to unsayability, they transform Auschwitz into a reality absolutely separate from language [. . .], then they unconsciously repeat the Nazis' gesture; they are in secret solidarity with the *arcanum imperii*."

40. Here, in my opinion, is a limit in the important reflections of Agamben, ibid., 12 and 51: "Truth is [. . .] unimaginable [. . .] but the sight of *Muselmänner* is an absolutely new phenomenon, unbearable to human eyes." To speak in these terms amounts to, among other things, ignoring the whole photographic production of Eric Schwab: a Jew, who was captured by the Germans but escaped after six weeks of imprisonment, Schwab followed the advance of the American army in 1945, discovering the camps of Buchenwald and Dachau (among others). He was as yet unaware of what had become of his own mother, who had been deported to Theresienstadt. It was in these conditions that he took photographs—which were obviously empathetic, unforgettable in any case—of *Muselmänner*, those living cadavers upon whom he was able to gaze, no doubt seeing his own fate as the fate of his people. I owe this information about Schwab, including some others in this text, to the remarkable preparatory work of Clément Chéroux for the exhibition entitled *Mémoire des camps: Photographies des camps de concentration et d'extermination nazis (1933–1999)* (Paris: Marval, 2001). I thank him very warmly.

41. Regarding the *Auschwitz Album*, Serge Klarsfeld writes: "And I said

to them [those in charge of the memorial of Yad Vashem], when, in 1980,
I gave them this album, which originally belonged to an ex-prisoner:
'One day, later, it will be like the Dead Sea Scrolls, because these are the
only authentic photographs of Jews arriving at a concentration camp.'"*
Klarsfeld, "A la recherche du témoignage authentique," in *La Shoah: Témoi-
gnages, savoirs, œuvres*, 50.

42. See in particular G. Koch, "Transformations esthétiques dans la
représentation de l'inimaginable" (1986), trans. C. Weinzorn, *Au Sujet de
Shoah, le film de Claude Lanzmann*, 157–166 ("he refuses any representation
by images. [. . .] Through the absence of images, he thereby gives a repre-
sentation of the unimaginable.") I. Avisar, *Screening the Holocaust: Cinema's
Images of the Unimaginable* (Bloomington: Indiana University Press, 1988).
S. Felman, "A l'âge du témoignage," 55–145. See, on the other hand, the
reaction of Anne-Lise Stern, a survivor of the camps: "I can understand
Shoshana Felman more or less when she speaks of the 'rupturing of the
very act of eyewitness testimony itself' or even her thesis of the Holocaust
as an 'event without a witness, an event whose historical project is the
literal obliteration of its witnesses.' At the same time, I find her absolutely
outrageous, and I refuse to understand her." A.-L. Stern, "Sois déportée
. . . et témoigne! Psychanalyser, témoigner: double-bind?" in *La Shoah*, 21.

43. It seems unnecessary here to discuss the unseemly debate between
Claude Lanzmann and Jorge Semprun (see *Le monde des débats*, May 2000,
11–15) on the subject of the existence and use of a hypothetical archival
film about the gas chambers.

44. See Didi-Huberman, "Le lieu malgré tout," 228–242.

45. G. Wajcman, *L'objet du siècle* (Paris: Verdier, 1998), 21, 23, 236, 239,
244, 247, 248, and passim.

46. M. Blanchot, *L'écriture du désastre* (Paris: Gallimard), 1980, 132.

47. Ibid., 129.

48. G. Bataille, "Sartre" (1947), in *Oeuvres Complètes, XI* (Paris: Galli-
mard, 1988), 226–228. Regarding the context of this debate, See Traverso,
L'Histoire déchirée, 214–215.

49. Bataille, "Sartre," 226.

50. R. Antelme, *L'espèce humaine* (1947; Paris: Gallimard, 1957).

51. G. Bataille, "Réflexions sur le bourreau et la victime" (1947), in
Œuvres complètes, XI, 266.

52. Ibid., 267.

53. Langbein, *Hommes et femmes à Auschwitz*, 87–88.*

54. See G. Didi-Huberman, *La ressemblance informe, ou le gai savoir visuel
selon Georges Bataille* (Paris: Macula, 1995). The link between the imaginary
and aggression was theorized—very much in the style of Bataille—by

J. Lacan, "L'agressivité en psychanalyse" (1948), in *Écrits* (Paris: Le Seuil, 1966), 101–124.

 55. G. Bataille, *Madame Edwarda* (1941), in *Oeuvres complètes*, III (Paris: Gallimard, 1971), 22.

 56. Müller, *Eyewitness Auschwitz*, 93–94.

In the Very Eye of History

 1. The drawing by David Olère is reproduced by Pressac in *Auschwitz: Technique and Operation* . . . , 259. The corpses (in the middle distance), are those of a transport of French Jews; on the table of the SS (in the foreground) the "booty" is spread; packs of Gauloises and bottles of Bordeaux. On David Olère, see S. Klarsfeld, *David Olère, 1902–1985: Un peintre au Sonderkommando à Auschwitz* (New York: Beate Klarsfeld Foundation, 1989). On the drawings of the camps, see in particular J. P. Czarnecki, *Last Traces: The Lost Art of Auschwitz* (New York, Atheneum, 1989). D. Schulmann, "D'écrire l'indicible à dessiner l'irreprésentable,"in *Face à l'histoire, 1933–1996: L'artiste moderne devant l'événement historique*, ed. J.-P. Ameline (Paris: Centre Georges Pompidou-Flammarion, 1996), 154–157.

 2. Cited by Mark, *Des voix dans la nuit*, 204.*

 3. Ibid., 245–251.

 4. W. Benjamin, "Sur le concept d'histoire" (1940), *Écrits français*, ed. J.-M. Monnoyer (Paris: Gallimard, 1991), 346. [Benjamin's articles collected in this edition were originally written in French.—Trans.]

 5. Arendt, "Le procès d'Auschwitz," 257–258. She then lists a number of actual situations marked by horror and absurdity. The conclusion of the text is as follows: "That is what happens when men decide to turn the world upside down."*

 6. Cited by Mark, *Des voix dans la nuit*, 194.*

 7. See M. Frizot, "Faire face, faire signe. La photographie, sa part d'histoire," in *Face à l'histoire*, 50: "The notion of photography of an event or photography of history is constantly to be reinvented in the face of history, being unforeseeable. [. . .] [But this same] photographic image is an image that is somewhat fore-seen [*pré-vue*]."

 8. See Wieviorka, *L'ère du témoin*, 14. See also M. Pollak and N. Heinich, "Le témoignage," *Actes de la recherche en sciences sociales*, nos. 62–63 (1986): 3–29. Pollak, "La gestion de l'indicible," ibid., 30–53.

 9. See Levi, *The Drowned and The Saved*, 11–21.

 10. See Wieviorka, *Déportation et génocide*, 161–166. Id., *L'ère du témoin*, 112 and 127, which does not include photography in the reflections on testimony.

11. The expression is Filip Müller's, cited by Lanzmann in *Shoah*, 179.

12. Bédarida and Gervereau, "Avant-propos," *La déportation*, 8.

13. Gervereau, "Représenter l'univers concentrationnaire," ibid. 244. Id. "De l'irreprésentable: La déportation," in *Les images qui mentent: Histoire du visuel au XXe siècle* (Paris: Le Seuil, 2000), 203–219. See also A. Liss, *Trespassing through Shadows: Memory, Photography, and the Holocaust* (Minneapolis: University of Minnesota Press, 1998). The question has been explored in more detail by S. Friedlander, ed., *Probing the Limits of Representation: Nazism and the "Final Solution"* (Cambridge, MA: Harvard University Press, 1992).

14. See Pressac, *Auschwitz: Technique and Operation* . . . , 422–424.

15. Langbein, *Hommes et femmes à Auschwitz*, 253.*

16. See *Mémoire des camps*, 86–91.

17. A. Brycht, *Excursion: Auschwitz-Birkenau*, trans. J.-Y. Erhel (Paris: Gallimard, 1980), 37, 54, 79, cited and commented on by Pressac in *Auschwitz: Technique and operation* . . . , 423–424.

18. See in particular Boguslawska-Swiebocka and Ceglowska, *KL Auschwitz*, 184–185 (all the photos that have been cropped). Swiebocka, ed., *Auschwitz: A History in Photographs*, 172–175 (all the photos that have been cropped). M. Berenbaum, *The World Must Know: The History of the Holocaust as Told in the United States Holocaust Memorial Museum* (Boston: Little, Brown and Company, 1993), 137 (cropped photo) and 150 (photo that has not been cropped). Bédarida and Gervereau, eds., *La déportation*, 59 and 61 (cropped photos). Y. Arad, ed., *The Pictorial History of the Holocaust* (Jerusalem: Yad Vashem, 1990), 290–291 (two cropped photos).

19. If even Pressac (*Auschwitz: Technique and operation* . . . , 422) crops the photos in a rectangular format, which distorts their original format of 6 × 6, it is because the negatives themselves have disappeared: all the Auschwitz museum has is a contact print whose surrounds have been reduced, and even torn (figs. 3–4).

20. Pressac, *Auschwitz: Technique and Operation* . . . , 422.

21. Agamben, *Remnants of Auschwitz*.

22. Ibid.

23. Simon Srebnik (survivor of Chelmno), cited by Lanzmann in *Shoah*, 18. See also, among the numerous expressions of this responsibility, Antelme, *L'espèce humaine*, 9. J. Améry, *Par-delà le crime et le châtiment: Essai pour surmonter l'insurmontable* (1977), trans. F. Wuilmart (Arles: Actes Sud, 1995), 68–79. Blanchot, *L'écriture du désastre*, 131. E. Wiesel, Preface to Mark, *Des voix dans la nuit*, IV.

24. Cited by Mark, *Des voix dans la nuit*, 309.

25. Cited by. Wieviorka, *Déportation et génocide*, 163–165.

26. Cited by Lanzmann in *Shoah*, 139.

27. *La grande encyclopédie*, VI (Paris: Larousse, 1973), 3592.

Similar, Dissimilar, Survivor

1. This is the kind of work invited by the entire *Mémoire des camps* exhibition. See for a start, the unpublished research by I. About, *Les photographies du camp de concentration de Mauthausen: Approches pour une étude iconographique des camps de concentration* (Paris: Université Paris VII–Denis Diderot, 1997; thesis edited by P. Vidal-Naquet).

2. According to the expression used by Antelme, *L'espèce humaine*, 22: "Death was on the same level as life here, but at every single moment. The chimney of the crematorium smoked beside that of the kitchen. Before we were there, there had been bones of the dead in the soup of the living, and the gold from the mouths of the dead had long since been exchanged for the bread of the living."

3. See Levi, *Si c'est un homme*, 29: "From here, the only way out is by the chimney. As to what these words meant, we would understand all too well afterwards."* Wiesel, *La nuit*, 65 : "The word 'chimney' was not a meaningless word here: it floated in the air, mixed with the smoke. It was perhaps the only word that had any real meaning here." Pollak, "La gestion de l'indicible," 39–40, citing the testimony of a survivor: "And from the moment of arrival, we heard: 'You see that cloud, it's your relatives burning!' I heard that, nothing more. And indeed, a hundred meters from there, you could see a great black cloud, like a great heavy cloud . . . A curious image, worrying. 'It's your relatives burning!' I saw it, heard it, but understood it, no, I didn't understand it."*

4. Levi, *Si c'est un homme*, 26.* See also 27, 131–132.

5. Ibid., 140 and 153.*

6. Ibid, 113 and 185.*

7. Ibid., 136. "Not only do we not have the time to be afraid, but we do not have the space."*

8. See Améry, *Par-delà le crime et le châtiment*, 43–44: "Men were dying everywhere, but the figure of Death had disappeared."

9. See Wiesel, *La nuit*, 61, 63, 85. Bettelheim, "Schizophrenia as a Reaction to Extreme Situations," in *Surviving and Other Essays* (New York: Alfred. A. Knopf, 1979), 112–124.

10. Levi, *Si c'est un homme*, 184–186. On the subject of the "mannequins" See C. Delbo, *Auschwitz et après*, I: *Aucun de nous ne reviendra* (Paris: Minuit, 1970), 28–33 and 142.

11. See Antelme, *L'espèce humaine*, 178–180: "I looked at the one who was K. [. . .] I recognized nothing."

12. M. Blanchot, *L'entretien infini* (Paris: Gallimard, 1969), 193–194.

13. Levi, *Si c'est un homme*, 42–43.*

14. T. Todorov, *Face à l'extrême* (Paris: Le Seuil, 1991), 108.

15. See Bettelheim, "Individual and Mass Behavior in Extreme Situations," 48–83. M. Pollak, *L'expérience concentrationnaire: Essai sur le maintien de l'identité sociale* (Paris: Métaillié, 1990).

16. E. Kogon, *L'État SS: Le système des camps de concentration allemands* (1946), translated anonymously (Paris: La Jeune Parque, 1947; 1993 ed.), 399–400.

17. Levi, *Si c'est un homme*, 74.* See J. Cayrol, "Les rêves concentrationnaires," *Les temps modernes* 3, no. 36 (1948): 520–535: "Dreams became a means of safeguarding, a sort of 'maquis' from the real world" (520).

18. See in particular F. Neumann, *Behemot: The Structure and Practice of National Socialism* (Oxford: Oxford University Press, 1942). Arendt, "L'image de l'enfer," 151–160. Id., "Les techniques de la science sociale et l'étude des camps de concentration," 213. Traverso, *L'Histoire déchirée*, 71–99 and 219–223.

19. See in particular E. Kogon, *L'État SS*, 49–50. P. Levi, *Si c'est un homme*, 21. Wiesel, *La nuit*, 59. C. Delbo, *Auschwitz et après*, II: *Une connaissance inutile* (Paris: Minuit, 1970), 33–34. Müller, *Eyewitness Auschwitz*. M. Buber-Neumann, *Déportée à Ravensbrück: Prisonnière de Staline et d'Hitler*, II (1985), trans. A Brossat (Paris: Le Seuil, 1988 ; 1995 ed.), 7–19. V. Pozner, *Descente aux enfers: Récits de déportés et de SS d'Auschwitz* (Paris: Julliard, 1980).

20. Cited in B. Mark, *Des voix dans la nuit*, 266–67 and 302–304.

21. Citied in ibid., 191–240

22. This graffiti is reproduced in Czarnecki, *Last Traces*, 95.

23. Levi, *Si c'est un homme*, 123* (and in general 29, 93–107, 116–123). Id., *The Drowned and the Saved*, 139–140.

24. "Dante's Hell had become reality here" (commandant Irmfried Eberl speaking of Treblinka). "In comparison, Dante's Hell seems like a comedy to me [. . .]. We are in the *anus mundi*." (Doctor Johann Paul Kremer). Cited by Poliakov, in *Auschwitz*, 40–41, and by Langbein, in *Hommes et femmes à Auschwitz*, 330.

25. See Levi, *Si c'est un homme*, 83, 138–139, and 169, in which a reflection of this kind is developed on the vanity and the necessity of "signs" in Auschwitz: "Today I think that the simple fact that an Auschwitz was able to exist should prevent anyone, in our time, from uttering the word Providence; but it is certain that then, the memory of biblical help that

came at the worst moments of adversity passed like a breath through every mind."*

26. Regarding urgency and speed in the writing of testimonies, see in particular Mouchard, "'Ici'? 'Maintenant'?" 245–249. Indeed, a number of concentration camp narratives begin with this motif of urgency. See Levi, *Si c'est un homme*, 8. Antelme, *L'espèce humaine*, 9.

27. P. Celan, 'Todesfuge' (1945), in *Poems of Paul Celan: German and English Selections*, rev. and trans. M. Hamburger (New York: Persea Books, 2002), 62.

28. Z. Gradowski, cited by B. Mark in *Des voix dans la nuit*, 241–242. In his introduction, Ber Mark points to that other desperate fact that, after the war, "entire groups of pillagers rummaged through the camps searching for money, for gold, for objects of worth, so much did they believe the legend that the Jews had brought their treasures with them. By digging around the crematoria, they found manuscripts, worthless objects to them, which they destroyed or threw away" (180).*

29. Many others never arrived at all: "Unfortunately, the majority of photographs sent beyond the barbed wire got lost, and only a few were transmitted." Boguslawsak-Swiebocka and Ceglowska, *KL Auschwitz*, 18.

30. See D. S. Wyman, *L'abandon des Juifs: Les Américains et la solution finale* (1984), trans. C. Blanc (Paris: Flammarion, 1987), 373–397.

31. Benjamin, "Sur le concept d'histoire," 341.

32. S. Beckett, "Imagination Dead Imagine," trans. from French by S. Beckett, in *The Complete Short Prose 1929–1989*, ed. S. E. Gontarski (New York: Grove Press, 1995), 182.

Fact-Image or Fetish-Image

1. See, for a recent example, the special issue "Image et histoire" of the journal *Vingtième siècle*, no. 72, (2001), ed. L. Bertrand-Dorléac, C. Delage, and A. Gunthert. Regarding the theoretical difficulties of taking images into account historically, including by the *Annales* school, see G. Didi-Huberman, *Devant le temps: Histoire de l'art et anachronisme des images* (Paris: Minuit, 2000), 9–55.

2. G. Wajcman, "De la croyance photographique," *Les temps modernes* 56, no. 613 (2001): 47–83. E. Pagnoux, "Reporter photographique à Auschwitz," ibid. 84–108.

3. Wajcman, "De la croyance photographique," 51–53, 70, and 80.

4. Ibid., 49–51 and 70.

5. Ibid., 75.

6. Ibid., 50, 81, and 83.

7. Ibid., 54 and 65–66.

8. Ibid., 51, 55, 57, 63–64, 70, 72, and 83.

9. Ibid., 60–61.

10. Ibid., 58, 60, 64, 72, and 75–76.

11. Ibid., 50, 53, 67, 72, and 81.

12. Ibid., 62–63 and 70. The last proposition is trotted out on p. 74: "This absence of thought [. . .] is the same that today makes the Palestinians the Jews of our time and the Israelis the new Nazis."

13. Pagnoux, "Reporter photographique à Auschwitz," 87, 90, 103, and 106.

14. Ibid., 93–94, 98, and 102–105.

15. Ibid., 91, 93, and 103.

16. Ibid., 105–108.

17. Ibid., 94, 102, and 106–107.

18. Ibid., 84–85, 89–90, and 95.

19. Ibid., 91 and 105.

20. I had had to verify this, ten years ago, regarding another polemic on the status of contemporary art. See G. Didi-Huberman, "D'un ressentiment en mal d'esthétique," *Les cahiers du Musée national d'art moderne*, no. 43 (1993): 102–118 (expanded edition with "Post Scriptum: du ressentiment à la *Kunstpolitik*," *Lignes*, no. 22 [June 1994]: 21–62). See also, regarding the philosophical position of this problem, J. Rancière, *Le partage du sensible: Esthétique et politique* (Paris: La Fabrique), 2000.

21. This dispute has, moreover, already been the object of a sociological analysis: See J. Walter, "*Mémoire des camps:* une exposition photographique exposée," in *Redéfinitions des territoires de la communication*, ed. I. Dragan (Bucarest : Tritonic, 2002), 367–383. Id., "Un témoignage photographique sur la Shoah: Des violences en retour?" *Violences médiatiques: Contenus, dispositifs, effets*, ed. P. Lardellier (Paris L'Harmattan, 2003), 133–155.

22. Wajcman, "De la croyance photographique," 47.

23. Ibid., 47–49 and 54: "the fact revealed, the real fact, perfectly beyond all will, beyond all consciousness and all unconsciousness, that there is no image [. . .], real fact that there is not".

24. Ibid., 47.

25. Wajcman, "'Saint Paul' Godard contre 'Moïse' Lanzmann, le match," *L'infini*, no. 65 (1999): 122: "Obviously, I do not discuss the question of knowing whether or not there are images of the gas chambers. I do not know at all."

26. [Here the notion of "the imaged" (*l'imagé*) is to be understood as an extension of the concept of "the signified" (*le signifié*).—Trans.]

27. *Ibid.*, 122. See, on the contrary, the testimonies collected in E. Klee, W. Dressen, and V. Riess, *Pour eux "c'était le bon temps": La vie ordinaire des bourreaux nazis* (1988), trans. C. Métais-Bührendt (Paris: Plon, 1990), 216. See also the drawings of David Olère, in D. and A. Oler, *Witness: Images of Auschwitz* (Richland Hills, TX: West Wind Press, 1998), 25–27, where the ray from the inside lamp is marked as strongly for the scene of entering the gas chamber as it is for the gassing itself.

28. Wajcman, "'Saint Paul' Godard contre 'Moïse' Lanzmann," 122.

29. Wajcman, "De la croyance photographique," 47.

30. Ibid., 47 and 63. My emphasis.

31.[Here the notion of the "imager" (*l'imageant*) is to be understood as an extension of the concept of the "signifier" (*le signifiant*). See note 26 above.—Trans.]

32. Wajcman, *L'objet du siècle* (Paris: Verdier, 1998), 92–133 ("Rien à voir"), which we can compare with *Ce que nous voyons, ce qui nous regarde* (Paris: Minuit, 1992): 53–85 ("The dialectic of the visual, or the play of the hollowing out"); or 171–187 ("Modern resemblance" like the "tearing of resemblance"), which we can compare with *La ressemblance informe, ou le gai savoir visuel selon Georges Bataille* (Paris: Macula, 1995): 7–30 ("How do we tear resemblance ?").

33. Wajcman, *L'objet du siècle*, 25 and 237–238.

34. Wajcman, "De la croyance photographique," 47–48.

35. Ibid., 48.

36. Ibid., 49 and 54.

37. Wajcman, "'Saint Paul' Godard contre 'Moïse' Lanzmann," 122.

38. Wajcman, *L'objet du siècle*, 239.

39. Z. Lewental, cited by Langbein in *Hommes et femmes à Auschwitz*, 3. We have since found a new, more complete French translation in B. Mark's edition (*Des voix dans la nuit: La résistance juive à Auschwitz-Birkenau* [1965], trans. E. and J. Fridman and L. Princet [Paris: Plon, 1982]) of the *Scrolls of Auschwitz*, ed. P. Mesnard and C. Saletti, in a special issue, "Des voix sous les cendres: Les manuscrits des *Sonderkommando* d'Auschwitz," of the *Revue d'histoire de la Shoah: Le monde juif*, no.171 (2001). It is this edition that will be cited henceforth.

40. Wajcman, "De la croyance photographique," 54.

41. On the use of and the quarrel about images in the Byzantine world, see in particular H. Belting, *Likeness and Presence: A History of the Image before the Era of Art*, trans. E. Jephcott (Chicago: University of Chicago Press, 1997). On Tertullian and his contradictory hatred of the visible, see Didi-Huberman, "La couleur de chair, ou le paradoxe de Tertullien," *Nouvelle revue de psychanalyse*, no.35 (1987): 9–49. On the survival of these

NOTES TO PAGES 65–68]

theologico-political problems in current debates, see in particular M. J. Mondzain, *L'image peut-elle tuer?* (Paris: Bayard, 2002).

42. Wajcman, "De la croyance photographique," 47.

43. C. Chéroux, ed. *Mémoire des camps: Photographies des camps de concentration et d'extermination nazis (1933–1999)* (Paris: Marval, 2001).

44. Pagnoux, "Reporter photographe à Auschwitz," 89.

45. See J. Fredj, ed., *Les archives de la Shoah* (Paris: CDJC-l'Harmattan, 1998). D. Michman, *Holocaust Historiography: A Jewish Perspective — Conceptualizations, Terminology, Approaches, and Fundamental Issues* (London: Vallentine Mitchell, 2003).

46. R. Hilberg, *Holocaust: les sources de l'histoire* (2001), trans. M.-F. de Paloméra (Paris: Gallimard, 2001), 18–19.* Further on, Hilberg quite pertinently — but without overdoing it — evokes the questions of framing and "composition" (55–56). He devotes an entire chapter even to the questions of "style" (77–141.)

47. Ilsen About, Christian Delage, and Arno Gisinger on the one hand; and Pierre Bonhomme, Clément Chéroux, and Katharina Menzel on the other.

48. P. Bonhomme and C. Chéroux, "Introduction," in *Mémoire des camps*, 10. C. Chéroux, "Du bon usage des images," in ibid., 16.

49. I. About, "La photographie au service du système concentrationnaire national-socialiste (1933–1945)," in ibid., 29–53.

50. C. Chéroux, "Pratiques amateurs," in ibid., 74–77.

51. C. Chéroux, "Photographies clandestines de Rudolf Cisar à Dachau" and "Photographies de la Résistance polonaise à Auschwitz," in ibid., 84–91. See also the interview by Georges Angéli, in ibid., 78–83.

52. [The French word *preuve* can mean either "evidence" or "proof," depending on the context. In this work I have generally chosen "evidence." Where both meanings fit, I have added "or proof." — Trans.]

53. C. Delage, "L'image photographique dans le procès de Nuremberg," in *Mémoire des camps*, 172–173. See the work by C. Brink, *Ikonen der Vernichtung: Öffentlicher Gebrauch von Fotografien aus nationalsozialistischen Konzentrationslagern nach 1945* (Berlin: Akademie Verlag, 1998), 101–142. S. Lindeperg, *Clio de 5 à 7: Les actualités filmées de la Libération — archives du futur* (Paris: CNRS, 2000), 211–266, which includes, in French translation, L. Douglas's article "Le film comme témoin," 238–255.

54. ["Visual ordeal": the French, *épreuve visuelle*, plays on the words *preuve visuelle* (visual evidence, or visual proof) used in the previous sentence. — Trans.]

55. C. Chéroux, "'L'épiphanie négative': production, diffusion et réception des photographies de la libération des camps," in *Mémoire des*

camps, 103–127. Id., "1945: Les seuils de l'horreur," *Art Press*, special issue, "Représenter l'horreur," May 2001, 34–39. See the work by S. Callegari, M. Guittard, and C. Richez, "Le document photographique: Une histoire à reconstruire," in *La libération des camps et le retour des déportés: L'histoire en souffrance*, ed. M.-A. Matard-Bonucci and E. Lynch (Brussels: Éditions Complexe, 1995), 101–105. M.-A. Matard-Bonucci, "La pédagogie de l'horreur," in ibid., 61–73. Brink, *Ikonen der Vernichtung*, 23–99. Lindeperg, *Clio de 5 à 7*, 67–111 and 155–209.

56. The third part of the exhibition, entitled "Le temps de la mémoire (1945–1999)," curiously chose to overlook the social repercussions of the photographs of the camps, focusing rather on a more controversial aesthetic exploration. This part was criticized in particular by M. B. Servin, "Au sujet de l'exposition *Mémoire des camps*," *Revue d'histoire de la Shoah: Le monde juif*, no.72 (2001): 340–342, and by C. Baron, "A propos d'une exposition (suite)," ibid., 342. It might have sufficed to exhibit Wladyslaw Strzeminski's collages or Gerhard Richter's *Atlas*, on which A. Gisinger's article focuses briefly (see Gisinger, "La photographie: De la mémoire communicative à la mémoire culturelle," in *Mémoire des camps*, 179–200). For a very complete study of the role of the photographic image in the German memory of the Shoah, see H. Knoch, *Die Tat als Bild: Fotografien des Holocaust in der deutschen Erinnerungskultur* (Hamburg: Hamburger Edition, 2001).

57. See in particular A. Bergala, *Nul mieux que Godard* (Paris: Cahiers du cinéma, 1999), 202–203. G. Walter, *La réparation* (Paris: Flohics, 2003).

58. See P. Mesnard, *Consciences de la Shoah: Critique des discours et des représentations* (Paris: Kimé, 2000), 35. This concerns an advertising campaign in the Parisian metro, in January 1997, intended to promote a tour of the French rock group Trust.

59. Wajcman, "De la croyance photographique," 64–65. Pagnoux, "Reporter photographe à Auschwitz," 84–85 (in which the formulas cited are taken not from the catalogue itself but from the magazine *Télérama*).

60. J. Mandelbaum, "La Shoah et ces images qui nous manquent," *Le Monde*, January, 25, 2001, 17.

61. These two arguments, put together, are the joy of the negationists: Robert Faurisson gave a delighted commentary on the article by Jacques Mandelbaum on the website *Aaargh* on January 25, 2001.

62. [The reference to the "absent one of any bouquet" in this sentence is to a celebrated (and difficult) sentence by French poet Mallarmé (*Divagations*, 1897), and could be translated as follows: "I say a flower! and, out of the oblivion where my voice banishes any contour as something other than the flower's chalice rises musically, the very idea, suave, the absent

one of any bouquet." The original reads: *Je dis une fleur! et, hors de l'oubli où ma voix relègue aucun contour en tant que quelque chose d'autre que les calices sus musicalement se lève, idée même et suave, l'absente de tout bouquet.*—Trans.]

63. See J. Lacan, *Le Séminaire, XX: Encore* (1972–1973), ed. J.-A. Miller (Paris: Le Seuil, 1975), 85: "All of the truth is that which cannot be said [*se dire*]. It is that which can only be said on condition that it not be pushed to the very end, that it be only half said." [The French reflexive *se dire*, translated here with the idiomatic passive voice, literally means "say itself."—Trans.]

64. Wajcman, "De la croyance photographique," 58.

65. R. Barthes, *Mythologies* (Paris: Le Seuil, 1957), 105–107.

66. See L. Gervereau, *Les images qui mentent: Histoire du visuel au XXe siècle* (Paris: Le Seuil, 2000), in particular 203–219. Id., *Un siècle de manipulations par l'image* (Paris: Somogy, 2000), in particular 124–131.

67. B. Zelizer, *Remembering to Forget: Holocaust Memory through the Camera's Eye* (Chicago: University of Chicago Press, 1998), 86–140. See also G. H. Hartman, *The Longest Shadow: In the Aftermath of the Holocaust* (Bloomington: Indiana University Press, 1996). A. Liss, *Trespassing through Shadows: Memory, Photography and the Holocaust* (Minneapolis: University of Minnesota Press, 1998).

68. This is quite well illustrated in Y. Doosry, ed., *Representations of Auschwitz: 50 Years of Photographs, Paintings and Graphics* (Oswiecim, Auschwitz-Birkenau State Museum, 1995).

69. P. Vidal-Naquet, *Les assassins de la mémoire: "Un Eichmann de papier" et autres essais sur le révisionnisme* (Paris: La Découverte, 1987), 133.

70. See J. Walter, "Les archives de l'histoire audiovisuelle des survivants de la Shoah: Entre institution et industrie, une mémoire mosaïque en devenir," in *Les Institutions de l'image*, ed. J.-P. Bertin-Maghit and B. Fleury-Vilatte (Paris: Éditions de l'EHESS, 2001), 187–200. For a more developed reflection on this problem, see the periodical *Cahier international—Études sur le témoignage audiovisuel des victimes des crimes et génocides nazis* (Brussels: Éditions du Centre d'Études et de Documentation–Fondation Auschwitz, 1996–2002).

71. I. About and C. Chéroux, "L'histoire par la photographie," *Études photographiques*, no.10 (2001): 9–33.

72. A position recently defended by Y. Michaud, "Critique de la crédulité: La logique de la relation entre l'image et la réalité," *Études photographiques*, no.12 (2002): 111–125.

73. Wajcman, "De la croyance photographique," 58–60.

74. Pagnoux, "Reporter photographe à Auschwitz," 94.

75. Ibid., 91.

76. Ibid., 87, 90, 94, and 102–103.

77. Ibid., 89 and 92–93.

78. Wajcman, "De la croyance photographique," 81–83.

79. Wajcman, *L'objet du siècle*, 207 and 243.

80. Wajcman, *Collection, suivi de l'Avarice* (Caen: Nous, 1999), 63–64: "By definition, the space of art is the universal and its unity, is the singular work. [. . .] We therefore call the work of art an absolutely singular work, unsubstitutable and unreproducible. [. . .] The work as that which resembles nothing and represents nothing. It presents, and presents itself. The only mode of being in the world of this object is presence."

81. Ibid., 46.

82. Wajcman, "De la croyance photographique," 82.

83. A movement that saw their all too exclusive rejection, because of the overexclusive use of texts by R. Barthes (*La chambre claire: Note sur la photographie* [Paris: Éditions de l'Étoile–Gallimard–Le Seuil, 1980]) or by R. Krauss (*Le Photographique: Pour une théorie des écarts* [1978–1985], trans. M. Bloch and J. Kempf [Paris: Macula, 1990]).

84. O. Mannoni, *Clefs pour l'imaginaire, ou l'autre scène* (Paris: Le Seuil, 1969), 9–33.

85. We owe this famous dictum of the experimental method to Claude Bernard: "When the fact that we encounter is in opposition to a reigning theory, we must accept the fact and abandon the theory, even when the latter, upheld by great names, is generally accepted." According to Octave Mannoni, this very principle is at the origin of Freudian psychoanalysis: "It was not enough to constitute psychoanalysis, but enough to remove obstacles. He [Freud] heard Charcot push aside theories ("theories are very nice, but they do not prevent existence") to converse with hysterics, rather than uncovering their secrets in the laboratory of histology." O. Mannoni, *Ça n'empêche pas d'exister* (Paris: Le Seuil, 1982), 33.

86. Wajcman, "De la croyance photographique," 81.

87. S. Freud, *Three Essays on the Theory of Sexuality* (1905), trans. J. Strachey, ed. N. Chodorow and S. Marcus (New York: Basic Books, 2000).

88. This was shown long ago by P. Fédida, "La relique et le travail du deuil," *Nouvelle revue de la psychanalyse*, no.2 (1970): 249–254.

89. J. Lacan, *Le Séminaire, I: Les écrits techniques de Freud* (1953–1954), ed. J.-A. Miller (Paris: Le Seuil, 1975), 247.

90. J. Lacan, *Le Séminaire, IV: La relation d'objet* (1956–1957), ed. J.-A. Miller (Paris: Le Seuil, 1994), 91.

91. Ibid., 85–86. See also 156–157 (on the fetish as a "monument," a trophy, a "sign of triumph").

92. Ibid., 119–120 and 157.

93. Ibid., 158.

94. Wajcman, "'Saint Paul' Godard contre 'Moïse' Lanzmann," 122.

95. Wajcman, "De la croyance photographique," 68 : "There simply cannot be any image of [the] horror [. . .]. One cannot reason any further, if there is horror, it tears all images, and when there is an image, then there is less horror. Horror has no image, it is in this way without any double, unique. The image on the other hand, is a double."

96. Ibid., 55.

97. Our controversy constitutes a symptom all the more characteristic since our respective points of departure were concomitant twenty years ago: the reference to psychoanalysis, the simultaneous study of that *mal d'images* [image-fever] which is hysteria, the interest in theater and the visual arts. See G. Wajcman, *Le maître d'hystérie* (Paris: Navarin, 1982). G. Didi-Huberman, *Invention de l'hystérie: Charcot et l'iconographie photographique de la Salpêtrière* (Paris: Macula, 1982).

98. G. Didi-Huberman, *La peinture incarnée* (Paris: Minuit, 1985), 115–132 ("Le doute [le déchirement] du peintre"). Id., *Devant l'image: Question posée aux fins d'une histoire de l'art* (Paris: Minuit, 1990), 169–269 ("L'image comme déchirure").

99. Wajcman, *L'objet du siècle*, 243, obviously supports the contrary: "The image is always affirmative. In order to deny, something else would be needed: words."

100. G. Bataille, *L'expérience intérieure* (1943), in *Oeuvres complètes*, V (Paris: Gallimard, 1973), 119–120, and passim. See G. Didi-Huberman, "L'immagine aperta," trans. M. Galetti, in *Georges Bataille: Il politico e il sacro*, ed. J. Risset (Naples, Liguori, 1987), 167–188.

101. M. Blanchot, "Le musée, l'art et le temps" (1950–1951), *L'amitié* (Paris: Gallimard, 1971), 50–51. Id., "Les deux versions de l'imaginaire" (1951), *L'espace littéraire* (Paris: Gallimard, 1955; 1988 ed.), 341–355.

102. Lacan, *Le Séminaire, I*, 134.

103. J. Lacan, *Le Séminaire, II: Le moi dans la théorie de Freud et dans la technique de la psychanalyse* (1954–1955), ed. J.-A. Miller (Paris: Le Seuil, 1978), 196 and 209. My emphasis.

104. Ibid., 210.

105. See F. Kaltenbeck, "Arrêts sur image," *La cause freudienne. Revue de psychanalyse*, no.30 (1995): 3: "For a long time, the exploration of the imaginary was inhibited by the villainous reputation that clung to it even in the school of Lacan. The noble symbolic or the heroic real are always preferred to it, forgetting that Lacan had finished making these three registers equal—R, S, I—in a knot. [. . .] Prejudices have tenacious lives

and Lacan's students continued [. . .] to treat the imaginary with disdain, favoring a symbolic-all [*tout-symbolique*]." This text opens a special issue of *La cause freudienne*, a journal devoted to "Images indélébiles ," in which, while the analyses of images tend to be mediocre, one can detect the appearance of the theoretical necessity to *dialectize the imaginary* between a "screen" use and a "real" use. See H. Rey-Flaud, "Qu'est-ce qu'une image indélébile?," ibid., 55–58. See also the precious distinctions concerning "imaginary unity" in G. Le Gaufey's work *Le lasso spéculaire: Une étude traversière de l'unité imaginaire* (Paris: EPEL, 1997), 21–113.

106. Levi, *The Drowned and the Saved*, 157.

107. I. Kertesz, "A qui appartient Auschwitz?" trans. N. and C. Zaremba, in Mesnard, *Consciences de la Shoah*, 149.*

108. See Mesnard, *Consciences de la Shoah*, 19–20.

109. Hellman, *L'album d'Auschwitz*. I recall here what Serge Klarsfeld specified about this capital document: "And I told them [those in charge of the memorial of Yad Vashem], when, in 1980, I gave them this album originally belonging to an ex-prisoner: 'One day, later, it will be like the Dead Sea Scrolls, because these are the only authentic photographs of Jews arriving at a concentration camp.'" S. Klarsfeld, "À la recherche du témoignage authentique," in *La Shoah: Témoignages, savoirs, œuvres*, 50. See also, regarding the case of Mauthausen, B. Bermejo, *Francisco Boix, el fotógrafo de Mauthausen: Fotografías de Francisco Boix y de los archivos capturados a los SS de Mauthausen* (Barcelona: RBA Libros, 2002).

110. A. Jaubert, "Filmer la photographie et son hors-champs," in Lindeperg, *Clio de 5 à 7*, 190.

111. Ibid. The same reflections could be made about the photographic corpus of the ghetto of Lodz, for example. See M. Grossman, *With a Camera in the Ghetto* (Tel Aviv: Hakibbutz Hameuchad, 1970). H. Loewy and G. Schoenberner, eds., *"Unser einziger Weg ist Arbeit": Das Getto in Lodz, 1940–1944* (Frankfurt: Jüdisches Museum, 1990).

112. S. Sontag, *On Photography* (1971; Penguin Books, 1979), 20.

113. Ibid., 19–20.

114. G. Wajcman, "Oh *Les derniers jours*," *Les temps modernes* 55, no. 608 (2000): 21.

115. Ibid., 27: "When Serge Daney says that from the moment he saw the 'non-images of *Nuit et brouillard* [*Night and Fog*]' he 'became one of those who would never forget'; I cannot dismiss from my mind the idea that before even having seen that film, before even knowing something with exactness, he was already one of those who had not forgotten, who had always known."

116. See J. Altounian, *La survivance: Traduire le trauma collectif* (Paris:

Dunod, 2000), 1–6, and also P. Fédida, "Préface ," in ibid., p.ix, who speaks
of the "anxiety without image" similar to those "autistic anxieties where
not the least image survives, not the least sentiment, not the least word."
See also M. Schneider, *Le trauma et la filiation paradoxale: De Freud à Fer-
enczi* (Paris: Ramsay, 1988).

117. Ka-Tzetnik 135633, *Les visions d'un rescapé, ou le syndrome d'Auschwitz*
(1987), trans. E. Spatz and M. Kriegel (Paris: Hachette, 1990), 88.*

118. Ibid., 19–20 and 27.*

119. J. Semprun, *L'écriture ou la vie* (Paris: Gallimard, 1994), 258–261.

120. [The word *étrangeté*, rendered here by "strangeness," can also mean
"foreignness"; perhaps to make the distinction, Didi-Huberman coins the
word *étrangèreté* (enclosed in the original in quotation marks), for what is
rendered here by "foreignness."—Trans.]

121. M. Proust, *À la recherche du temps perdu*, II : *Le côté de Guermantes*
(1920–1921), ed. P. Clarac and A. Ferré (Paris: Gallimard, 1954), 140.

122. See S. Weigel, "Lesbarkeit. zum Bild- und Körpergedächtnis in der
Theorie," *Manuskripte: Zeitschrift für Literatur* 32, no.115 (1992): 13–17.

Archive-Image or Appearance-Image

1. W. Benjamin, *The Arcades Project*, trans. Howard Eiland and Kevin
McLaughlin (Cambridge, MA: Harvard University Press, 1999), 463.

2. Pagnoux, "Reporter photographe à Auschwitz," 93.

3. Ibid., 105.

4. Wajcman, "Oh *Les derniers jours*," 12.

5. Wajcman, "De la croyance photographique," 53.

6. Pagnoux, "Reporter photographe à Auschwitz," 87–88.

7. G. Didi-Huberman, "Le lieu malgré tout" (1995), in *Phasmes: Essais
sur l'apparition* (Paris: Minuit, 1998), 228–242.

8. Pagnoux, "Reporter photographe à Auschwitz," 95–96.

9. Wajcman, "'Saint Paul' Godard contre 'Moïse,'" 125–126.

10. Ibid., 127.

11. Wajcman, *L'objet du siècle*, 241. See the concomitant terms of M. He-
nochsberg, "Loin d'Auschwitz, Roberto Benigni, bouffon malin," *Les
temps modernes* 55, no. 608 (2000): 58: "The production of the concept of
Auschwitz, that is to say, of penetrating the idea of the Shoah, is consub-
stantial with the impossibility of representing the event as such. More
precisely, *the impossibility of representation is part of the concept*: to envisage
Auschwitz, is to admit *the impossibility of its setting into an image*. [. . .] This
has happened, and there is nothing left but a memory, not an image, not
one [. . .]. *Representation and misrecognition go together.* This lesson comes

from everywhere, and it has been clearly presented and sealed in *Shoah*, the definitive film by Claude Lanzmann."

12. C. Lanzmann, "La question n'est pas celle du document, mais celle de la vérité" (interview with Michel Guerrin), *Le Monde*, January 19, 2001, 29.

13. C. Lanzmann, "Le lieu et la parole" (1985), *Au sujet de* Shoah, 295.

14. C. Lanzmann, "La guerre a eu lieu," *Les temps modernes* 54, no. 604 (1999): 6. These lines concern Regis Debray.

15. C. Lanzmann, "La question n'est pas celle du document, mais celle de la vérité," 29.

16. Nonetheless, Lanzmann does not refrain from also questioning survivors of the concentration camp world.

17. C. Lanzmann, "Parler pour les morts," *Le monde des débats*, May 2000, 14.

18. C. Lanzmann, "Le monument contre l'archive? (interview with Daniel Bougnoux, Régis Debray, Claude Mollard, et al.)," *Les cahiers de médiologie*, no.11 (2001): 274.

19. Ibid., 278.

20. Ibid., 273.

21. Lanzmann, "Parler pour les morts," 14.

22. C. Lanzmann, "Holocauste, la représentation impossible," *Le Monde*, March 3, 1994, i and vii.

23. Ibid., vii.

24. Lanzmann, "Parler pour les morts," 15: "*Schindler's List* comes down to manufacturing false archives, like all films of that kind."

25. Lanzmann, "Holocauste, la représentation impossible," p. vii.

26. J. Semprun, "L'art contre l'oubli," *Le monde des débats*, May 2000, 11–13. Lanzmann, "Parler pour les morts," p.14.

27. Lanzmann, "Le monument contre l'archive?" 273.

28. Ibid., 273.

29. Ibid., 276.

30. Ibid., 273.

31. Lanzmann, "Parler pour les morts," 14.

32. Pagnoux, "Reporter photographe à Auschwitz," 96.

33. Wajcman, *L'objet du siècle*, 19 and 63. Id., "De la croyance photographique" 70.

34. J.-J. Delfour, "La pellicule maudite: Sur la figuration du réel de la Shoah—le débat entre Semprun et Lanzmann," *L'arche*, no. 508 (2000): 14–15.

35. M. de Certeau, *L'écriture de l'histoire* (Paris: Gallimard, 1975), 84.

36. J. Derrida, *Mal d'archive: Une impression freudienne* (Paris: Galilée, 1995), 144.

37. Ibid., 143.

38. Ibid., 26–27 and 141–143.

39. Ibid., 141.

40. A. Farge, *Le goût de l'archive* (Paris: Le Seuil, 1989), 10, 19, 70, and 97.

41. Ibid., 135.

42. Against the common idea of the Nazi crime as a "pure industrial product" (Wajcman, *L'objet du siècle*, 226), Pierre Vidal-Naquet remarks that "the gas chambers are merely the product of a very poor technique," which can also be said of the incineration pits visible in the photos of August 1944. See P. Vidal-Naquet, "Le défi de la Shoah à l'histoire" (1988), *Les Juifs, la mémoire et le présent*, II (Paris: La Découverte, 1991), 232.

43. Farge, *Le goût de l'archive*, 11–12, 45, and 55.

44. Ibid., 9 and 77. A Warburg, "L'art du portrait et la bourgeoisie florentine: Domenico Ghirlandaio à Santa Trinita; Les portraits de Laurent de Médicis et de son entourage" (1902), trans. S. Muller, in *Essais florentins* (Paris: Klincksieck, 1990), 106.

45. R. Badinter and A. Wieviorka, "Justice, image, mémoire," *Questions de communication*, no.1 (2002): 101. See also A. Farge, "Écriture historique, écriture cinématographique," in *De l'histoire au cinéma*, ed. A. de Baecque and C. Delage (Parisand Brussels: IHTP–CNRS–Éditions Complexe, 1998), 111–125.

46. Vidal-Naquet, "Le défi de la Shoah à l'histoire," 233. R. Hilberg, *Holocaust*, 50.

47. P. Vidal-Naquet, "Lettre," in *Michel de Certeau*, ed. L. Giard (Paris: Centre Georges Pompidou, 1987): 71–74. Id., "Sur une interprétation du grand massacre: Arno Mayer et la 'Solution finale'" (1990), in *Les Juifs, la mémoire et le présent*, II, 262–263, where he defends Jean-Claude Pressac's "archeology" against the generalized doubt of Arno Mayer on the "sources" of the Shoah.

48. C. Ginzburg, "Just One Witness," in *Probing the Limits of Representation*, 82–96. See also D. LaCapra, "Representing the Holocaust: Reflections on the Historian's Debate," ibid., 108–127. The problem is also examined by Y. Thanassekos, "De l'histoire-problème' à la problématisation de la mémoire," *Bulletin trimestriel de la Fondation Auschwitz*, no.64 (1999): 5–26. P. Ricoeur, *La mémoire, l'histoire, l'oubli* (Paris: Le Seuil, 2000), 201–230 and 320–369. P. Burke, *Eyewitnessing: The Uses of Images as Historical Evidence* (Ithaca: Cornell University Press, 2001).

49. C. Ginzburg, *Rapports de force: Histoire, rhétorique, preuve* (2000),

translated into French by J.-P. Bardos (Paris: Gallimard–Le Seuil, 2003), 13–14 and 33–34.

50. Ibid., 34. [On "evidence" and "proof," see note 52 in "Fact-Image or Fetish-Image," above.—Trans.]

51. C. Ginzburg, "Nota all'edizione italiana," *Rapporti di forza* (Milan: Feltrinelli 2001), 11.

52. Wajcman, "De la croyance photographique," 53.

53. G. Wellers, ed., "La négation des crimes nazis: Le cas des documents photographiques accablants," *Le monde juif* 37, no. 103 (1981): 96–107.

54. See S. Felman, "A l'âge du témoignage: *Shoah* de Claude Lanzmann," trans. C. Lanzmann and J. Ertel, in *Au sujet de* Shoah, 55–145. A. Wieviorka, *L'ère du témoin* (Paris: Plon, 1998).

55. Pagnoux, "Reporter photographe à Auschwitz," 95. Wajcman, "Oh *Les derniers jours*," 22.

56. Wajcman, *L'objet du siècle*, 240.

57. P. Levi, *Si c'est un homme* (1947), trans. M. Schruoffeneger (Paris: Julliard, 1987), 7.*

58. P. Levi, "Comprendre et faire comprendre" (1986), trans. D. Autrand, in *Conversations et entretiens, 1963–1987* (Paris: Laffont, 1998), 237–252.

59. R. Dulong, *Le témoin oculaire: Les conditions sociales de l'attestation personnelle* (Paris: Éditions de l'EHESS, 1998), 226.

60. J.-F. Lyotard, *Le différend* (Paris: Minuit, 1983), 9–55.

61. Agamben, *Remnants of Auschwitz*. This position is criticized in particular by S. Levi Della Torre, "Il sopravvissuto, il musulmano e il testimone," *Una città*, no.83 (2000): 16–17 (taken up again in P. Levi, *I sommersi e i salvati. Nuova edizione*, ed. D. Nidussa (Turin: Einaudi, 2003), 214–223); F. Benslama, "La représentation et l'impossible," *Le genre humain*, no.36 (2001): 59–80; and above all by P. Mesnard and C. Kahan, *Giorgio Agamben à l'épreuve d'Auschwitz: Témoignages/interprétations* (Paris: Kimé, 2001) (a critique that is justified when it challenges the notion of muteness as a "spectacular syntax [*syntaxe spectaculaire*]" or when it gives center stage once more to the testimonies of the *Sonderkommando*; an excessive and unjust critique when it becomes suspicious of every detail—the theme of the Gorgon, for example—or when it forces each nuance of Agamben's thought).

62. J.-P. Vernant, "Histoire de la mémoire et mémoire historienne," *Pourquoi se souvenir? Forum international Mémoire et histoire de l'Académie universelle des cultures*, ed. F. Barret-Ducrocq (Paris: Grasset, 1999), 27. My emphasis.

63. See Levi, *The Drowned and the Saved*, 11–12. É. Wiesel, *La nuit* (Paris:

Minuit, 1958), 17–18. A. Wieviorka, "Indicible ou inaudible? La déporta-
tion: premiers récits (1944–1947)," *Pardès*, nos. 9–10 (1989): 23–59.

64. M. Edelman, *Mémoires du ghetto de Varsovie* (1945), trans. P. Li and
M. Ochab (Paris: Liana Levi, 2002), 42.*

65. See Felman, "A l'âge du témoignage," 81–87.*

66. There exists, however, a journal kept secretly by SS Johan Paul Kre-
mer about his three months spent at Auschwitz, and also the evidence left
by Pery Broad and, especially, Rudolf Höss: the commander of the camp,
Höss wrote his story in prison before being hanged in 1947. These texts
were published in *Auschwitz vu par les SS*, trans. J. Brablec, H. Dziedzinska,
and G. Tchegloff (Oswiecim: Éditions du musée d'état d'Auschwitz, 1974).
See also R. Höss, *Commandant of Auschwitz: The Autobiography of Rudolf
Hoess* (London: Weidenfeld and Nicolson, 1959).

67. See R. Vrba (with A. Bestic) *Je me suis évadé d'Auschwitz* (1963), trans.
J. Plocki and L. Slyper (Paris: Ramsay, 2001). Müller, *Eyewitness Auschwitz*.
Y. Gabbay, "Témoignage (recueilli par Gideon Greif)," trans. C. Suppé-
Hirsch, *Revue d'histoire de la Shoah: Le monde juif*, no.171 (2001): 248–291.

68. M. Nyiszli, "SS Obersturmführer Docteur Mengele: Journal d'un
médecin déporté au crématorium d'Auschwitz" (1946), trans. T. Kremer,
Les temps modernes 6, no. 66 (1951): 1865–1866.

69. Wajcman, *L'objet du siècle*, 240: "Witness, or [. . .] that which super-
poses survivor and witness."

70. Pagnoux, "Reporter photographe à Auschwitz," 107–108.

71. E. Ringelblum, cited by A. Wieviorka, *L'ère du témoin*, 17 (and pas-
sim, 17–19).

72. See G. Bensoussan, "Éditorial," *Revue d'histoire de la Shoah: Le monde
juif*, no.171, 2001, 4–11. This special issue, "Des voix sous les cendres:
Manuscrits des *Sonderkommando* d'Auschwitz," contains the best edition
to date of the *Scrolls*, edited by P. Mesnard and C. Saletti.

73. C. Saletti, "A l'épicentre de la catastrophe," in "Des voix sous les
cendres," 304 and 307. See also P. Mesnard, "Écrire au dehors de la mort,"
ibid., 149–161. N. Cohen, "Manuscrits des *Sonderkommando* d'Auschwitz:
Tenir face au destin et contre la réalité" (1990), trans. M. B. Servin, ibid.,
317–354.

74. Z. Gradowski, "Notes" (text dates September 6, 1944), trans.
M. Pfeffer, ibid., 67.*

75. Z. Lewental, "Notes" (text dated October 10, 1944), trans.
M. Pfeffer, ibid., 124.*

76. L. Langfus, "Notes" (text dated November 26, 1944), trans.
M. Pfeffer, ibid., 77–78.*

77. Z. Gradowski, *Au coeur de l'enfer: Document écrit d'un Sonderkom-*

mando d'Auschwitz (1944), ed. P. Mesnard and C. Saletti, trans. B. Baum (Paris: Kimé, 2001), 53.*

78. Ibid., 53.*

79. A. Foincilber [or Fajnzylberg], "Procès-verbal" (1945), trans. M. Malisewska, *Revue d'histoire de la Shoah: Le monde juif*, no.171 (2001): 218.*

80. [In the phrase "to broaden the channels—and the voices—of testimony," Didi-Huberman is playing on the words *voies* (channels) and *voix* (voices).—Trans.] I did not want, in this context, to use the ambiguous formulation given in *Mémoire des camps* as a legend for the four images from August 1944—"Photographs of the Polish Resistance of Auschwitz"—which unduly extends the expression used by Jean-Claude Pressac, "Photographs of the Polish Resistance." The Polish Resistance, in this story, played the role of introducing the camera into the camp (via Mordarski and Szmulewski) and that of the consignee of the images (for a putative expedition, via Krakow, of the prints toward the allies), but not that of the *actor*. Directed by Alex, a Greek Jew, the four images of August 1944 bear witness in fact to the Jewish resistance in the *Sonderkommando*. See the shattering reflections by Zalmen Lewental in *The Scrolls of Auschwitz*: "[. . .] still in contact with the Polish. [*lacuna*] it was simply the [*lacuna*] devotion to the [cause?] [*lacuna*] they used us in every domain [*lacuna*] we supplied them with everything they [demanded], gold, silver and other precious objects, valued at several million. And what is even more important is that we gave them secret documents, material on everything that was happening to us [*lacuna*]. We shared everything with them, the least thing that arose, facts that one day might interest the world. [. . .] But [it seems] that we were mistaken, the Polish, our allies, and everything that they squeezed from us, they have used for their own objectives." Lewental, "Notes," 122.*

81. Gradowski, *Au coeur de l'enfer*, 81–102 ("Dans la salle de déshabillage"—"Elles sont là"—"La marche à la mort"—"Le chant de la tombe"). Langfus, "Notes," 79–83 ("Les trois mille femmes nues").

82. Wajcman, "De la croyance photographique," 82. My emphasis.

83. Ibid., 49 and 72.

84. Aristotle, *De Anima*, 3.8.432a, trans. H. Lawson-Tancred (Penguin Classics, 1986), 210. See id., *De la mémoire et de la réminiscence*, 1.449b–450a, trans. J. Tricot (Paris: Vrin, 1951), 58–59 : "It is impossible to think without an image [. . .]. Memory, even that of objects of thought, does not exist without an image."*

85. J.-P. Sartre, *L'imaginaire: Psychologie phénoménologique de l'imagination* (Paris: Gallimard, 1940; 1980 ed.), 229 and 235.

86. J.-P. Sartre, *L'imagination* (Paris: PUF, 1936; 1981 ed.), 5.

87. Ibid., 139–159.

88. Ibid., 162.

89. Sartre, *L'imaginaire*, 20–28 ("Le phénomène de quasi-observation") and 231–235 ("Image et perception").

90. Lanzmann, "La question n'est pas celle du document, mais celle de la vérité," 29. To which he adds, truly in bad faith, that I would have had the "obscure intention of making us believe that we are in possession of photos of what happens inside a gas chamber *during the gassing operation.*" My emphasis.

91. Pagnoux, "Reporter photographe à Auschwitz," 90.

92. Wajcman, "De la croyance photographique," 79.

93. See in particular J. Fredj, ed., *Auschwitz, camp de concentration et d'extermination* (Paris: Centre de Documentation juive contemporaine, 2001), 70.

94. Pressac *Auschwitz: Technique and Operation . . .* , 422–424. For a precise description of crematorium V, see the testimonies of S. Dragon, A. Foincilber, and H. Tauber, "Procès-verbaux" (1945), trans. M. Malisewska, *Revue d'histoire de la Shoah: Le monde juif*, no. 171 (2001): 174–179 and 200. These testimonies are used by J.-C. Pressac, "Etude et réalisation des *Krematorien* IV et V d'Auschwitz-Birkenau," *L'Allemagne nazie et le génocide juif: Colloque de l'EHESS (Paris: juillet, 1982)* (Paris: Gallimard–Le Seuil, 1985), 539–584.

95. Chéroux, "Photographies de la Résistance polonaise à Auschwitz," 86–89.

96. And to redirect the topographical verification process carried out by Pressac, *Auschwitz: Technique and operation . . .* , 422.

Montage-Image or Lie-Image

1. C. Baudelaire, "Notes nouvelles sur Edgar Poe" (1857), ed. C. Pichois, in *Œuvres complètes*, II, ed. C. Pichois (Paris: Gallimard, 1876), 329.

2. See G. Didi-Huberman, *Ninfa moderna: Essai sur le drapé tombé* (Paris: Gallimard, 2002), 127–141 ("Histoire et imagination").

3. A. Jarach, ed., *Album visivo della Shoah: Destinazione Auschwitz; Ricorda che questo è stato* (Milan: Proedi, 2002), 31. My thanks to Ilsen About for bringing this work to my attention.

4. See J. Derrida, *L'écriture et la différence* (Paris: Le Seuil, 1967). [In this work, translated by Alan Bass as *Writing and Difference* (Chicago : University of Chicago Press, 1978), Derrida coins the word *différance*, ending –*ance* rather than –*ence*, to denote a kind of alienation or distancing.— Trans.]

5. Wajcman, "De la croyance photographique," 76–77.

6. Ibid., 77.

7. See D. Bernard and A. Gunthert, *L'instant rêvé: Albert Londe* (Nîmes: Jacqueline Chambon, 1993).

8. See the slightly different version by É. Wiesel, *Célébration hassidique* (Paris: Le Seuil, 1972), 236.

9. See S. Freud, *Inhibitions, Symptoms and Anxiety*, trans. J. Stratchey (New York: W. W. Norton, 1977).

10. Wajcman, "'Saint Paul' Godard contre 'Moïse' Lanzmann," 121–127.

11. M. Blanchot, *L'entretien infini* (Paris: Gallimard, 1969), 635.

12. Lacan, *Le Séminaire, XX: Encore*, 13.

13. Wajcman, *L'objet du siècle*, 156 and 167. In contrast to this trivial position on absence, see, twenty years earlier, P. Fédida, *L'absence* (Paris: Gallimard, 1978).

14. See Schneider, *Le trauma et la filiation paradoxale*, 83–84: "The world that traumatism makes it necessary to construct could be compared with the creation of a diptych [. . .] montage of two antagonistic pictures."

15. [The words *expérience évidante: évider* means "to empty," the participle *évidant(e)* means "emptying," while the adjective *évident* means "evident." Didi-Huberman plays on both of these meanings.—Trans.]

16. Lanzmann, *Shoah*. Godard, *Histoire(s) du cinéma*.

17. See Lindeperg, *Clio de 5 à 7*, 266–269.

18. L. Saxton, "*Ana*mnesis Godard/Lanzmann," trans. C. Wajsbrot, *Trafic*, no.47 (2003): 48–66.

19. Wajcman, "'Saint Paul' Godard contre 'Moïse' Lanzmann," 121–127.

20. Wajcman, "De la croyance photographique," 60–61.

21. Wajcman, "'Saint Paul' Godard contre 'Moïse' Lanzmann," 127.

22. R. Hilberg, *La politique de la mémoire* (1994), trans. M.-F. de Paloméra (Paris: Gallimard, 1996), 182.

23. The English version is clearer on this point than the French translation: "Lanzmann even found most of his interviewees in small places, and these people and localities are shown in a nine-and-half hour mosaic." R. Hilberg, *The Politics of Memory: The Journey of a Holocaust Historian* (Chicago: Ivan R. Dee, 1994), 191.

24. See M. Halbertal and A. Margalit, *Idolatry*, trans. N. Goldblum (Cambridge, MA: Harvard University Press, 1992), 37–66.

25. J.-F. Forges, "*Shoah*: Histoire et mémoire," *Les temps modernes* 55, no. 608 (2000): 30, 35, and 40. Vincent Lowy rightly observed that, given that *Shoah* is in some ways similar—according even to Lanzmann—to a funeral, "it could be accomplished only once." V. Lowy, *L'Histoire infilmable: Les camps d'extermination nazis à l'écran* (Paris: l'Harmattan, 2001), 80.

26. Lanzmann, "Holocauste, la représentation impossible," vii. Id., "Le monument contre l'archive?," 275–276.

27. Lanzmann, "Parler pour les morts," 15.

28. On the polemic between Lanzmann and Spielberg, see in particular J. Walter, "*La liste de Schindler* au miroir de la presse," *Mots: Les langages du politique*, no.56 (1998): 69–89. Lowry, *L'Histoire infilmable*, 153–164. For a critique of Benigni, see Henochsberg, "Loin d'Auschwitz," 42–59.

29. P. Sorlin, "La Shoah: Une représentation impossible?" in *Les institutions de l'image*, 183.

30. See R. Raskin, *"Nuit et brouillard" by Alain Resnais: On the Making, Reception and Functions of a Major Documentary Film* (Aarhus: Aarhus University Press, 1987). C. Delage, "Les contraintes d'une expérience collective: *Nuit et brouillard*," in *Le film et l'historien*, ed. C. Delage and V. Guigueno (Paris: Gallimard, 2004).

31. A. Kyrou, *"Nuit et brouillard*: le film nécessaire" (1956), in *Alain Resnais*, ed. S. Goudet (Paris: Positif-Gallimard, 2002), 44.

32. M. Oms, *Alain Resnais* (Paris: Rivages, 1988), 67. On pages 23–57 the author points to the extensive reflections by Resnais on death in history, through *Guernica* (1950), *Les Statues meurent aussi* (1950–1953), *Hiroshima mon amour* (1959), even *Stavisky* (1974).

33. J. Cayrol, *Nuit et brouillard* (1956; Paris: Fayard, 1997), 17 and 21. Here, before Cayrol's text, is the beginning of the synopsis written by Resnais: "*Nuit et brouillard*. Color. A neutral landscape, calm, banal. The camera retreats. We are inside a concentration camp that is disused and deserted. With a panoramic sweep, the camera discovers in the distance the entrance to the camp, flanked by a watchtower. (Perhaps we can even make out a group of tourists dressed in bright-colored clothes walking through the camp entrance following a guide. The weather might be sunny. But subsequently the sky will always be gray and cloudy). A series of very slow panoramic shots starting off each time from an 'exterior' element and ending on an "interior" element (ideally, each one of these panoramic shots would be performed in a different camp: Struthof, Mauthausen, Auschwitz–Birkenau, Majdanek)." A. Resnais, cited byDelage, "Les contraintes d'une expérience collective."

34. Lanzmann, *Shoah*, 18.

35. A. Fleischer, *L'art d'Alain Resnais* (Paris: Centre Georges Pompidou, 1998), 33.

36. J. Rivette, "De l'abjection," *Cahiers du cinéma*, no. 120 (1961): 54–55.

37. S. Daney, "Resnais et l'"écriture du désastre"' (1983), in *Ciné-journal, II, 1983–1986* (Paris: Cahiers du cinéma, 1986; 1998 ed.), 27–30. *Id.*, "Le travelling de *Kapo*" (1992), in *Persévérance: Entretien avec Serge Toubiana*

(Paris: POL, 1994), 13–39. See, more recently, F. Niney, *L'épreuve du réel à l'écran: Essai sur le principe de réalité documentaire* (Brussels: De Boeck Université, 2000), 95–100. C. Neyrat, "Horreur/bonheur: Métamorphose," in *Alain Resnais*, 47–54.

38. Against these severe judgments by Georges Bensoussan (*Auschwitz en héritage? D'un bon usage de la mémoire* [Paris: Mille et Une Nuits, 1998], 44) and by Annette Wieviorka (*Déportation et génocide: Entre la mémoire et l'oubli* [Paris: Plon, 1992], 223), Christian Delage has established, on the basis of Anatole Dauman's archives, that the recognition of the genocide of the Jews—and of its specificity—was indeed inscribed in Resnais's project. See Delage, "Les contraintes d'une expérience collective."

39. Lindeperg, *Clio de 5 à 7*, 183.

40. Cayrol, *Nuit et brouillard*, 23–24.

41. Ibid., 43.

42. See P. Mesnard, "La mémoire cinématographique de la Shoah," in *Parler des camps, penser les génocides*, ed. C. Coquio (Paris: Albin Michel, 1999), 480–484. Id., *Consciences de la Shoah*, 289–290.

43. "I went the other morning into the theater to check, with the projectionist, the conditions of the projection; whether the sound was loud enough; the quality of the copy, etc. And then I walked past the ticket desk; *Shoah* is scheduled for 2 o'clock, and I see 12 o'clock: *Nuit et brouillard.* So I say to myself, 'this is very strange' . . . So I go and see the owner of the theater [. . .] and say to him: 'What is this?' He answers: 'I have to show a film at noon, there are laws.' So I say to him: 'Wait, this is a joke! This is a joke, right!' And he says: 'No, my program planner thought that after all, it was the same subject.' [. . .] So I say: 'Very well, if you show *Nuit et brouillard*, there will be no *Shoah*, I will withdraw the film.' [. . .] I think the confrontation or contiguity between the two films makes no sense. Even if the subject is identical, *Shoah* has nothing to do with *Nuit et brouillard.*" C. Lanzmann, cited by Lowry, *L'Histoire infilmable*, 85–86.

44. As V. Sánchez-Biosca believes; see "Représenter l'irreprésentable: Des abus de la rhétorique," in *Les institutions de l'image*, 177.

45. See Mesnard, "La mémoire cinématographique de la Shoah," 473–490 (which counts 1194 films produced between 1985 and 1995). Id., *Consciences de la Shoah*, 294–297 ("L'obstination des archives" in which films by A. Jaubert, E. Sivan, and R. Brauman are mentioned in particular). See also F. Monicelli and C. Saletti, eds. *Il racconto della catastrofe: Il cinema di fronte ad Auschwitz* (Verona : Società Letteraria-Cierre Edizioni, 1998). W. W. Wende, ed., *Geschichte im Film: Mediale Inszenierungen des Holocaust und kulturelles Gedächtnis* (Stuttgart and Weimar: Metzler, 2002).

46. See Niney, *L'épreuve du réel à l'écran*, 253–271 ("Les archives").

47. Wajcman, "'Saint Paul' Godard contre 'Moïse' Lanzmann," 126.

48. Ibid., 125.

49. [The noun *évidance* is a neologism made of two French words—the verb *évider* (to empty) and the noun *évidence* ("evidence, obvious facts"); see note 15 above.—Trans.]

50. This information was given by the Imperial War Museum (London), where the film is shown. According to Dany Uziel, director of the photographic archives of Yad Vashem, the film takes place in Minsk and not in Mogilov.

51. J.-L. Godard, "Le groupe Dziga Vertov," in *Jean-Luc Godard par Jean-Luc Godard*, I: *1950–1984*, ed. A. Bergala (Paris: Cahiers du cinéma, 1985; 1998 ed.), 348.

52. J.-L. Godard (with Y. Ishaghpour), *Archéologie du cinéma et mémoire du siècle: Dialogue* (Tours: Farrago, 2000), 81.

53. J.-L. Godard, "Jean-Luc Godard rencontre Régis Debray" (1995), in *Jean-Luc Godard par Jean-Luc Godard*, II: *1984–1998*, ed. A. Bergala (Paris: Cahiers du cinéma, 1998), 430.

54. J.-L. Godard, "Alfred Hitchcock est mort" (1980), in *Jean-Luc Godard par Jean-Luc Godard*, I: *1950–1984*, 412–415.

55. Ibid., 412.

56. R. Bresson, *Notes sur le cinématographe* (Paris: Gallimard, 1975; 1995 ed.), 22, 30, 33, 35–36, 52, 56, 69, 93–94, and 107.

57. G. Sadoul, "Témoignages photographiques et cinématographies," *L'Histoire et ses méthodes*, ed. C. Samaran (Paris: Gallimard, 1961), plates 392–1394.

58. See V. Sánchez-Biosca, "*Hier ist kein Warum*: À propos de la mémoire et de l'image des camps de la mort," *Protée: Théories et pratiques sémiotiques* 25, no. 1 (1997): 57–59. Lindeperg, *Clio de 5 à 7*, 231–235. M. Joly, "Le cinéma d'archives, preuve de l'histoire?" in *Les institutions de l'image*, 201–212. See also C. Drame, "Représenter l'irreprésentable: Les camps nazis dans les actualités françaises de 1945," *Cinémathèque*, no.10 (1996): 12–28.

59. Concerning the role of cinematographic images in the Nuremberg trials, see the remarkable analyses by C. Delage, "L'image comme preuve: L'expérience du procès de Nuremberg," *Vingtième siècle: Revue d'histoire*, no.72 (2001): 63–78.

60. Godard, "Alfred Hitchcock est mort," 415.

61. Godard, "Le montage, la solitude et la liberté" (1989), in *Jean-Luc Godard par Jean-Luc Godard*, II: *1984–1998*, 244.

62. Godard, *Histoire(s) du cinéma*, III, 55.

63. Godard (with Ishaghpour), *Archéologie du cinéma et mémoire du siècle*, 26–27.

64. Ibid., 13 and 82.

65. J. Rancière, "La phrase, l'image, l'histoire" (2002), *Le Destin des images* (Paris: La Fabrique, 2003), 72.

66. Godard (with Y. Ishaghpour), *Archéologie du cinéma et mémoire du siècle*, 21 and 24–25.

67. Godard, "Le cinéma est fait pour penser l'impensable" (1995), in *Jean-Luc Godard par Jean-Luc Godard*, II: *1984–1998*, 296. *Id.*, "*Histoire(s) du cinéma*: à propos de cinéma et d'histoire" (1996), ibid., 402: "[When] you have the biologist François Jacob writing: 'In the same year Copernicus and Vesalius . . . ,' well, Jacob is not doing biology there, he is making cinema. And that is only where history is. It is *rapprochement*. It is *montage*."

68. J.-L. Godard, "Le cinéma a été l'art des âmes qui ont vécu intimement dans l'Histoire (entretien avec Antoine de Baecque)," *Libération*, April 6–7, 2002, 45.

69. On the Benjaminian content in *Histoire(s) du cinéma*, see in particular Bergala, *Nul mieux que Godard*, 221–249 ("L'Ange de l'Histoire"). Y. Ishaghpour, "J.-L. Godard cinéaste de la vie moderne: Le poétique et l'historique," in *Archéologie du cinéma et mémoire du siècle*, 89–118. On "knowledge through montage" in Walter Benjamin, see Didi-Huberman, *Devant le temps*, 85–155.

70. J. Rancière, "L'inoubliable," in *Arrêt sur histoire*, ed. J.-L. Comolli and J. Rancière (Paris: Centre Georges Pompidou, 1997), 47–70. Id., "L'historicité du cinéma," in *De l'histoire au cinéma*, ed. A. de Baecque and C. Delage (Paris and Brussels: IHTP–CNRS–Éditions Complexe, 1998), 45–60. All of this is pronounced—as in the already mentioned debate regarding Carlo Ginzburg—against the postmodern "end of history," which is illustrated, for example, in the article by A. Kaes, "Holocaust and the End of History: Postmodern Historiography in Cinema," in *Probing the Limits of Representation*, 206–222.

71. Godard, "Le cinéma est fait pour penser l'impensable," 294–299.

72. Godard, "Le cinéma n'a pas su remplir son rôle" (1995), in *Jean-Luc Godard par Jean-Luc Godard*, II: *1984–1998*, 336.

73. J.-L. Godard, "La légende du siècle (interview with Frédéric Bonnaud and Arnaud Viviant)," *Les Inrockuptibles*, October 21, 1998, 28: "We always discover archives a long time afterward. [. . .] I have no proof whatsoever of what I am claiming, but I think that if I worked with a good investigative journalist on this, I would find the images of the gas

chambers after about twenty years. We would see the prisoners entering, and we would see in what state they come out."

74. Godard, "Entretien avec Marguerite Duras" (1987), in *Jean-Luc Godard par Jean-Luc Godard*, II: *1984–1998*, 144–146: "*Jean-Luc Godard.*— We do not want to see, we prefer to speak ill of something. I always take that example of the concentration camps: we prefer to say 'never again' than to show. [. . .] We prefer to write books to say that they never existed, to which other books respond by saying that they did exist. But it suffices to show, the vision still exists. [. . .] *Marguerite Duras.*—*Shoah* showed the roads, the deep pits, the survivors . . . *Jean-Luc Godard.*—It showed nothing."

75. Godard, "Feu sur *Les Carabiniers*" (1963), in *Jean-Luc Godard par Jean-Luc Godard*, I: *1950–1984*, 239 : "Let us take the example of the concentration camps. The only true film to be made about them—which has never been filmed and never will be, because it would be intolerable— would be to film a camp from the point of view of the torturers [. . .]. What would be unbearable is not the horror that would radiate from such scenes, but quite the contrary, their perfectly normal and human aspect." Id., *Introduction à une véritable histoire du cinéma* (Paris: Albatros, 1980), 269–270: "And if we study the camps . . . This is why there are never any films that are really made on the concentration camps, because we would see our own world, exactly, and in a very clear form."

76. Ibid., 221–222.

77. Godard, "Lettre à un ami américain" (1995), in *Jean-Luc Godard par Jean-Luc Godard*, II: *1984–1998*, 344. This is one of the reasons invoked by Godard for refusing the award that the New York Film Critics Circle offered him.

78. J. Rancière, *La fable cinématographique* (Paris: Le Seuil, 2001), 236.

79. J. Aumont, *Amnésies: Fictions du cinéma d'après Jean-Luc Godard* (Paris: POL, 1999), 9–32. [By hyphenating the verb *re-monter*, Aumont is playing on the the words *monter*, meaning "to make a montage of," and the expression *remonter le temps*, meaning "to go back in time."—Trans.]

80. Ibid., 241.

81. Godard, *Histoire(s) du cinéma*, IV, 103.

82. Ibid., I, 130.

83. F. Goya, *Les Caprices* (1799), trans. J.-P. Dhainault (Paris: L'Insulaire, 1999), 166.*

84. Godard, *Histoire(s) du cinéma*, I, 131. On this "convoy," also photographed by Éric Schwab, Lee Miller, and David Scherman, see C. Chéroux, "Le train," in *Mémoire des camps*, 150–151. On the color

218 [NOTES TO PAGES 146–152

archive, See C. Delage, "La guerre, les camps: la couleur des archives," *Vertigo*, no.23 (2003): 39–42.

85. Godard, *Histoire(s) du cinéma*, I, 131–133. Godard is mistaken about "Auschwitz and Ravensbrück," for it is in fact Dachau.

86. Godard, "*Histoire(s) du cinéma*: Godard fait des histoires. Entretien avec Serge Daney" (1988), in *Jean-Luc Godard par Jean-Luc Godard*, II: *1984–1998*, 172.

87. Godard, *Histoire(s) du cinéma*, I, 134–135.

88. Rancière, *La fable cinématographique*, 231–232.

89. Godard, *Histoire(s) du cinéma*, I, 164–167 and 214.

90. Ibid., I, 166.

91. Ibid., I,.135.

92. W. Benjamin, *Sens Unique* (1928), trans. J. Lacoste (Paris: Les Lettres nouvelles–Maurice Nadeau, 1978), 209.*

93. Benjamin, "Sur le concept d'histoire," 343.

94. Godard, *Histoire(s) du cinéma*, I, 191.

95. Bergala, *Nul mieux que Godard*, 221–249.

96. As I suggested earlier, Godard is certainly not the only agent of this rapport with history, with archives and with montage: one must also question, among others, the works of Chris Marker or Harun Farocki. On Marker, see R. Bellour, *L'entre-images 2: Mots, images* (Paris: POL, 1999), 335–362. On Farocki, see R. Aurich and U. Kriest, eds., *Der Ärger mit den Bildern: Die Filme von Harun Farocki* (Konstanz: UVK Medien, 1998), and C. Blümlinger, "Harun Farocki ou l'art de traiter les entre-deux," trans. B. Vilgrain, in H. Farocki, *Reconnaître et poursuivre* (Montbard: Théâtre typographique, 2002), 11–18.

Similar Image or Semblance-Image

1. Lanzmann, "La question n'est pas celle du document," 29. See C. Chéroux, "L''épiphanie négative': Production, diffusion et réception des photographies de la libération des camps," in *Mémoire des camps*, 103–127.

2. The only "parallel" established by C. Chéroux in his catalogue (*Mémoire des camps*, 108–109) is the placing of two photographs of Buchenwald opposite one another: the beaten guard is confronted by charred human remains.

3. Godard, *Introduction à une véritable histoire du cinéma*, 308.

4. Godard, *Histoire(s) du cinéma*, IV, 54–55.

5. Godard (with Ishaghpour), *Archéologie du cinéma et mémoire du siècle*, 71.

6. See M.-A. Matard-Bonucci, "L'image, figure majeure du discours antisémite?" *Vingtième siècle: Revue d'histoire*, no.72 (2001): 27–39.

7. See Didi-Huberman, *La ressemblance informe*.

8. Wajcman, "De la croyance photographique," 74.

9. Ibid., 73–74.

10. Ibid., 74–75.

11. Ibid., 73.

12. On Chaplin's film, see C. Delage, *Chaplin: La grande histoire* (Paris: Jean-Michel Place, 1998).

13. Cayrol, *Nuit et brouillard*, 42–43.

14. W. Sofsky, *L'organisation de la terreur: Les camps de concentration* (1993), trans. O. Mannoni (Paris: Calmann-Lévy, 1995), 4.* See also G. Decrop, *Des camps au génocide: La politique de l'impensable* (Grenoble: Presses universitaires, 1995).

15. See C. Coquio, "Du malentendu," in *Parler des camps, penser les génocides*, ed. C. Coquio (Paris: Albin Michel, 1999), 17–86. Y. Thanassekos, "Shoah, 'objet' métaphysique?" *Bulletin trimestriel de la Fondation Auschwitz*, no.73 (2001): 9–14.

16. See J. Rovan, ed., *Devant l'histoire: Les documents de la controverse sur la singularité de l'extermination des juifs par le régime nazi* (Paris: Le Cerf, 1988). C. Coquio and I. Wohlfarth, "Avant-propos," in *Parler des camps, penser les génocides*, 11–16. E. Traverso, "La singularité d'Auschwitz: Hypothèses, problèmes et dérives de la recherche historique," in ibid., 128–140. S. Trigano, *L'idéal démocratique à l'épreuve de la Shoa* (Paris: Odile Jacob, 1999), 9–20 and passim.

17. J.-L. Nancy, "La représentation interdite," *Le genre humain*, no.36 (2001): 13–39; reprinted in *Au fond des images* (Paris: Galilée, 2003), 57–99.

18. Godard, *Histoire(s) du cinéma*, I, 79–83.

19. Aumont, *Amnésies*, 98.

20. On Warburg's *Pathosformel* as symptom, montage, and seismography of history, see G. Didi-Huberman, *L'image survivante: Histoire de l'art et temps des fantômes selon Aby Warburg* (Paris: Minuit, 2002), 115–270.

21. Rancière, *Le partage du sensible*, 43–44.

22. Rancière, "S'il y a de l'irreprésentable" *Le genre humain*, no.36 (2001): 81.

23. Ibid., 83.

24. Wajcman, "'Saint Paul' Godard contre 'Moïse' Lanzmann," 126–127.

25. Rancière, "S'il y a de l'irreprésentable," 89 and 94–96.

26. Ibid., 97–102.

27. Wajcman, "De la croyance photographique," 49–50 and 66. Id., "Oh *Les derniers Jours*," 20–21.

28. For a philosophical approach to the question, see in particular the recent study by G. Deniau, *Cognitio Imaginativa: La phénoménologie herméneutique de Gadamer* (Brussels: Ousia, 2002).

29. A summary of this tradition is given by Ricoeur, *La mémoire, l'histoire, l'oubli*, 5–66 ("Mémoire et imagination").

30. Wajcman, "De la croyance photographique," 55, 58 and 60–61.

31. Ibid., 72.

32. Ibid., 58–59.

33. See M. Revault d'Allonnes, *Le dépérissement de la politique: Généalogie d'un lieu commun* (Paris: Aubier, 1999), 249–255.

34. Revault d'Allonnes, "Une mémoire doit-elle en chasser une autre?" (1998), in *Fragile humanité* (Paris: Aubier, 2002), 143.

35. Revault d'Allonnes, "À l'épreuve des camps: L'imagination du semblable" (1998), in ibid., 148.

36. Antelme, *L'espèce humaine*, 100–101.

37. Revault-d'Allonnes, "À l'épreuve des camps," 151.

38. Revault-d'Allonnes, "Peut-on élaborer le terrible?" (2000), in *Fragile humanité*, 180–182.

39. Antelme, *L'espèce humaine*, 9. My emphasis.

40. G. Deleuze, *Critique et clinique* (Paris: Minuit, 1993), 11.

41. Revault d'Allonnes, "Le 'coeur intelligent' de Hannah Arendt" (1995), in *Fragile humanité*, 56.

42. Revault d'Allonnes, *Ce que l'homme fait à l'homme: Essai sur le mal politique* (Paris: Le Seuil, 1995), 21–72. Id., "Hannah Arendt: le mal banal, la guerre totale" (1999), in *Fragile humanité*, 89–116.

43. E. Kant, *Critique of the Power of Judgment*, trans. P. Guyer and A. Wood (Cambridge: Cambridge University Press, 2001). H. Arendt, *Lectures on Kant's Political Philosophy*, ed. R. Beiner (Chicago: University of Chicago Press, 1989). R. Beiner, "Hannah Arendt et la faculté de juger," in ibid., 129–216. Revault d'Allonnes, "Le courage de juger," in ibid., 217–239. P. Ricoeur, "Jugement esthétique et jugement politique selon Hannah Arendt," *Le juste* (Paris: Éditions Esprit, 1995), 143–161.

44. See Revault d'Allonnes, "À l'épreuve des camps," 151–167. On the role of the imagination in Spinoza's *Ethics*, see in particular M. Bertrand, *Spinoza et l'imaginaire* (Paris: PUF, 1983), 171–185. On the imagination as a social relation, see also C. Castoriadis, *L'institution imaginaire de la société* (Paris: Le Seuil, 1975). A. M. Piper, "Impartiality, Compassion, and Modal Imagination," *Ethics* 101, no. 4 (1991): 726–757.

45. Wajcman, *L'objet du siècle*, 221–254.

46. P. Celan, *"Le Méridien & autre proses,"* bilingual French-German edition, trans. J. Launay (Paris: Le Seuil, 2002).

47. Z. Gradowski, *Au coeur de l'enfer*, 40–41.* These lines for a "preface" are repeated, with slight variations, on pages 53–55 and 119–120.

48. Wajcman, "De la croyance photographique," 67–68.

49. Ibid., 68.

50. Ibid., 51–52.

51. Ibid., 60–61.

52. Ibid., 62–65.

53. Ibid., 81–83.

54. Ibid., 54 and 56–57.

55. Godard, *Histoire(s) du cinéma*, I, 86.

56. Ibid., I, 214.

57. Wajcman, "'Saint Paul' Godard contre 'Moïse' Lanzmann," 121–127.

58. The history of art itself is aware of two *concurrent* models of resurrection (Vasari) and of survival as relic [*survivance*] (Warburg). See Didi-Huberman, *L'image survivante*, 9–114.

59. Godard, *Histoire(s) du cinéma*, I, 87.

60. W. Benjamin, *Theses on the Philosophy of History*, trans. H. Zohn (New York: Schocken Books, 1969), 260.

61. See M. Löwy, *Rédemption et utopie: Le judaïsme libertaire en Europe centrale; Une étude d'affinité élective* (Paris: PUF, 1988).

62. Ibid., 92–120.

63. F. Rosenzweig, cited by S. Mosès, *L'ange de l'histoire: Rosenzweig, Benjamin, Scholem* (Paris: Le Seuil, 1992), 56.

64. F. Rosenzweig, *L'étoile de la rédemption* (1921), trans. A. Derczanski and J.-L. Schlegel (Paris: Le Seuil, 1982), 286–295 ("La rédemption comme catégorie esthétique").

65. Ibid., 299.*

66. G. G. Scholem, "Sur l'édition de 1930 de *L'étoile de la rédemption* de Rosenzweig" (1931), in *Le messianisme juif: Essai sur la spiritualité du judaïsme*, trans. B. Dupuy (Paris: Calmann–Lévy, 1974), 449–454.*

67. Scholem, "La rédemption par le péché" (1937), in ibid., 139–217.

68. Scholem, "L'idée de rédemption dans la Kabbale" (1941–1955), in ibid., 74–75.*

69. Ibid., 78–79.* The "dialectic" to which Scholem refers (ibid., 92) is found in the Kabbala in terms of a "contraction" (*tsimtsum*), a "breaking" (*shevirah*) and a "repairing" (*tikkun*).

70.[For Didi-Huberman's play on words, see note 79 in "Montage-Image or Lie-Image" above.—Trans.]

71. Benjamin, "Sur le concept d'histoire," vi, 431.

72. Ibid., ii, 428.*

73. Ibid., v, 430.*

74. See M. Löwy, *Walter Benjamin: Avertissement d'incendie; Une lecture des thèses "Sur le concept d'histoire"* (Paris: PUF, 2001), 35–40.

75. Benjamin, "Sur le concept d'histoire," xi, 436.

76. Ibid., B., 443.

77. Benjamin, cited by Löwy, *Walter Benjamin*, 99. See R. Wolin, *Walter Benjamin: An Aesthetic of Redemption* (New York: Columbia University Press, 1982). For a very recent contribution to this Jewish philosophy of redemption, see P. Bouretz, *Témoins du futur: Philosophie et messianisme* (Paris: Gallimard, 2003.

78. Benjamin, *Theses on the Philosophy of History*, 254.

79. See E. Bloch, *The Principle of Hope* (Cambridge, MA: MIT Press, 1995). K. Löwith, *Meaning in History: The Theological Implications of the Philosophy of History* (Chicago: University of Chicago press, 1957).

80. S. Kracauer, *Theory of Film: The Redemption of Physical Reality* (Oxford: Oxford University Press, 1960).

81. S. Kracauer, *From Caligari to Hitler: A Psychological History of the German Film* (Princeton: Princeton University Press, 2004).

82. S. Kracauer, *Kino, Essays, Studien, Glossen zum Film* (1926–1950), ed. K. Witte (Frankfurt: Suhrkamp, 1974). See also the excellent English edition, id., *The Mass Ornament: Weimar Essays* (1920–1931), trans. T. Y. Levin (Cambridge, MA: Harvard University Press, 1995). On Kracauer, see in particular M. Jay, "The Extraterritorial Life of Siegfried Kracauer" (1975–1976), *Permanent Exiles: Essays on the Intellectual Migration from Germany to America* (New York: Columbia University Press, 1985), 152–197. H. Schlüpmann, "Phenomenology of Film: On Siegfried Kracauer's Writings of the 1920s," trans. T. Y. Levin, *New German Critique*, no. 40 (1987): 97–114. I. Mülder-Bach, "Négativité et retournement: Réflexions sur la phénoménologie du superficiel chez Siegfried Kracauer," trans. É. Saint-Étienne, in *Weimar: Le tournant esthétique*, ed. G. Raulet and J. Fürnkäs (Paris: Anthropos, 1988), 273–285. M. Kessler and T. Y. Levin, eds., *Siegfried Kracauer: Neue Interpretationen* (Tübingen: Stauffenburg, 1990). M. Hansen, "Decentric Perspectives: Kracauer's Early Writings on Film and Mass Culture," *New German Critique*, no.54 (1991): 47–76. D. Barnouw, *Critical Realism: History, Photography, and the Work of Siegfried Kracauer* (Baltimore: Johns Hopkins University Press, 1994). E. Traverso, *Siegfried Kracauer: Itinéraire d'un intellectuel nomade* (Paris: La Découverte, 1994). P. Despoix, *Éthiques du désenchantement: Essais sur la modernité allemande au début du siècle* (Paris: L'Harmattan, 1995), 169–212. G. Koch, *Siegfried Kracauer: An introduction*, trans. J. Gaines (Princeton: Princeton University Press, 2001). M. Brodersen, *Siegfried Kracauer* (Reinbek: Rowohlt, 2001). P. Despoix and N. Perivolaropoulou, eds., *Culture de masse et*

modernité: Siegfried Kracauer, sociologue, critique, écrivain (Paris: Éditions de la Maison des sciences de l'homme, 2001).

83. W. Benjamin, "Un marginal sort de l'ombre: À propos des *Employés* de S. Kracauer" (1930), trans. P. Rusch, in Benjamin, *Œuvres* II (Paris: Gallimard, 2000), 188.*

84. See P. Despoix, "Avant-propos," in S. Kracauer, *Le voyage et la danse: Figures de ville et vues de films*, trans. S. Cornille (Saint-Denis: Presses Universitaires de Vincennes, 1996), 20.

85. Kracauer, "La photographie" (1927), in ibid., 42–57. See B. Lindner, "Photo profane: Kracauer et la photographie," in *Culture de masse et modernité*, 75–95.

86. Kracauer, "Les actualités cinématographiques" (1931), in *Le voyage et la danse*, 124–127.

87. Kracauer, "Les lampes de Jupiter restent allumées: À propos du *Cuirassé Potemkine*" (1926), in ibid., 64.* See, id., "L'homme à la caméra" (1929), in ibid., 89–92.

88. Kracauer, *"The Gold Rush"* (1926), in ibid., 41.*

89. Kracauer, *"Sous les toits de Paris"* (1930), in ibid., 101–103. Id., "Jean Vigo" (1940), in ibid., 142–145.

90. Kracauer, *"Westfront 1918"* (1930), in ibid., 108–109.*

91. Ibid., 110.*

92. Kracauer, *De Caligari à Hitler*, 12: "Thus, beyond the manifest history of economic changes, of social demands and of political machinations, there is a secret history involving the interior disposition of the German people. The revelation of these dispositions through German cinema can help an understanding of the ascension and ascendancy of Hitler."* See Traverso, *Siegfried Kracauer*, 156–166.

93. See T. W. Adorno, "Das wunderliche Realist: Über Siegfried Kracauer" (1964), in Adorno, *Gesammelte Schriften*, XI: *Noten zur Literatur* (Frankfurt: Suhrkamp, 1974), 388–408. M. Jay, "Adorno and Kracauer: Notes on a Troubled Friendship" (1978), in *Permanent Exiles*, 217–236.

94. Kracauer, *Theory of Film*, 285–311. See Mülder-Bach, "Négativité et retournement" 273–285. K. Koziol, "Die Wirklichkeit ist eine Konstruktion: Zur Methodologie Siegfried Kracauers," in *Siegfried Kracauer: Neue Interpretationen*, 147–158. P. Despoix, "Siegfried Kracauer, essayiste et critique de cinéma," *Critique* 48, no. 539 (1992): 298–320. N. Perivolaropoulou, "Les mots de l'histoire et les images de cinéma," in *Culture de masse et modernité*, 248–261. On the notion of "extraterritorialité," see Traverso, *Siegfried Kracauer*, 178–189. Id., "Sous le signe de l'exterritorialité: Kracauer et la modernité juive," in *Culture de masse et modernité*, 212–232.

95. See G. Koch, "'Not Yet Accepted Anywhere': Exile, Memory, and

Image in Kracauer's Conception of History," trans. J. Gaines, *New German Critique*, no.54 (1991): 95–109. H. Schlüpmann, "The Subject of Survival: On Kracauer's Theory of Film," trans. J. Gaines, ibid., 111–126. Banouw, *Critical Realism*, 200–264.

96. Kracauer, *Theory of Film*, 46–59.

97. Ibid., 193–214.

98. Ibid., 305–306.

99. S. Krakauer, *History: The Last Things before the Last* (Oxford: Oxford University Press, 1969), 78–79. See D. N. Rodowick, "The Last Things before the Last: Kracauer on History," *New German Critique*, no.41 (1987): 109–139.

100. Kracauer, *Theory of Film*, 305–306.

101. Ibid., p. xi. See J.-L. Leutrat, "Comme dans un miroir confusément," in *Culture de masse et modernité*, 233–247.

102. Blanchot, *L'entretien infini*, 180–200.

103. Kracauer, *Theory of Film*, 309–311.

104. See Despoix, "Siegfried Kracauer, essayiste et critique de cinéma," 318–319.

105. J.-M. Frodon, "L'image et la 'rédemption mécanique': Le récit et son conteur," in *La mise en scène*, ed. J. Aumont (Brussels: De Boeck University, 2000), 318.

106. Agamben, *Remnants of Auschwitz*. See on this point the critique by Mesnard and Kaha, *Giorgio Agamben à l'épreuve d'Auschwitz*, 79–83.

107. Wajcman, "De la croyance photographique," 67.

108. A. Warburg, Letter to Mary Warburg, December 15, 1923, cited by E. H. Gombrich, in *Aby Warburg: An Intellectual Biography* (London, Warburg Institute, 1970), 281–282.

109. P. Celan, "Le Méridien," 73.

110. T. W. Adorno, *Minima moralia: Réflexions sur la vie mutilée* (1944–1951), trans., E. Kaufholz and J.-R. Ladmiral (Paris: Payot, 1980; 1991 ed.), 52.*

111. Antelme, *L'espèce humaine*, 9.

112. S. Beckett, "Imagination Dead Imagine," trans. from French by Beckett, in *The Complete Short Prose, 1929–1989*, ed. S. E. Gontarski (New York: Grove Press, 1995).

113. G. W. F. Hegel, *The Phenomenology of Mind*, trans. J. B. Baillie, 2nd ed. (1931; New Yorok: Humanities Press, 1977), 543.* [Didi-Huberman cites the French translation of Hegel by J. Hyppolite (Paris: Aubier-Montaigne, 1941, II, 80). Hyppolite translates the German *das ehrliche Bewusstsein* literally as *conscience honnête* (honest consciousness), and the English translator Baillie likewise gives "honest consciousness"; Hyppolite

also translates *das zerrissene Bewusstsein* literally as *conscience déchirée* (torn consciousness), whereas Baillie gives "distraught and disintegrated soul." Here I have modified Baillie's translation in order to match Hyppolite's and to reproduce Didi-Huberman's reference to the concept of "torn." Another important deviation from Baillie is the term "perversion" (see Didi-Huberman's comment following the quotation), for which Baillie gives "inversion." For the German text, see G. W. F. Hegel, *Phänomenologie des Geistes*, ed. W. Bonsiepen und R. Heede, Felix Meiner Verlag Hamburg, 1980, 283.—Trans.]

114. Löwith, *Meaning in History*.

115. H. Arendt, *Condition de l'homme moderne*, trans. G. Fradier (Paris: Calmann-Lévy, 1961; 1994 ed.), 230.*

116. H. Arendt, *La crise de la culture: Huit exercises de pensée politique* (1954–1968), trans. and ed. P. Lévy (Paris: Gallimard, 1972; 1995 ed.), 14.

INDEX

228

INDEX

Printed and bound by CPI Group (UK) Ltd, Croydon, CR0 4YY

09/06/2025

14685686-0001